A Paradise
for Fools

Books by Nicholas Kilmer

O Sacred Head
Man with a Squirrel
Harmony in Flesh and Black
Dirty Linen
Lazarus Arise
Madonna of the Apes
A Butterfly in Flame
A Paradise for Fools

A Paradise for Fools

A Fred Taylor Art Mystery

Nicholas Kilmer

Poisoned Pen Press

Poisoned
Pen
Press

Copyright © 2011 by Nicholas Kilmer

First Edition 2011

10 9 8 7 6 5 4 3 2 1

Library of Congress Catalog Card Number: 2011926953

ISBN: 9781590589342 Hardcover
 9781590589366 Trade Paperback

Poisoned Pen Press
6962 E. First Ave., Ste. 103
Scottsdale, AZ 85251
www.poisonedpenpress.com
info@poisonedpenpress.com

Printed in the United States of America

for Anne Hillis,
Constant Weeder

Chapter One

An eerie, almost ominous silence had descended on Harvard Square. The students had packed their traps and left. Graduation was done. The honorands, glorified at the graduation ceremonies, had said their say, eaten the canapés, pocketed their extra degrees and medals and left town as absolutely as the Class of 'Ninety two. Summer school hadn't begun. It was like the vacancy before the hurricane strikes, when all the birds go quiet. The day wasn't hot yet, but that was coming for sure.

Fred had walked all the way into Cambridge from Boston after waking early in a place that, for all Clay's most earnest effort to let him feel at home, still made him nervous. These days he was bunking on the old leather sofa in the basement office of Clayton Reed's house on Beacon Hill. Clay, heading for a wedding in Lugano, was grateful to leave Fred in charge of the building and his collection. "Use the guest bedroom," he had offered. But that would be worse. That wouldn't only make him itch, it would lead to a mortal case of hives. A dwelling was a trap. There was no way to get around it.

He'd not been long with Clay. Still hadn't proved himself, not to his own satisfaction. He was almost dizzy from the obtuse self-confidence of the man's willingness, making the leap of faith that left Fred, whom he barely knew, in residence and in charge of several million dollars worth of art—if one cared to translate Clayton's objects into the metaphor of currency, as Fred

did not. Though art was transitory, money was more so. And money, apart from the damage it can do, was uninteresting to Fred, whose own life had become bearable only as the result of being simplified almost to a monastic level. Aside from the car, which was already pretty much in the public domain, and the necessary minimum of clothes, Fred had come close to freeing himself of possessions. He liked it that way.

Fred sat in the Tasty Diner and ordered a breakfast that would also do for lunch—hash, eggs, toast, coffee and more coffee. From his vantage point at the counter, while he ate he could look out at the sidewalk and enjoy the period of reprieve, while this portion of Cambridge reverted to times long gone when Cambridge was a small town with a Woolworth's. Much more briefly, it had been inhabited by an undergraduate student named Fred Taylor whose mind and heart were seduced and ravaged when he wandered one day into the Fogg museum and found wild beasts ranging freely on its walls.

The man back of the counter, between deft exercises with toast, eggs, sausages, and bacon, was doing his best to engage Fred in talk of baseball. Fred, being a fellow male and human, was supposed to know enough at least to grunt, or nod, or shake his head. Fred would be closer to maintaining his part of the conversation if he'd been back in Thailand.

"Death in the family," Fred apologized. "I'm distracted," and was left to a reverie that could now be accepted as mourning.

Mourning was close enough.

Family or not, there had been a good deal of death during the intervening years. And exotic suffering that, as suffering always does, gravitated implacably toward grim simplicity.

"Good coffee," Fred raised his mug. Wake up, Fred. He'd disappointed the man without cause. That was a fellow human after all. Why offend when there was no reason to? The cook nodded forgiveness. He could talk with other people at the counter.

The rage and color of a single mind, fully engaged—in all its danger, its cruelty, and its beneficent anguish—that was what Fred had felt offered itself, unfettered, in many of the paintings

on the museum's walls. He'd stumbled in mistakenly, believing that it was here they were about to teach him expository writing. Wherever the class might be, he never found it. He'd been assaulted, as had Saul on the road to Damascus, but by Tintoretto, Rembrandt, van Ruisdael, and Cézanne.

When it came time, after an interlude, to start his life again, Fred, remembering the jolt that had transformed him once before, thought about this place and settled, if it could be called settling, across the river. He'd bought a house in Charlestown, along with some other guys with similar experiences and a similar need to adapt inappropriate skills, learned overseas, to the democratic peacetime economy of their native land.

"I'm sorry for your loss," the man back of the counter said, refilling his mug.

"Thanks." Fred put his money down, took a last swig, and rose.

◇◇◇

Fred timed it to get to the public library at around ten o'clock. He nodded to the shadowy straggle of homeless men who gathered in the shabby park in front of the library building. Dense trees cast a desirable shade as well as offering, when needed, protection from rain. The city, acknowledging, at a distance, that these residents were likely to be men who had served their country, afforded them a wary and aloof protection that became aggressive only when things got out of hand.

The library building was the sort of gingerbread fairy castle an eight-year-old child might have invented in 1880, and built out of brown and yellow blocks, adding extra turrets when it was done. The building was almost fustier outside than in. But all that stone made the inside cooler than the day was going to be. Fred found his way to the reference desk. It stood in a crowded main reading room that also served as copy room and the vestibule for the public toilets—one of the attractions for the homeless who sheltered in the park. A man in shirtsleeves was playing solitaire with index cards on the desk's surface.

"I'd called with a question," Fred said. "I talked to someone. Ms. Riley, if I remember. Is she here?"

"Molly's around. Likely in the stacks. I can help."

"I started with Ms. Riley," Fred said. "I'll wait till she comes back." He took a seat at one of the long tables and glanced through yesterday's *Globe*. It might as well be last week's *Globe*, or tomorrow's. The names changed. The stories didn't.

There. That must be Ms. Riley. A graceful young woman of medium height, green dress with buttons up the front, brown hair short, with curls. Fred had only spoken to her on the telephone, but what he saw went with the voice. He put the paper down. The reference colleague in shirtsleeves was gesturing in his direction.

"Ms. Riley?"

"Molly," she said. "On the phone it's Ms. Riley."

"I should have come a month ago. I left a request. If I ran up a charge, I'm overdue."

"If it's only a month I'll have it," she said. "Provided I found what you wanted. What was the…"

"Fred," Fred said. "I might not have gone beyond Fred, being of a retiring nature."

Molly Riley looked at the craggy heft of him and grinned. Those eyes were green.

"Fred. Yes. The value of a scudo in Milan in 1525," she said. "In today's money. That was the question, wasn't it?"

Fred nodded. The shirt-sleeved colleague went away with his handful of index cards. Behind the reference desk, at a slight remove, someone chinked quarters into the Xerox machine and then jostled it.

"People think they can beat the odds," Molly Riley said.

Fred said, "I read around and I find that scholars, or what passes for scholars, are downright ignorant or at least completely lacking in curiosity. Wouldn't you think, say an art historian tells you that the *Mona Lisa* was appraised at one hundred scudi in 1525, that same art historian might also be interested to know,

and tell you, what else you could buy with the same hundred scudi? A horse? A house? A Xerox copy?"

"I wrote some notes. I can probably find them," Molly said. "It's been…"

Chapter Two

"I said I'd come in and I didn't," Fred admitted again. "I started running in another direction, lost track. Is there a bill for your time?"

Molly shrugged, flipping through papers and folders on a shelf under the counter. She looked up suddenly. "Is it true? Leonardo da Vinci's *Mona Lisa* was appraised in 1525 at a hundred scudi? That's..."

Fred said, "And what the scholars like to go on about..."

Molly interrupted, "Wait a minute. 1525? Leonardo died in 1519."

"Granted," Fred said. "His estate had gone to an intimate assistant and hack painter named Salai. It's Salai's estate where it was appraised, because Salai popped off in about 1523. What scholars like to go on about is gee, the shame of it, the *Mona Lisa,* which everyone knows is the greatest painting in the history of the universe—hangs in the Louvre, the Japanese tourists love it—was appraised at a hundred scudi, despised and rejected, and right next to it, another Leonardo that nobody has even seen since fifteen something, *Leda and the Swan*, was appraised at two hundred scudi. Twice as much! As if the appraisals had anything to do with artistic merit. No, the accountant came in, it was like measuring dried beans or corduroy. *Leda* was worth more because it was a bigger picture. In *Leda* you got the whole figure, not one chopped off above the waist, plus a big bird who was expressing a proprietary interest in the lady."

"You are an art historian?" Molly was dubious.

Fred said, "I get to wondering about things."

"I never heard of Salai." Molly pulled out a handful of papers clipped together. "There. That's my notes."

"The way people read the story, Salai started out as Leonardo's page boy and evolved into what we'd call a personal assistant. He's a footnote. If you track the history of the *Mona Lisa,* that's where you have to start."

"It would be fun," Molly said. "Especially if the search requires a side trip to Milan. And Paris. And where else? But here's the best I could do. Take it with a grain of salt, OK? Twenty five K."

"One scudo was worth twenty five thousand dollars?" Fred said. "You mean the *Mona Lisa* was appraised at two and a half million?"

"Sorry. No. I jumped ahead, did the math, being swept into your story. The best I can figure, the scudo was worth two hundred fifty dollars in today's money. If I'm right, that brings the *Mona Lisa* when it was appraised for the estate, in 1525, to twenty-five thousand. That's what I think. Don't quote me."

She was looking at notes scribbled in pencil on white lined paper.

"I could be way off. I know that an unskilled worker could collect one scudo for four days of work. I'm putting that arbitrarily at two hundred fifty bucks. In Rome in 1610, though. Milan, almost a hundred years earlier, I couldn't find out."

Fred held his hand out for the notes. Molly, shaking her head, said, "They won't help you. It's pretty seat-of-the-pants stuff. But fun now, since I know what it was about. There's no charge. I spent time on it but it's still a guess. Back then they were as likely to value things in terms of dozens of eggs, or, what have you: bread or arrows. Not everyone used money. Not everyone *had* money."

Fred told her, "The twenty-five K will do me fine. Even if you're wrong, you can't be all that wrong."

Molly said, "I was going to keep on looking. Maybe I will. The question becomes more interesting now you explain it. I lost track when you didn't..."

"Right," Fred said. "What I'll do, in case you bump into something else, I'm in Cambridge now and then, is put my nose in, and if you're at the desk, you'll keep me up to date. Glad I had a question that's not easy."

"I'll call, if you want," Molly offered. "If I get something real."

"I move around so much," Fred said.

He stepped out of the building into the dusty shade of the worn-out park, cast a glance at his disheveled brothers and suffered the revelation, "I've been letting myself go."

Chapter Three

The face looked walked-on. He'd normally avoid looking at it, but the only way to keep track of the girls behind him was to look past it. It was in the way.

The taller one had a place to stand, a lectern, from which she had directed the only available customer—Fred—to the empty chair that would be serviced, when she got around to it, by the only available—what do they call a female barber in a cut-rate shop called CUT - RATE - CUTS? She wasn't ready. Fred, walking in, had failed to interrupt their line of intense conversation. The tall one, a blonde with long loose straight hair, gestured him toward the empty chair without pausing.

"…which I often think, but then you'll get older, at least that's the plan. People don't think. The expense is another thing I do think about, if I were doing it somewhere else which I'm not, minimum wage, plus my share of tips when the tips are pooled honestly. Not you, Claire. The other girls, when they collect the tips. They're who the client thinks about. Who am I? Usherette. Keep the place running. Make sure the girls show up. So, and you can't tell, when it goes in the pocket, how much. It was. Me, who'd think I'd get a tip for showing them the chair, or telling them 'It'll be ten minutes' when so many clients are lined up waiting it's obvious, any idiot, the wait is gonna be a half-hour, more?"

"I know," Claire said. Fred, from his seat, looking straight ahead, saw Claire, behind him, take a sip from the cardboard

Dunkin' Donuts container she was using to warm her fingers. Claire's hair was short, dark and curly. "Beyond the little one on my butt," she said.

"Starter kit," the taller one said. "Like a training..."

"You have to start somewhere," Claire said. "I live at home, I don't need my mother—she has an opinion about everything already and she will not shut up. Even talks in her sleep. Being on your own, Kim, you don't give a shit." Sip. "Be right with you."

The last four words were for Fred's benefit. Claire took another sip of coffee.

"Besides," Claire said. "Until they make it legal in Massachusetts, the travel and all..."

"My guy..." Kim said.

"I know," Claire interrupted. She'd heard this one already. The two women were close in age, early twenties—very early twenties probably. Claire clacked a pair of scissors impatiently. Kim went on.

"...was in New Hampshire. We went to high school. How I know him. Where tattooing is legal but there's no customers to speak of. Bikers, in summer, heading through, or the marines coming home, but they already have theirs. Got them in 'Nam. Snakes, skulls. The cross. The virgin. Arthur was gonna get the license, New Hampshire, but figured why bother there; he wants to work somewhere else, anyway. Get away from Nashua like I did, and word gets around, he's learning, but he's good. He's got clients don't care about the license any more than he does, and it's cheaper. For everybody."

Both women wore the smocks of the establishment—long-sleeved Dunkin' Donuts pink, buttoning up the front, hanging halfway down the thigh, emblazoned at the left breast with an open pair of scissors and the shop's name, CUT - RATE - CUTS. While Kim talked Claire approached to stand back of Fred. Coffee and patchouli. The scent of the young woman striving to break free. She began selecting tools, taking her time, from the shelf beside him, under the mirror that filled the wall.

Kim went on, "As long as you're careful, which we are. Arthur says, 'I care what goes into my body. So keep everything clean, no problem.' You, I'll take you over some afternoon, evening, Claire, we get off at the same time, you're interested, you meet Arthur, you both, like he says, survey the territory. His place, it's in Central Square."

"Cambridge. You told me."

"Cambridge, sure. Ten minutes from this end of Harvard Square. You can walk it, or the bus."

"What can I do for you? Sorry. We get in the middle of something. Women." Claire was talking to Fred.

"Buzz cut. I forget a trim, let it go. It's been two months. Try to set me back two months."

Claire ministered cold mist from a plastic spray bottle.

Kim, from her lectern, continued talking, looking toward the reflection of Claire, working back of Fred's seamed and scarred face. Claire's eyes, if Fred interpreted correctly, took more interest in the reflection of Kim than they did in the square head she was charged with trimming. Why not? Both women were markedly pretty, both vivid and lively this morning. All three in the room struggled to look past Fred. As far as they all were concerned, Fred wasn't there.

"And so, I was saying, and that's what I was saying, I was thinking, but when I get old? The first thing Arthur says is, 'Don't get fat. You get fat, *it* gets fat at the same time. Everything distorts. Then, next thing, you get sick, lose weight, you're thin again,' he says. 'It's all in folds like a balloon with the air out.' Where he lives, his apartment, Arthur…"

"I know Central Square," Claire said, clipping.

"Over the G Spot," Kim said. "Third floor. On Green Street. Lots of cops in the G Spot, most of the time. Coffee break, off duty, whatever. Station's what, four blocks away? Cops just as soon not go home. At first I thought you don't want to be doing anything illegal upstairs. But then, what Arthur says, what could be better protection than cops on the street floor drinking beer, coffee, or a hamburger. They do a hamburger you should avoid.

Worse is the hot dog, which they had ready for your dining pleasure since last week. The hamburger, at least they are 'on demand.' Fry them up frozen while you wait. Fry the hell out of them. Anyhow, some of the customers are cops. You'd be perfect. The right body. Nice skin. Arthur'll go ape. And he's still..."

"Tapered or square?" Claire asked.

"Tapered," Fred told her. "I want to look as close to natural as I can."

"...learning, so he's cheap," Kim said. "He advertises there. The G Spot. Bulletin board next to the bar. Not his address, the telephone number and what he'll do. You want the Japanese look he'll do that, Loony Tunes, runes. Whatever you want. I get it almost for free. Old friends. He figures it could be another year, we get done. It keeps...one thing leads to another. The last thing he started, we call it a gremlin, is like an egg with two heads and chicken feet, I love. In the middle of my back. I feel it. Where I can't reach with the oil. I don't know how he keeps from going blind, the fine work he does. *My* idea, first time I went in...I wanted a pirate ship full of the pirates, the flags, the maidens. Parrot screaming. Guns, sabers. Over my whole entire back. Maybe the front. It was all in my mind but I couldn't see it. That's why you go to an artist. You think it, they see it. They see it, they make it, *you* see it. After they make it.

"Then I saw this, what he had kicking around, like a dirty old wooden painting, and him and I fell in love at the same time. With the idea."

Kim kept talking. The electric clipper resounding its buzz off the bones back of Fred's ears, and reverberating through the skull, drowned out the words. But Kim's gesture wasn't hard to miss. She opened the buttons of her smock, did a half turn while lifting the white Tee shirt she wore under it, and exposed, for the sake of the mirror, and her colleague—and their invisible customer, Fred—a square yard of back and side so intricately tattooed with figures—humans, animals, plants, birds, all inter-woven—there was hardly room left for the girl.

"That's only a start," Kim said. She was pushing the waistband down over a decorated hip when she recalled, or her sidelong glance caught, Fred's looming presence not only in the mirror, but in the real world of the shop. Her clothing almost clattered into place again. She continued as if oblivious to the passage of a minor earthquake. "There's a thousand more things in the plan. Devils and a burning city. It's not like you can see it clearly, it's so dark. He's going to make drawings I can look at, and we'll talk. Plans. On me, though, it's not gonna be dark because, Arthur says, and it's what he calls his credo, at least a third of the final color has to be me. And a round pool where there's naked women swimming he thinks is perfect for my left butt, I mean hip, and why not keep going? I'm young, he's young."

Claire's attention focused on the blade of the straight razor she was applying to Fred's neck and the lower edge of his sideburns.

"It's like a garden where you hope you're never going to wake up in it," Kim said. "And at the same time you say, 'Here I am already. As long as I am here, I hope I never have to leave.' That's, in about a year, going to be me. The whole entire garden, including hell."

Claire's hot, damp towel addressed the areas she had scraped, before she applied the powdered whisk brush, infusing Fred's nostrils with the scented equivalent of crawling under the bed. She held a mirror to the back of Fred's neck and asked him, "Did we get close to natural?"

Fred nodded, standing to count out bills. "And thanks." He added a couple more.

"And for you, Kim." He stopped at the lectern on his way out, giving her two bucks. "If it's permitted to recognize the management."

Chapter Four

Fred crossed the river and walked the Boston side, letting the cool glare from the rippling water defy the day's increasing heat. It was a nice day for lolling in the sun, but the age group that lolls most convincingly had pretty much left town. Unless it was still in bed.

He couldn't get that painting out of his head, though he hadn't seen it. It pressed against the inside of his skull, as possibility.

The cherry trees had long since given up their blossoms and moved into activities more suitable for mature adults. Each tree cast its puddle of shade, neatly arranged in such a way as not to fall across the bench the Parks Department had placed in its vicinity. Cormorants worked the river, singly or in pairs, and on the Boston side were ducks. The drakes clubbed in their own reserve, letting the mothers with their ducklings parade and forage slightly downriver.

That river smell of wary fecundity, maybe yesterday's fecundity. Morning-after fecundity. The water rippled slowly along. The Charles was a small river, speedily growing smaller as the universities—Harvard on the Cambridge side, and Boston University on the other—dwarfed it with greedy high-rises that were echoed, in turn, by hotels put up by the big chains. In due course this sleepy, modest, charming country river would become an urban trickle. It was all a matter of scale.

No wedding ring on that woman, was there? Molly Riley? Was there? Recently Fred had been trying to look *before* he became interested, rather than after.

Molly Riley, the librarian whose voice had already attracted him—she itched even more than the painting did—another possibility: more certain, more complex. She was real.

What did scale have to do with the woman with green eyes, made greener by the dress she had to know was going to do that for her, or to her? A woman doesn't do that by accident. But the issue of scale was in his mind, not color.

Fred found a bench that happened to fall within the green shade of a maple, from which he could keep track of the river and the Cambridge bank.

Question: was it true that the smell of the surrounding world is different in shade from what it is in sun? That the place from which one smells all the same things influences the smells themselves? The shift from sun to shade—was that similar to the shift in sun? So that as soon as a building was tall enough for its cast shadow to cross to the far bank of the river, the river itself was irrevocably changed, becoming smaller?

Brave girl that was. At the barber shop. Allowing her body to be so taken over by a single image. When her body was already, you might say, in and of itself, already an image of sufficient complexity, and with the power to compel attention on its own. The insouciance of her exposing twist, whether from arrogance or innocence, had left a haunting image. But it was not, surprisingly, the image of the young girl's exposed skin but rather—because, given all the marks that had been inked onto it, that skin was far from naked—it was the image itself, the picture, drawn and stained, that stayed with him. He'd seen it before. Or something very like it. Odd birds. Structures of trees that seemed to be half egg. A weird resolution of unnatural clarity that aped surrealism but seemed almost medieval. The girl looked, under her smock, like an ancient fable with worrying religious undertones, more than likely heretical.

Although she sounded, when she spoke, like a grade-C movie in the early stages of rehearsal.

Scale. Yes. It was the inked marks on that woman, the receptionist at CUT - RATE - CUTS. They were haunting Fred's retina and making him pretend to be occupied with a purely abstract musing about scale. Reversed in the glass, truncated by the furtiveness of her exposure, the display had lasted, what? Five seconds?

Five seconds. Time enough to assess the intentions of the man with the drawn blade; time enough to steer the careening truck, loaded with munitions, into the guardrail; time enough to say the two words that might kill a friendship; time enough to step off a high building, although the falling might take longer and most likely feel a good deal longer. Wouldn't one notice everything? The flavor of the air? The shocked faces below?

Scale. The kayak fit the river, with the single oarsman. The kayak almost took the river's shape, moving upstream. Whereas that pleasure craft, white fiberglass with radio beacons and a cabin and a raised seat from which to fish—because of its size, it seemed to disregard the river, defy it and diminish it, rendering it less than real.

The woman—Kim?—the receptionist—had mentioned an egg with two heads and chicken's feet. It was that she'd been trying to show, somewhere up in the middle of her back, but Fred hadn't spotted this so-called gremlin, partly because he was aware she was only inadvertently showing her tattoos to him. He did not want to contribute to her discomfiture when she realized he was there. Until she noticed the back of his head, she had forgotten that he had the mirror image of her spread before him.

Scale. No, even before the issue of scale there was another that intruded. A pattern, originally flat, is—surely "violated" would be the wrong word?—when that pattern is transferred to the convexities of the human body. The eagle, flag, anchor, or Mandala in the tattooist's pattern book, flat in the book, takes on bulk and ripples or bulges, even grows, as its new support moves.

"Am I calling her a support?" Fred mused aloud. "That's not going to be appreciated by the women's movement." The tattoo didn't care. It could as easily be embellishing a male support. Irrelevant. Dismiss. There was nobody around but ducks. "Seems mighty crass and cold. Am I an art historian, as Molly Riley accused me of being?" Because the art historians love to talk technique: the support (canvas, paper, plaster, wood) and then the ground (whatever material prepares the support to receive paint—or protects the support from being destroyed by paint)—pigment or paint, then varnish. Oh, and then, whatever the painting seems to be about. Or, like Clay, they start from what they think the painting is about—the story they read as if it is an illustration—and try to work backwards from there.

Where seven ducklings had been swimming at the grassy edge, there were suddenly six only. Something below had pulled one under. The mother and the six remaining siblings formed a tighter line. The appalling speed, vacancy, deliberation, nourishment in progress, hidden menace—all those things in a brisk act barely puckered the bright surface of the water—the bright *support* of the water—in less than five seconds.

That was how Fred saw a good painting. It was like that moment, but made—not permanent, nothing is permanent—made far less transitory.

"Turtle," Fred guessed. "Or a gremlin." How had Kim described her embellishment? In the center of her back, out of her easy reach, and beyond what she had thoughtlessly revealed in the mirror. An egg with two heads, and the feet of a chicken.

The back of Fred's neck prickled. The sun glared down. Beneath the surface of the water, something gulped and crawled deeper into the concealing mud. The remaining ducklings snapped at flotsam. The mother, swimming in a nervous circle, looking for a way to comprehend the missing unit, quacked nine times.

A dragon fly now. No, two—but flying in a tandem cemented by copulation—glistened a jeweled blue close enough to the surface to reflect in the ripples and attract one duckling's inquisitive

attempt at capturing the coupling with its beak. The flying object was too fast, too large, too high.

You'd have to be a swallow.

Scale. Suppose yourself the duckling's size. That would quickly change the world.

There, that was the issue. A pattern in a pattern book, or the picture painted on the canvas, either could be interpreted as any size at all. Because of the way our eyes are trained from the age of two, we see the thing on the page that we recognize as a duck, and know it for a duck despite the fact that it is flat and only an inch tall. The image on the page can be accepted as potentially any size at all. Draw the giant an inch high, and call it a giant, it becomes alarming. But only on the page, because we quickly learn to disregard the edges of the pages as limits defining scale.

But ink that same figure into the skin of the woman's forearm, at one inch high, it becomes forever one inch high because it must be seen in contrast to the size of her elbow or her finger. Call it a giant all you want, the size of the woman, the support, gives that claim the lie. Or does it? Might the image conveyed in the tattoo occasionally prove so compelling as to negate the nature of the support?

Not long ago, on several occasions not that many blocks away, the serpent engraved around that woman's arm—what was her name? She'd been Fred's lover—that snake had done a fair job, from time to time, at claiming an existence almost independent of the woman. What had her name been? She had an apartment over one of the antique and junk shops on Charles Street. Had or, in the pluperfect tense, *had* had. Fred, at the woman's instance, had lost track of her.

Lose track of. How nice a euphemism. It could be used for almost any disappearance. Gentler than "passed on."

For that seventh duckling—too young to know its sex, scrambling amongst the bickering comfort of its siblings, within the illusory protective shade of a scolding, anxious, and distracted mother—nine square yards of river had been paradise enough. Not nine square yards. Nine *cubic* yards.

The remaining six continued stitching patterns into the water's surface, their little webbed feet needling only into the top two layers of the water. If it were possible for those feet to administer ink, along with their earnest puncturing, what pattern would be created? Something far more confused than Japanese. Fred watched the tracks, but they caused ripples, and the ripples crossed and complemented and negated each other. The marks were speedy. Transitory. Evanescent. In any case, the water had its own notions of the patterns it was making, as did the hint of breeze caused by the difference in the temperatures of the river's surface, and the heating air.

Molly Riley. Fred's question, over the phone a month ago, had inked a track into her attention. Now Fred, tardily traipsing after the question he had planted, had found the voice was connected to a smart and pretty woman with green eyes, whose presence in the world had caused him to submit unexpectedly to the haircut he had been deferring.

Fred stuck by the river until he reached a spot where he could cut over to Charles Street.

Chapter Five

Since he had accepted the validity of one of Clayton's instructions, "Look at everything," Fred could not walk down Charles Street without putting his head into one shop or another. The canny proprietors shifted their material from time to time, changing the placement of an object so that Tuesday's hasty glance might spot what had been hidden the Saturday before. If you are not looking for anything in particular, context changes everything. Fred liked to stay ahead of them.

Oona's, closest to the subway's elevated stop on the Boston side of the Longfellow bridge, was open, though it was nearing time for Oona to shift the door's hanging *OPEN* sign to *CLOSED* to allow herself lunch at her big desk, and a siesta in the back room.

Oona, seated behind the desk in the rear of the cluttered showroom, lifted her eyes from a folder, took note of Fred, and shifted the folder under a blotter as she gave a half wave of recognition. If Oona was the portion of the iceberg that appeared above the surface, the rest of the iceberg was mammoth indeed. She did not appear to have been designed for locomotion, although Fred had seen her move with astounding alacrity on occasion. Much of her material was Hungarian, as if she herself had been accompanied by containers full of old bric-a-brac, antiques, and objets d'art when she arrived, probably right before the war. Unless she had a current source, though traffic in objects

between Hungary and Charles Street would not presently be either easy or aboveboard. However she managed it, every week there was something new.

"Little painting you might like," Oona suggested, pointing toward a wall where pictures hung over an impossibly large buffet covered with glassware. The central place of honor on the wall had for the last month been taken by a ferociously green oil painting representing happy days in the Hungarian countryside, probably in the 1920s. Fat pink children rollicked in a field of daisies, backed by a village and some mountains. It was a better than competent work of decoration, signed definitely but indecipherably in the bottom left corner. Oona and Fred had talked it over in the past. It was Hungarian, yes—but even Oona couldn't read the signature. In a portfolio she had seven watercolors and a handful of drawings by the same hand, all with the same illegible signature. Her prices on all these things were highly speculative, and open to negotiation.

But it wasn't the landscape with children she referred to. Oona knew perfectly well that this had long since been dismissed. No, she had caught Fred's eye moving to the spot to the right of the Hungarian landscape with well-fed children. Dark picture around eight by ten inches, old varnish, beautifully executed, representing a kitten having its way with a peony left on a marble table top. Modest, battered, gilded frame. Signature, yes, hard to read under the dirt; probably French: the whole thing late 19th century.

"You have a price on it? Fred asked.

Oona shrugged. "It just came in," she temporized.

A woman bustled into the store, making the bell of the front door ring. She was encumbered with filled shopping bags: a customer, but dangerous to Oona's displays of stuffed birds and otters, sword canes, étagères crammed with inkwells, paperweights and saltcellars, gilded embroidered moth-eaten chairs, flags, vases, silverware, clocks, lamps, chinaware, scrimshaw, cases of coins and stamps, antique tools and cookware—though probably the rugs and clothing were safe enough.

"Leave the bags by the door, dear," Oona commanded. "I'll watch them. You'll be more comfortable. Take your time."

"May I take it down?" Fred asked, doing so.

The surface of the picture was smooth to the touch, smelled pleasantly old. No new varnish smell, therefore less likelihood of recent trickery. The gilded frame was of a reassuring age and dinginess that, because it was consistent with the rest of the package, affirmed that it and the picture had been together for a long time. Fred turned it over. Yes, it was on a wood panel, old, dark, with a few old marks in pen—yes, French—a title that would translate *Idle Moments*.

"Haven't had a chance to look at it," Oona said. "You want, I make you a price. Lady, you like glass? Glass I have in the back room. You tell me, Fred. We make a price."

The wooden panel was fixed into the frame with old nails, one of which was missing. The panel chattered against its frame on that side. Fred looked carefully. He'd been learning. Any dealer who considers such a picture is going to want to see it out of the frame. But any dealer also knows that any customer for such a picture wants to hog for himself the pleasant romance of discovery. He wants the thing not to look messed with. And sure signs that a picture has been messed with are that it's suspiciously clean; it has a bright new frame, or—if it's old like this one—if the back shows bright scratches where the nails have been pulled and replaced after the picture has been examined.

What the dealer does in order to maintain the illusion of virginity is to slip an index card back of each nail, remove the nail carefully with a pair of side-snips, look the edges over, then replace the panel and slide the nails back into the holes they came from.

Fine and good. But in this case the dust had been disturbed and the nails showed bright scars where the snips had gripped them.

"It's pretty," Fred agreed, flipping it over again. The front edge was concealed by the frame's rabbet. If he cared—this wasn't Clay's cup of tea in any case—he could demand to see the panel

out of its frame. In that case he might, or might not, confirm what he believed, and Oona must suspect, to be the case. This was one of many instances when, in the late nineteenth century, a good reproduction of a popular decorative painting, printed on paper, was laminated to a wood panel, possibly with a thin skin of actual paint applied to the surface before it was heavily varnished. It was its own day's equivalent of a modern museum replica in which the customer is even treated to the irregular imitation of the three-dimensional surface of the Monet or the van Gogh. The darkness of the varnish sealed the deal. This was a trap and his friend Oona, from whom he had yet to buy anything, would be delighted to see him fall into it.

If print was what it was, the paper had even taken on the slight variations of the wood's grain.

"I am watching your bags," Oona called out to reassure the woman, who had gone past her to look at the glassware in the inner sanctum.

Fred hung the little picture back where it had been. Even the picture's hardware was of sufficient age. Nothing had been replaced. Oona, as passive mistress of illusion, would be perfectly willing to sell a nineteenth-century reproduction as an original work, cheerfully leaving it up to the unwary customer to make whatever sense could be made of the object's identity and its authenticity.

"I'll keep looking." Fred gave the bell on the street door a chance to do its thing.

He hadn't proved himself in certain ways. It would be pleasant to have a surprising painting waiting in the office when Clay returned. For the hell of it. Why not?

Chapter Six

Fred climbed Beacon Hill by way of Mountjoy Street. Clay's place was halfway up the hill, on a corner that had long since lost all memory of having been farmland exploited by Tory families before the revolution.

Clayton Reed was so irritating an enigma, it was good to have him gone. His sanity was accentuated by foibles that, in a man of lesser wealth and position, might lead to an asylum. He seemed oblivious to his wealth, whose extent remained inscrutable. His shock of thick, untidy white hair was so vigorous that it gave no hint as to his actual age, which must be other than what appeared. He delivered hints of his vast knowledge and culture only when it was appropriate to a matter at hand, and never for self-entertainment. And he was astoundingly lacking in certain basic information, such as the bus routes in the city of Boston—or even what bus fare was. His sexual orientation was unclear. He seemed equally ill-at-ease with both men and women. He had been married, briefly, to a woman from Boston's social stratosphere who had died suddenly, unexpectedly, and catastrophically, of a wasting illness.

His social mannerisms, habits of speech, sartorial affectations, and the exquisite care and interest he took in his domestic surroundings, particularly of his collection, all suggested the easy conclusion that he might be gay. Whether that was a fact or not, it didn't seem to be an issue. What was apparently true, in so far as Fred allowed the question to preoccupy him—truth

to tell, not much—was that Clayton's capacity for, and interest in, the expression of any adult attraction of a romantic nature seemed to have flamed out in that brief, tragic marriage. Through his alliance to Lucy, Clay had come into a claim on being one of the Boston Brahmins—a position he defended with all the zeal of any convert. As far as Fred could read it—and this was not talked of—the town house itself had been maintained as a shrine to Lucy Stillton, Clay's lost bride—her identity, her person, her existence, the marriage, and even the ghost of certain human comforts. The ghost of an intimacy so formal it seemed Victorian.

Was that part of the diffident bond that had come about, almost instantly, between Fred and Clay? The fact that each had, for whatever reason, abjured the full implications of surrender to another human person? Clay, in his way, was also homeless. He lived in a museum that even had, for the love of God, a Kashmir shawl draped over a grand piano that was never played.

And it was not remarkable that he lived alone. In many ways, he was impossible.

Fred climbed the stoop and let himself in by Clay's front door, disregarding the separate entrance that would have taken him directly to the basement floor where he had the run both of his own office and of the area where Clay stored paintings that were not presently displayed in his living area.

Clay wouldn't have an alarm system. Because of an instinctive paranoia, which he masked with the appearance of rational argument, he reasoned that as soon as one made an inquiry of an alarm company, looking for estimates and proposals, immediately an alert went out to all the villains wanting to know where objects of value were to be found in the world. Fred, by the fact of having entered the picture, and by default, had taken charge of Clay's security. The need to install an alarm system was one of the issues he was working on. That is to say, he was working on Clay—but so far without appreciable effect.

So, entering Clay's house required no more than having a key and opening the door. No codes to punch in. No big dog

to face down. But to walk into the house was to be assaulted by the dangerous vitality of the paintings on the walls. Here again, Fred had not been able to make out what it was that Clayton thought he had. When they looked at a painting, although both surveyed the same object, neither one saw the same thing.

The entrance hall was lined with hanging scrolls of huge, almost abstract calligraphy—Japanese and ancient Persian. No daylight could touch or fade them here. Although they were aesthetic exercises intended to demonstrate the artists' skills, Clay knew what the words were. He couldn't read them, but he cared what they said, and he had taken the trouble to learn what it was.

Once in the parlor, which was hung with paintings, Clay seemed to lose his ear. He wasn't one of these dullards who seek to prove his wealth by purchasing, for large sums, trophy, and easily recognizable minor (or inferior) works by recognized masters. He didn't care about names. And he went after good pictures. But he hadn't a clue what any of the paintings said, although to Fred they screamed. On a wall next to the open double doorway that separated the two parlors—those sliding doors were never closed—hung a little abstract work by Arthur Dove. Though it might not be Clay's cup of tea, because he relied on the reassurance he could take from more illustrative works, the little painting—seven by ten inches—in brown, black and poisonous green, presented a configuration of opposed globular forms that were witty, salacious, irreverent and, as they worked on Fred, pompous in an unreflective way, like a senator who has gone to work missing one shoe, and wearing socks that fail to match.

The house was cool. It would stay cool as the day outside became warmer. He wouldn't have an answering machine—"It lets them know what we are doing"—but Clay did accept the values of plumbing, heat, and air conditioning. And there was a telephone, which Clayton used as circumspectly as he could, instructing Fred to keep nouns at a minimum. So Clayton wasn't a Luddite. Drove a nice car and the rest of it. But he would not allow a painting that he owned to be submitted to examination by X-ray. "It alters cells," he explained. Argument was pointless.

When he was wrong, his wrongness formed an impermeable shell. It was its own parallel universe. You couldn't crack it. There was nowhere to begin.

Clay was regular in his personal habits. Rose early, eschewed stimulants (he believed), read impenetrable books late into the night, and entertained a weakness for sherry or, worse, crème de menthe. Fred had never seen him close to inebriation—not that it would be easy for a human being to drink enough crème de menthe to achieve that happy resolution.

After Fred had been settled into the work space in the office downstairs, though Clay often spent time down there, he had set up shop for himself at a desk off the first floor kitchen, in a room intended as a butler's pantry. The desk there, fragile and inlaid with roses and incongruous mermaids, was more suited to the needs of someone's grandmother—but it was where Clay liked to respond to his bills, consider his personal mail, write checks for whatever eccentric charities he favored, and plot his purchases and the occasional de-acquisition, as he called it—as if he were a museum.

The work that had brought them together, a wooden chest that incorporated what they believed to be a Leonardo, had gone to a conservator in Brussels. It was the subject of noun-less telephone calls during which Fred, when Clay stopped in downstairs, occasionally overheard Clay's end. The conservator was prepared to spend years considering the work before she lifted a hand to it, as if it were a large diamond that must be re-cut. Clay was delighted to have her take the time. He loved the contemplation of certain triumph more than he enjoyed the triumph itself.

Fred was more inclined to, for God's sake, get it done.

But Clayton's methods were remarkably productive. He knew what he was doing, and had assembled an extraordinary collection, chiefly of American paintings, but not limited to that field. He was willing to spend money when it was unavoidable, but he far preferred to buy a treasure for a song, and quietly (if only figuratively) thumb his nose at his competitors afterwards. Not long ago he'd left town for an overnight trip—he would not say

where he had gone, but he had taken the car—and returned with a brilliant fragment. Oil on a rough canvas, almost the consistency of burlap, maybe twelve by fourteen inches, it was painted in large, jagged, parallel slashes of gold, white, red, and ochre, with here and there an accent of bright green. It looked almost like an exercise by a modern such as Jasper Johns until the whole business took focus on account of the single black double apostrophe of wings on the horizon. The subject was a field of wheat.

Clayton unwrapped it on Fred's desk, smirking, allowing Fred to acclimatize to the painting's warmth and energy. "That signature on the right," Fred had started, struggling to read it. "It says 'Theo.' Yes? That's what I read. It can't be Théodore Rousseau. It's French, but it's too jazzy, too modern-looking."

"It says 'Theo,'" Clay agreed. "But that isn't a signature. If it had been signed it would have cost over a million and I would have disregarded it. Not French, but done in France. It's not a signature. I'd never get near it with the signature. No, it's a dedication. To the painter's brother."

"Holy mackerel," Fred had said.

"Indeed," Clay agreed. "We will not trouble the so-called *committee*. Contention brings me no pleasure. We know what we have. It remains only to have it cleaned and framed. In due course. There is no rush, Fred. Find a place for it in the racks, would you? I must bathe."

A triumph like that, passed off as sleight of hand, could earn Clay hatred from the most indulgent colleague. He'd climbed the spiral staircase, oblivious.

It was good to have him gone.

Chapter Seven

Fred gathered the mail from the box into which it fell next to the front door, and carried it in to Clayton's desk. Four days had produced a small pile. Fred, acting on instructions, did not sort or deal with it beyond unwrapping and removing the auction catalogues to browse through downstairs. Sometimes there would be something. He had a lot to learn about the business. His recent association with a collector obliged him to learn a whole new language; the structure of the arcane and shifting rules by which art can be translated into and expressed as currency.

The world of art was big here in the 1990s. If one was going to learn it, as Clay said, one must look at everything. Remember everything. Take nothing at face value.

Fred's office, mostly underground, was cool. A half-window above his desk gave daylight and a view of brick, ivy, and passing feet. The heat of today's sun—did that alter the color of its light?

Fred sat on the couch attempting to clarify and isolate the image he had seen during Kim's brief unveiling at CUT - RATE - CUTS. Abstract the image from the girl. Turn it around to compensate for the mirror's reversal. It was more than an idle pastime. Hadn't the girl said that the basis for the pictures was a painting? "An old wooden painting," she'd said, and "dark."

The intertwining of forms had been more stolid than the traditional Art Nouveau reverse curves common in the more complex tattoo designing, which had its ultimate source in

Japanese models. There was a lasting impression not only of small human figures, but of birds, and fish, and metamorphic creatures with both animal and human forms.

"Arthur is working from something," Fred said. "That much we know. Kim said so. Not that Clay would give a hoot about it, but let's start with the obvious. Has Arthur got hold of one of those Victorian English fairy paintings?"

Clay had an extensive library down here that could shed light on almost any aspect of Western painting after 1200. The Eastern stuff was upstairs on the third floor, in another study Clay kept off his bedroom. If Clayton could discover and acquire an unattributed van Gogh, why shouldn't Fred respond in kind by landing, in Clay's absence, a minor art historical footnote on his own?

He started his research, one book pulled out leading to another, and another. At around the same time as Christmas cards and paper valentines were invented, and—who knows?—cheap color lithographic printing made it possible to mass-produce scenic wall calendars—introverts among the English painters hit upon yet another way to explore sex without getting too close. The theme they developed and illustrated was fairies. Or, worse, to be more accurately perverse, that excruciatingly Victorian literary wet dream, *faerie.* Though the fixation had links to spiritualism, mythology, and the patriotic jingoism of a revival of the Arthurian stories, it was also an excuse to portray scantily clad charming female bodies—with wings, granted, and of a scale so tiny that a grown man couldn't even begin to achieve frustration. Or it could suggest other erotic misdirections such as might lead the unwary into Neverland. Or, more recently, to *Star Wars* and Tolkien and their fantastic bastard progeny.

There had been a willing commercial audience for the fairy pictures. And in the 1800s they even passed as art. A lot of English painters, some Germans also, got into them. Well-trained, highly competent, if deeply silly painters. By the evidence that they continued making it, they managed to sell their work: fairies frisking in moonlight; Oberon, king of the fairies, basking in undergrowth so large as to make the edge of a British

dell seem like a jungle imagined by Rousseau; fairies bathing in the presence of large pruriently interested fish. It was all utterly pure and leering and absurdly English.

What Kim described, and what Fred himself had witnessed during those few seconds of exposure, sounded like Victorian fantasy as interpreted by a preadolescent child. Whatever their origin, those images had come from something. An old dark wooden painting, Kim had said. Clayton was in the market for old dark wooden paintings. On the rare occasion when such old dark wooden paintings were interesting. It was probably nothing.

Still, why disregard a track that might lead to an interesting picture—a long-lost unimportant work by (drum roll) Richard Dadd, Joseph Noel Paton, John Anster Fitzgerald, Francis Danby, Daniel Maclise or Richard "Dickie" Doyle?

"I'll take a look," Fred said.

◇◇◇

Central Square had done what it could to rid itself of shade. It made up for that by supplying crowd, heat, exhaust, and noise. Fred emerged from the subway into a ragged, bustling choreography involving people with somewhere to go, who could only get there by navigating through the crowds of stragglers staked out in positions on the sidewalk from which to practice the mild larceny that kept them going.

Fred found Green Street and walked in the direction indicated by an adept he chose from among the stragglers. They all knew where the G Spot was. And all pointed in the same direction, though in some cases the pointing wobbled. Fred tracked Green Street a couple of blocks past three-deckers, parking lots, and a few commercial establishments such as bakeries and dry cleaners, until he reached the G Spot's chipped green door, through whose glass panel a large, sullen-looking common room was visible with, at one side, a bar. Next to the outside entrance a separate door must lead to stairs that would arrive at the second and third floor apartments or offices in the three-decker. No posted names to guide visitors or delivery men. The visible mailboxes

were busted out anyway. In this part of town, even four blocks from the city's main police station, you'd do better to use a P. O. box if you actually wanted to receive your mail.

According to what Kim had said, the tattooist, Arthur, worked on the third floor—top floor, therefore, under the flat roof. Those were his open windows, supposing one apartment on each floor. It must be hot up there.

The smell in the G Spot was dismay diluted by insouciance and deflated suds. The booths were mostly empty, though about seven people occupied the space, two in uniform, in addition to the thickset man back of the bar whose heavy facial scarring suggested the serious burns a firefighter might have suffered before being thrust into this form of retirement. The sense of the place was definitely "townie." At one end of the bar sat an old-style cash register. At the other, last week's hot dogs spun sullenly under a red light in a scuffed and unsanitary looking plastic warmer. A ceiling fan circulated, giving a few flies something to dodge.

Fred sat on a stool at the bar and told everyone, "Hot day." The bartender found him and stood opposite, his eyebrows moving upward against the weight of the scar tissue that blighted his forehead. Some mishap had forced a dreadful amount of reconstruction.

The yellowing sign taped to the mirror back of the bar threatened, *LUNCH*.

"Whatever's cold on tap," Fred said, and asked for a menu.

"Hotdog or hamburger," he was told. "You want, we can do you a cheeseburger."

"Hamburger's fine. With fries."

"Chips," the barman corrected him and called toward a swinging shutter door to his left, "Burger, Maggie." The sound from behind the doors resembled what happens when a large sleeping animal is startled in the attic. "Be a minute," the man said, drawing a pint from a lever that claimed "Budweiser."

Fred gazed around the room. It had gone silent when he entered, while the occupants sized up the implications of the stranger's arrival. Now that he'd signaled his bona fides as a

customer, their attention could go back to their desultory conversations, and to the silent television that flickered recycled baseball above the bar. The place could serve as the vestibule for Limbo.

Nothing remotely resembling a woman was visible, other than what was represented on the calendar photo for PRECISION PISTONS. The invisible Maggie was presumably human and female.

Next to the calendar, in the space leading to the swinging shutter door back of which Fred's lunch was beginning to spit on a grill, hung an assortment of home-made neighborhood notes with fringes of tear-off tabs. They were illegible from where Fred sat. He'd have to get back there to look closer.

"Men's room?" Fred asked.

The genial host jerked his head toward the swinging shutter. "Through the kitchen." Fred took a swig from his mug and headed through. The kitchen was a narrow passageway, made narrower by Maggie. Her large blue-and-white-checkered form tended the objects sizzling on the frying pan she balanced on the hot plate that sat on a mini fridge, next to a slate sink that had been bright and new in 1937. The place was well protected from the Board of Health. One of the advantages to having city cops among the regulars.

"On through," Maggie growled without looking up from the fork she was poking unhappily at his lunch: a violently thawing burger and two separated halves of a bun. The passage doubled, or tripled, as a store-room for glasses, paper goods, bottles, cases, and the odd chair. Fred found the door—*WC*—the little room equally available to either sex—and followed his star inside.

The G Spot was indeed well protected from the Board of Health.

The only available sink was in the kitchen passage. In Maggie's absence, Fred made use of it as he passed through. He hesitated before the selection of notices and posters next to the calendar on his way back to the bar. Baby sitters, a dog walker, someone selling bookcases, two competing readers of Tarot cards, someone who would shovel your walk or driveway—there, that had to

be it. *A FINE LINE* was illustrated with the famous portrait of Che Guevara, all in black, with a black rose on one side and, on the other, a cross around which a serpent coiled. No service was offered. The tear-off stubs at the bottom had the name, Arthur, with a phone number.

Fred took one and slid it into the breast pocket of his polo shirt. He'd masked his interest with his body, though he might not have completely hidden the action from the bartender, nor from Maggie, who had crossed the room in order to get one little plastic squeeze packet each of yellow mustard and ketchup to slap on the bar next to the plate bearing his hamburger.

"Shit. Forgot his chips." She muscled past him, sighing, toward her kitchen.

Fred sat down to his meal. "The people posting are regulars?"

The bartender shrugged. "I don't pay much attention."

"Guy shoveling snow," Fred said. "Given the kind of day we're having, that sign's premature."

The bartender shrugged. Fred drank beer, pried his bun open and squirted the contents of the two plastic envelopes onto the rigid huddle of fried meat. Maggie reappeared with a package of chips. The bartender washed glasses. One of the men in a booth behind Fred called out, "Two more, Leo?"

"Things get crowded, I pull stuff down," the bartender elucidated. "Otherwise, free country, I don't care. Unless it's a hooker. Health food nut, Young Republican, something like that. Off color. Give the place a bad name. What do you want to post? Music concert, animal rights, paint my house, yoga lessons, you're probly wasting your time."

"I'm making conversation," Fred said. He got around his lunch while Leo took care of his customers.

Maggie emerged from the kitchen and stood back of the bar. Leo went to sit at one of the tables with a drinker resplendent in a blue uniform with all the trimmings. City of Cambridge cop. Their murmur of talk was so crammed with statistics that it must concern either life insurance or baseball. Fred took a final bite and told Maggie, "Feels like home."

Her look, not amazed, not alarmed, was mostly not friendly. Fred had spoken and bar ethics demanded a reply. "You're not from here."

Fred lifted his shoulders in agreement. "Boston, at the moment. I've been overseas."

"There's a lot of that." Maggie shook her head. "Not on a cruise, to look at you."

Fred's silence affirmed her guess.

Maggie said, "These students."

She let that hang. Fred left it hanging as well until he shook his head and agreed, "You got that right."

"Twenty-eight and six," someone said in a loud, disbelieving voice across the room. The exclamation was followed by a complex murmur of mixed male voices.

"I started out in the Middle West," Fred said. This conversation was not going to lead to Arthur any time soon.

"Somebody has to," Maggie said. "Besides Indians."

"You're native?" Fred asked.

"Indian? Hell no, I'm born Cambridge."

"That's what I meant," Fred said. "Native to Cambridge."

"Then fucking say so, will you? Next thing he'll want to know am I a gypsy." Maggie, offended, moved to the end of the counter where the cash register waited and demanded, "Something else?"

"I'll finish the beer," Fred said, pulling his wallet out. "As long as you're at the box, save you the trouble later…"

Chapter Eight

Not only were the two mailboxes popped open, next to the street entrance to the second- and third-floor apartments, the door itself was not locked. Recent green paint on both door and jamb covered, but did not obscure, the gouges made by an impatient visitor's crowbar at some past time. The two ancient ceramic, breast-shaped doorbells with their little nipples—both unmarked anyway—would be as dysfunctional as the mailboxes. Fred stepped into the entranceway.

That smell of mildew, dust, under-linoleum, defeat, stale beer, and urine—that could be marketed in a spray can, like new-car-smell, to be spritzed into old apartment buildings in order to give the edifices the sense of every possible kind of decay. The smell serves as a boundary marker separating youth from age. For youth, the smell signals horizons opening as supervision is relaxed. For those who have crossed the boundary into age, the smell means, "There's no way out of here."

Fred could see marketing a whole line of such scents, perhaps under the brand name "*Rédolescence*," pronounced à la française, as Inspector Clouseau would do it.

The stair's flesh-colored linoleum was lifting despite sprung and dangerously flapping aluminum corner strips that had been nailed over the treads' front edges. The stairwell's walls had once been as green as the Gobi desert before the ice age had sucked it dry. Fred, climbing, disregarded the despondent

notices taped along the walls by landlords, fellow tenants, and fast-food delivery services.

The door on the second floor landing had also been jimmied in the past. Now it boasted an armored skin of plywood that had been in place long enough to darken with age. Written neatly onto the plywood in black magic marker was the legend, "Hammond. Knock." Outside the door, on the narrow landing leading to the next flight up, lay phone books still in their plastic, mass-mailing advertisements for everything that exists that's cheap and colorful, and more ads for food delivery, drug counseling, and marginally literary periodicals.

A window on the landing allowed a dingy view of Green Street below.

Fred climbed to the third floor. The smell grew although it seemed, by its nature, the kind of smell that should sink until it found its proper basement home. It was hotter here, under the flat roof.

Arthur was making good use of his landing. Three dinged metal folding chairs stood against the wall in the passage overlooking the stairwell, where an untrustworthy-looking railing offered a place for the person using a chair to rest his feet. Arthur's landing also had a window overlooking Green Street. The walls were thickly decorated with pages torn from tattoo magazines; advertisements for concerts; designs, both hand-drawn and Xerox copies, for decorations to be applied with ink under the top layers of the skin. Most were depressingly familiar: the skulls, the knives, the handguns, the busty insouciant women, snakes, raptors, feline beasts of prey, flowers, vines, Popeye and Porky Pig, portraits—was that Doris Day? Why?—crosses, devils, impolite mottos such as BITE ME in a Gothic script, angels, fairies, feathers, sharks, suns; *MOTHER* in a pierced heart. No sign of the goblin Kim had described—no, "gremlin" was her word—nor of anything resembling it. Everything visible was trite enough to make you gag. A fat glass ashtray on the floor next to the chairs, stuffed full, added its own encouragement to the gag reflex.

Brown panel door. The panels could be easily kicked in, but they hadn't been. The neatly hand-lettered notice affixed to the door confirmed, *A FINE LINE.* Fred knocked and waited. Nothing. The life style that applied back of this door implied a day that started late. Still, it was after noon. He knocked again. No response.

Well, there were chairs, and a few magazines kicked into a corner—tattoo magazines, it turned out—scuffed, dog-eared, and decaying like the rest of the decor. Fred, sitting, flipped and idled through one. The concentration of all this material between covers made it seem a world. This was a culture he hadn't previously given more than a passing thought—a culture that like all others brought with it many implied appendages: the bikes, the inks, the machines to power the needle's application, the lingo, the sense of vulnerable and defiant loner camaraderie. The many possible conventions, contests, rivalries and jealousies, knockoffs, and hero worships. The culture seemed, in an odd way, to be empowered by a nostalgia for the 1940s, when a nation at war depended on the antisocial talents of its misfits at the same time as it forced its best and brightest, its most admired, into lives that, in peacetime, must be called hideously unethical.

"We bear the mark of Cain as a badge of honor," Fred mused, leafing through a particularly gaudy display in which chains and Harleys squared off against the far more fragile arabesques of color sported by their scantily-clad female riders. His eyes, wandering to the ceiling, took note of the rectangular opening that held the hinged trap that would lower a narrow fold-up staircase with access to the roof. "This kind of weather, that's where I'd sleep for sure," Fred mused. The eye bolt that was intended to be pulled, by means of the hooked dowel that must be around somewhere, had been fixed by a flimsy padlock to a ring in the wooden molding that housed the trap. Security. Barely. To discourage, for five minutes, unauthorized entry from a roof that could be jumped to from either of the adjoining buildings. Above the trapdoor there'd be a hatch, hinged, to keep out rain and snow so long as the tenants remembered to keep it closed.

These people, the ones living within the magazine, had their own conventions; their own class systems, habits and expectations; their own myths and heroes; their own narrow aesthetic codes. You can't be human without despising something. They had their own languages, both in words and symbols. Here in the affluent and culturally scattered Western world, the ethos of the tattoo had spread far more widely than its roots in the military and in prisons. Its attraction was by no means limited to the rogue male, or to the impertinently young.

Heavy tread on the stairs. Brisk and uneven. Cigar smoke rising. Black leather cap. Brown leather flight jacket on this steaming day, then the rest of the climbing man, puffing around the wet cigar stump, his red face seamed. "Got held up," the man said, stretching a square hand out, its fingers stained with tar. Late fifties? The walrus mustache was as stained as the fingers. He hadn't shaved for a while.

"Fred," Fred told him, rising to take the hand.

"Still Sammy Flash. See anything you like?" the man challenged. "I got held up." Sammy Flash lowered a bulging leather shoulder bag to the floor in order to manage a ring of keys that was clipped to his belt. "They call me Flash."

Chapter Nine

"Arthur around?" Fred asked.

Flash selected a key, inserted it in the apartment door, turned it. "Search me. Take a seat." He pulled a heavy green extension cord out of the shoulder bag and began to uncoil it, pushing the door open far enough to enter. The odor from inside the apartment was different, but no improvement over what had congregated on the landing. It was dark inside. Fred got barely a glimpse of sparse furniture and almost empty walls. The impression was of an ascetic darkness. The *Rédolescence* spray can could be labeled *Unwashed Carthusian*.

"I'll get set up," Flash said. "Take me a minute." The cigar stump being clenched between his teeth, his words were indistinct, but predictable enough to be easily understood. He stepped into the apartment with one end of his cord and emerged again quickly. "Plug out here's busted," he explained, closing the apartment door again with difficulty, on account of the cord. Out of the bag he pulled a contraption resembling a corkscrew, nutcracker, and Notary Public seal-stamp combination designed by Hammacher Schlemmer for the executive who has everything. A roll of paper towels followed, as well as a cigar box containing plastic vials of ink.

"Ink supply's low," Flash said. "Depending what we need, I'll borrow from Arthur." He took a deep drag from the stump of the cigar before grinding it out in the ash tray. He walked back and forth in front of the wall display. "Till I get my own place

or move on. Sit, take the load off. Have something in mind? What do you like? Fred, you said? Didn't you say 'Mike' before?"

Fred shook his head. "Still Fred."

"You look different," Flash continued. "But you found the place all right." He attached his machine to the extension cord and laid his equipment out on the seat of one of the chairs. "It's informal. Still beats a lot of setups. Prisons and that. I'm clean. So you found the place?"

"I'm here now," Fred said.

"What did you say you want? The cat in the hat? Was that you?"

"Could be a different conversation," Fred said.

"We weren't talking that place in Quincy? The other end the Red Line?"

"I'm looking for Arthur," Fred said.

Flash took the available folding chair and set it across the landing where he could sit facing Fred, his back to the railing. "Light's better from the window. You say you're not Mike. OK. Whatever you want Arthur to do, I can do it," he added. "Arthur…"

Fred said, "Tell me about Arthur."

Flash reached inside the leather jacket, pulled out a fresh cigar and lingeringly started to unwrap cellophane. "Whole different world when I first got into it. I'm never gonna go high end, highbrow. I don't get along with those people. I started in the Navy? Liked what the Japanese did, admired all that—but not for Americans. People are people, OK, I get that. At the same time, Americans are Americans. They should look like Americans. For years I moved around. Any big city, I'd find a place to work. People. Then I move on.

"Don't get me wrong. You want Japanese, I do it. Runes. Tribal, I can do that if you show me what you want. I have no flash for tribal. How I got my name, Sammy Flash: working San Diego, the docks. I keep a couple hundred designs posted, which we call flash. But you know that. Guy and girl come in, three the morning, I'm open, he wants to remember her name next morning, she wants to remember his, they run through my flash on the wall, say 'This one,' and 'This one,' they're both

enough in the bag they're laughing while I do them and tell you the truth half the time I was half in the bag myself, another reason you move from one town to another. Next morning they wake up, he has an eagle with a banner on his shoulder, says *Edna*. She, on her hip maybe, depending how far she'll go, has his name *Wilfrid*. There is no way in the world to spell *Wilfrid* right, I don't care what you try, and a rose or a snake or a snake swallowing a skull, one of my specialties.

"That may be how I met Arthur. No. I'm lying."

Flash lit a kitchen match on a stained thumbnail and lit the cigar after warming it. "So you're in a place, settled, and you wake up one morning, it's noon, there's a lady next to you that's the same lady's been there for weeks. She's a dancer, tends bar, or she's hooking—your school teacher keeps different hours. I found that out. Anyway, the lady, you learn, in her opinion a contract has been mutually agreed that only she knew about.

"Now you start listening to that train whistle blow with more attention.

"By now I have pals everywhere. I'd turn up in a place, Tucson, Crazy Charlie Geech had a shop there, said, 'Use my chair when I'm sleeping.' I'd do anything from Disney. Disney was big. Which brings me to Arthur. No, I'm wrong. So any town I thought I'd try, I knew someone there. We'd get together, swap designs, ideas, what we'd heard, what we'd seen. Legal, but underground. People show up want a bulldog and *Fuck Jimmy Hoffa* under it, three pals the size of refrigerators are sitting outside on their bikes waiting, you do it, you don't ask questions. Tell the guy, 'I oughtta clean the area first,' he like to takes your head off. Last time he had a bath he also had a mother. Which brings me to Arthur. You asked about Arthur?

"There's guys now, doing it, call themselves artists. Which is not me. And the client is—are you ready?—a collector. Me, I'm a tattooer. That does it for me." Flash tore a paper towel from the roll, clenching the cigar between his teeth, and polished his machine.

"Which brings us to Arthur," Fred said.

Chapter Ten

"Nashua, New Hampshire. Right?" Fred said. He'd never gotten over his training; listened to what people said, Kim, back in CUT - RATE - CUTS even if it was not interesting. Put it together, file it. It's there later, with a lot of other crap.

"Nashua, New Hampshire, isn't anywhere," Flash announced. "Which is where I needed to be at the time. This and that happened, some other things and the rest of it. Money. Well, and I did some time. Learned to work like they did in the stone ages. Ink from a ballpoint pen. Can't bring a machine in there obviously. Scary guys want you to write *Sweetheart* on their dick, it's not like they're not sitting there watching while you do it, leave it with you, come back in the morning, tell you if they like it or not. These are some scary fucks. That was before.

"Is it Wednesday?

"You're asking, Arthur. Wherever you are, there's gonna be a law. Under a certain age. Contributing, delinquency of a minor. Girls they get particular. It's they can say statutory rape and assault, she's under eighteen. And a girl you can't tell. Whatever *she* tells you, forget it. Says she's eighteen, the boobs, everything? Back she comes next day with her father, the sheriff, turns out she's fourteen. You outlined a parrot on her left shoulder, she's supposed to come back for the color? She comes back all right. And Dad's with her.

"As I was saying, my friend in Nashua, heard I got out, said come on up, I can help out while I get my license, sleep in the back room. That's, did I mention Harley Petersen? Everyone knew Harley. You couldn't *not* know Harley. One of the old timers, went way back. Him and I. He did the whole thing, not like me. Japan, Okinawa, apprenticed himself to, I forget the guy's name, one of the big ones over there, came back, he was a changed man. Came back with *theories*, but still no attitude. That's, in my opinion. Well, he's into Zen now in a big way, he picked up over there, and not too particular who he does Zen with. Which I guess is part of it. But the thing—talking about Arthur, Harley Petersen is now calling himself Kenzo Petersen, with a shop in Nashua he calls *Kenzo*. It's complicated, he was looking for something Japanese-sounding that he could believe he had a right to, without attitude, and there's a Japanese wrestler Kenzo Suzuki. Suzuki's the name of a bike, and Harley is the name of a bike, and he said what could be more natural. Harley became Kenzo. His hair goes back in a pony tail at the same time. Hell, I don't care. Harley, Kenzo. It all comes out the same hole.

"Arthur's in the shop cleaning up nights, odd jobs, runs out for pizza, makes the green tea clients hafta drink while they wait. Arthur's in school, high school. In the shop whenever he can manage, soaking it in. Reads the magazines, making copies from the flash and the magazines and the photos. Ideas he has himself. Watches everything and talks to Kenzo, everybody he can, until the kid…there's no law I know of an underage kid can't handle a needle. I don't know. Due course Arthur is an apprentice. Harley's excited. Kenzo, he is now, but to look at, aside from all the green tea in his veins, you know there's no Japanese blood in him. The blood is American.

"I'm sleeping in the back room. There's enough business I get my share. Arthur watches. He learns. We make him draw. Friends of his come in, underage, we let him draw designs on them, make transfers, they can see what it would look like, but no needles. Not when you're underage. I learned my lesson and Harley, that's Kenzo now, is Mister do-it-right-or-don't-do-it. I

get into it too, having this kid to boss around, clean up, check the needles, check the ink stock, answer the phone. It's good, too, because Arthur's a geeky kid, but he's got the other kids interested. They start coming around, they start turning eighteen and it's almost, you've heard of Sweet Sixteen? Party they throw, coming of age? Kids'd like to sneak in right after, maybe midnight the morning they turn eighteen, get their first ink.

"Mike shows up, tell him I'll be right back."

Flash stood abruptly, parked his cigar, and followed his green extension cord into the apartment, swinging the door to behind him. Fred twiddled his thumbs one way and then the other, until they came out even. In three minutes Flash came back, rubbing his palms on the seat of balding brown corduroy pants.

"That's better," he said. He stooped to the shoulder bag, withdrew a pint bottle of Early Times and took a swig. Wiped the neck on the sleeve of his jacket, held the bottle toward Fred's shaking head, wiped his mouth with the back of his hand, put the bottle back. "That's even better," he said. "OK, Mike, let's get started."

Fred said, "Not Mike. Fred. Waiting for Arthur. What's Arthur's last name?"

"Tattoo clubs," Flash said. "The S & M routines, music. People do what they want."

"Arthur," Fred murmured.

"Next thing, Arthur turns eighteen. Xerox copy of his birth certificate he brought in a year before so it will be ready, we've been talking all this time, what he's gonna do to pop his cherry. New idea every time he comes in. Flag of Switzerland with the doves? Black sun around his left nipple? There's a Japanese mermaid he's in love with for about a week to wrap around his thigh. By now he's done so much work around the place for no pay, he's gonna get his ink in trade. He's already doing some lining, even some shading on the simple stuff. We can see the kid could be a genius. Could be, ten or fifteen years, one of these guys he can live wherever he wants, people from all over the country make appointments, hell, all over the world, plan their vacation time

to come where he is, get their work done. When Kenzo's free, the two of them talk together, look over plans, speculate how many years this design takes to execute, where to start, once he turns eighteen. It's going to be a big deal.

"What a man like Kenzo doesn't get very often, a guy like Arthur, he's in love, he's still a virgin, he knows all about it, though. He hasn't made half-assed mistakes already in the back seat before he gets wise to how beautiful love can be, you follow? Let a scratcher start him with something that has to be covered later if that's even possible. Or it goes too deep and blossoms. Or it fades. Go to the wrong person, a thousand things can happen. And they do. He hasn't started with a mistake like most people do, for the simple reason he hasn't started.

"So, there's not a mark on Arthur yet. Kenzo sees him for a long-term prospect that will become a billboard, in the magazines, photos, with the name Kenzo Petersen underneath as the tattooer. If Kenzo takes his show on the road in a few years, conventions, Arthur can be the main exhibit. I know this is in Kenzo's mind. But in Arthur's mind, the kid? One week it's nothing but swans, then it's fish, then it's an English rose garden in June but each rose different, Lord Baltimore, Fanny Crisp, Gloria l'Amoria. Then it's big carp the Japanese do, scales and the weeds everywhere, so everyone is wondering. What Arthur is going to choose. Where he will start.

"With Arthur, the one thing we know, he's got discipline. He starts something, he's going to see it through to the end. He promised his Dad he's gonna finish high school, you can take that promise to the bank. So once he's set on a design..."

"This is how long ago?" Fred asked.

"Couple of years. Say, you're not law?"

Fred shook his head.

"Funniest job I ever did. Cleveland. Whole college football team got that naked lady tattoo from somebody, a year or so back, a way to keep together, souvenir, they played in another town. Now, still keeping together, they all decide they'll join the service, no service will take them on account of the naked lady.

My job, I'm in Cleveland, seventeen pairs of panties, I did them all different colors, stripes, polka-dots, the works. Presto-changeo the naked lady's ready to pass inspection." Flash picked up his cigar and examined it critically. It had gone out.

"That's what Arthur went with?" Fred prompted. "Naked ladies? After all that?"

"Why do I smoke these fucking things?" Flash asked.

Fred stood and stretched. "I'm going to use Arthur's bathroom."

Flash held up the thumb and finger of his right hand in a ring. "One blue circle this size on his right shoulder. One sixteenth of an inch wide, the line. One color. Blue. That's it. That's what Arthur wanted.

"'I've thought about it,' is all Arthur would say."

Chapter Eleven

Fred pushed into Arthur's apartment, leaving Sammy Flash yammering along. The man was like one of those talking dolls with the pull-string in back, but the string activated a Moebius strip recording inside that flipped from side to side infinitely, only occasionally and accidentally making tangential reference to the matter at hand.

Arthur lived like a monk. The Thomas Merton of tattoo artists. His apartment occupied a large space that had been intended as a living room but was now understandable as Arthur's shop, furnished with street furniture: chairs, a small table, a rudimentary platform bed or divan. A few lamps that could be moved as needed. The minimum tools required. Kitchen off one end of this room; small bedroom, equally austere; bathroom also giving off the living room, or shop. The smell was bachelor: unclean bathroom and kitchen, dust, garbage waiting to be remembered. Fred knew it well. Cleanliness may be on the shelf *next* to Godliness, but they are not even close to being the same thing.

"Don't touch nothing," Flash called out. He'd moved into the apartment's doorway and was going to stand there while Fred used the john.

On the bathroom wall, over the toilet, a print was attached to the wall with pushpins: Piero della Francesca's *Baptism of Christ* from the National Gallery in London. David Hockney had the same print taped to his studio wall. Arthur was a monk all right.

You want images of Western myths all over your body? Why not start with Piero's humane angels? The carefully delineated foliage on the tree over Christ's head; the dove, the holy ghost, the paraclete; or Christ himself: in shape, confident, humble, at the top of his game but only now getting started.

Fred hadn't closed the bathroom door. He became aware of Flash standing there as he zipped up. "Center of an altarpiece for the chapel of Saint John the Baptist in Borgo Sansepolcro," Fred said. "Painted some time in the 1450s."

"You don't say."

"How England got hold of it I don't know," Fred said, looking at the reproduction.

Not that religion hadn't inspired plenty of bloodshed in the Europe of the 1450s—but there was no sign of trouble, pain, or misery in the moment Piero had chosen to reflect on. And no sign anywhere of the ghoulish extravagance of funhouse caricature that by now had come to infect representations, on American bodies, of Christian religious themes, if Fred's brief skimming trip through the magazines on the landing were any guide. "Seems to me you could use those little plants in the foreground," Fred suggested. "No? Piero had a mighty fine hand, nice nose for detail. None of the plants alike. Maybe a woman turns up who wants something delicate?"

Flash said, "I come in here, do my business, I can't stop wondering. Since they both have beards, which one is Jesus? It's obviously religious, the scene, I see that, the story, even without haloes."

"The one doing the baptizing is Saint John, aka 'The Baptist.' He's wearing clothes."

"Arthur doesn't want people in the apartment, he's not here," Flash said.

Fred flushed the can and followed him out. Seated on the landing again, he asked, "That's where Arthur gets his ideas?" He was intrigued. The only image visible inside Arthur's place was in the bathroom, where Arthur was obliged to confront it every time he took a leak—the reproduction of an ancient painting austere, complex, and beautiful, unlike the frantic

garbage pinned to the wall in the vestibule. A medieval paint-
ing. Depending when you want to start the Renaissance. Not
Fred's problem. But in the brief time he'd had to glance around,
there'd been no sign of what Kim had described—an "old dark
wooden painting" that had that gremlin in it.

"Wait out here," Flash said. "There's plenty to look through.
Like as not the client has something with him. Most times. Or,
this is worse, something they saw they try to describe and hope
you can draw it like they saw it? A snake inside out? You tell
me. Let's get started."

"No rush." Fred stretched his legs. "Arthur, when he left
Nashua, figured on art school?"

"A lot of them do that," Flash said. He relit his cigar, taking
his time. "Not Arthur. High school was about it for Arthur, and
that was pushing it."

"You followed him down," Fred said.

Flash lapsed into a distracted silence before he reached into
his bag and took another pull from the Early Times. The look
was furtive, almost hunted. He put the bottle away again.

Fred tried, "Kenzo's still in business? In Nashua."

Another silence until, "Kenzo is not the easiest guy in the
world to get along with, I warn you. He's also way the fuck up in
Nashua, for God's sake. Why do you need Kenzo? Whatever you
want, I can do," Flash said. "Tell you the truth, I can use the..."

"It's more a business proposition," Fred said. "With Arthur.
It's Arthur I need to talk to. What's the best way to deal with
Arthur? Clue me in."

"Funny guy," Flash said, sullen. "For a guy with a place to
sleep. I'll give it to him, he's generous. Generous but private. For
one, I can't sleep in the apartment. I have the keys, he lets me
use the electric, I'm not complaining. I appreciate. He doesn't
mind I sleep on the landing like a fucking wino, big of him,"
Flash said. "Except the landlord catches me there I'm out in the
rain. Don't think I don't appreciate that also. But Arthur won't
let me help. With his clients. Lining, shading? My hand is steady.
Look." He held out both hands and, indeed, they were steady.

"I could do brain surgery, I knew my way around in there. And I haven't eaten yet today."

"He gets clients then. Arthur."

"Word of mouth. He gets them, sure. People don't have the time, drive up to New Hampshire, into Rhode Island, whatever. Plus the desire. People working? It's not, I'm not saying he's got attitude. Some ideas—one girl, young lady—what she wants is Porky Pig on her hip. Well, lower down. Some people, they want to tell the whole story of their life which is not what we are here for. They are gonna talk while you work. What do you say? 'Shut up, Lady, I'm working'? Arthur doesn't wanna do it."

"Stays away from the women's butts?" Fred hinted.

"Hell, that's no problem. Arthur *can* do anything he wants. What he stays away from—she says, the lady says, 'My boyfriend calls me *Porky*, so next time'—now she's leaning on the railing here, with one side of her panties hiked up in the crack, out here's the only place I have to work—'next time he gets a surprise,' she says. But to get back to Arthur, as long as I'm here and can do it, what Arthur does not like is Porky Pig. So I get Porky. Fine with me. I grab anything comes my way. Guy's gotta live."

Fred said, "I have a room I'm not using. Not to work in, but you can sleep there. I can't tell you how long it will be free. Two weeks, I guess, while I'm watching another place. Depending. How much is the booze a problem?"

"Look at my hands." Flash held out his hands again.

"We know you drink," Fred said. "Early Times before your first meal of the day, and while you wait for your first client? You can't remember if it's Wednesday? I have a house in Charlestown with some guys. My room is free. That feels like a crime. I don't like to eat in front of a hungry person, and I don't like to know my room is empty when someone can use it.

"The general run of guys in the place is younger than you, but that doesn't matter.

"I don't want you smoking that cigar in my bed and setting the place on fire. Take a look at the place. You like it, the room is yours until I need it. But don't smoke in the room. I'll tell

the guys, anyone smells one whiff of smoke coming under your door, you're out. Otherwise there's two rules. No women. Don't ask anybody his business. You interested?"

"What do I have to…what does it cost me?"

"It's my room. You're my guest. Food you'll have to figure out. There's a kitchen, but the guys don't eat together, not to depend on. Sometimes by accident. It's a place, not a community. Keep the room clean. Where's your stuff?"

Flash motioned to the shoulder bag.

Fred said, "There's a box of duds. Ask whoever's at the front desk. He'll fix you up. Living rough, you've likely picked up unwanted fellow travelers. I'd appreciate, you take care of them before you bunk in. The place has what you need to get comfortable."

"I'll think about it," Flash said. He thumbed his tools and his scraps of flash, twitching impatiently in his folding chair. "Fact is, there's something I have'ta…"

Flash ripped a sheet from a small spiral notebook he had in the bag. "Give me the address." Fred tore the sheet in half and wrote the coordinates for the place in Charlestown, handing that back, along with a note on the other side for whoever might be awake in the front hall. Nobody there could sleep if there wasn't someone awake, and watchful, and Flash would need to get past the guard.

On the other half-page he wrote, *Arthur, I like the Piero. I stopped by. Can we talk? Call me.* He added his name and the office number at Clay's. That's where he'd be. He consolidated the displays on the wall of the landing until he had freed a pushpin he could use to pin the note to Arthur's door. "I'll leave this for Arthur," he told Flash. "If he comes in before you go, do me a favor, would you? Tell him I'm on the up-and-up."

Chapter Twelve

Telephone. Ten-thirty. Fred at his desk with a meatball sub.

"Fred? Morgan, at the place. Guy with a note. Looks like your handwriting." Pause while conversation happened at the Charlestown end. "Says his name is Sammy Flash. He OK?"

"Give Flash what he needs to scrub down and change his clothes," Fred said. "He sleeps in my room. He wants to smoke those cigars, tell him keep them outside."

"Right," Morgan said. "I can read. Wanted to be sure it was you, that's all."

◇◇◇

Telephone. Murky darkness.

The leather couch creaked as Fred's bare arm reached for the noise. Enough light from the half-window. Streetlights. Mountjoy.

"What time is it?" The reedy male voice was firm.

"I'll take a look," Fred said. He found the lamp. "We're getting close on two AM," Fred said. "Happy to help."

"You Fred Taylor? You left a note."

"Arthur," Fred said.

Fred sat up. The room was still a pleasant temperature. There's an advantage to living underground. The street had been hot last night, even at ten, when he'd gone for food. Young women on the sidewalks, out for a good time, dressed up, had dressed in as little as they could manage.

"I didn't understand the note. I don't know Piero."

Fred said, "This is Arthur?"

"I don't know any Piero," the man insisted. That was fear in his voice.

"Thanks for calling," Fred said, looking to force some reassurance over the wire. "I appreciate it."

"Whoever Piero is, he isn't here. He hasn't been here. I don't know Piero. I never met any Piero. I won't do it. I can't help you. I don't know anything. I don't…"

The voice was frantic, the man seemingly on the point of breaking the connection.

"This will be easier face to face," Fred said. "To clarify—I was hanging out at your place, wanting to meet you, on the landing, this afternoon, talking with Sammy Flash. Maybe he told you, Flash let me take a leak in your john. That reproduction, the print, the picture on the wall in there—I recognized the picture. That's the name of the painter, Piero. I recognized it. That's all."

Long pause. Fred scratched the back of his neck. The new haircut.

"The name of the artist who made that painting is Piero della Francesca. I saw the picture, the original, one time in London. It blew me away."

"I love that picture. I'd love to see it," Arthur said. "That's where he lives? It's so clean and so fresh but it still looks, well, *old*."

"That's where *who* lives?" Fred was on the point of asking, when it dawned on him—Arthur hadn't a clue that the print he'd stuck over his toilet represented a painting made by a man whose particles of dust had been reprocessed at least four thousand times in the six centuries since they had been accidentally and temporarily congregated into the configuration of a man within the mess of city-states that was presently assembled into a temporary amalgam known as Italy.

"What else can you tell me? How big is the picture?" Arthur asked. "Would the artist let me in? If you…it's a lot to ask."

"I'll drop over," Fred said. "You going to be up for a while?"

Pause. The pause was on Arthur's end, impossible to evaluate. Finally, "You never mentioned what you want," Arthur said.

"I saw some of your work. I like it. I know it's late."

"I work at night," Arthur said. "I'm working now. Taking a break. You know where I am. Bring coffee. You want coffee?" Interruption on Arthur's end—a muddled jumble of distant voices. "Three coffees, lots of sugar but separate. There's a…"

Fred said, "Be there in twenty minutes."

◇◇◇

Parking on Green Street was no problem at two-thirty in the morning, any more than there'd been a traffic problem between Boston and Central Square. The four large coffees Fred had picked up before he crossed the bridge were still a good deal warmer than the night. Though the air outside had become comfortable, the day's heat was still trapped in the stairwell leading to Arthur's floor. Not Fred's business, but why didn't they open the window on the landing and admit the cool of the evening? Of course. The window was painted shut. The landlord had "improved" the place, and was not obliged to live with the consequences of the improvement.

Arthur opened immediately to Fred's knock. A tall guy, skinny, with round glasses and a mess of reddish hair, barefoot, wearing jeans and a yellow T-shirt bearing the slogan *RANDOM LAW* in scarlet across the front. He wiped his hands on a regular white Tee, saying, as if he were already in the middle of the paragraph, "And the reason I happen to know where London is, being from Nashua already, it's north on 93, then take 89 northwest." He didn't move from the doorway, called back over his shoulder, "He looks OK." He stepped aside. "Come on in. Don't mind us. Let's take a minute."

Two young women were in the room, one standing, wearing a beaten-up blue terry-cloth bathrobe, the other naked, rising from the long couch (or bench) where she'd been lying on her stomach under the lights. Her back, sides, buttocks, and in front, the shoulders, stomach and chest, were outlined in a

swirling rush of what looked to be folds of fabric dotted with floral sprigs. Suggestion of a full female figure, reaching…. The standing woman handed her a second robe, once tan, which she put on gingerly. Small dancer's breasts, thick pubic thatch of auburn—her mass of flowing hair was auburn also. Once she was clothed that fact was notable.

"Eva. Beth," Arthur said. It was Beth, in blue, who had been standing. Heavy set, brunette, with hair as short as Fred's had been before his morning visit to CUT - RATE - CUTS. Fred put the cardboard tray on a table and pried the cups out. "Fred," he told everyone, nodding to each woman as he passed the cups.

"It's OK if I sit?" Eva asked.

"Not a problem. You can't hurt it. It might hurt you some," Arthur said.

"I guess I'll stand," Eva decided. She began tearing open sugar packets and dumping the contents into her coffee. The room was arid and mostly empty, but far from sterile. The only light came from the gathering of hot lamps that played over the bench where Arthur had been working. A rolling metal table held his equipment: inks, tools, a couple of machines with cords that led to a surge protector.

Fred said, "It's an ambitious piece you're working on. You don't mind me saying…I don't want to be rude."

"We'll get the outlines done tonight," Arthur said. "The black lines. Dark blue. Dark green."

"I don't see what you're working from," Fred said.

"It's in here," Arthur pointed at the left side of his head. He motioned to chairs that sat here and there around the room. Arthur, Beth, and Fred gathered three of them into a loose confederation not far from the working pool of lights, and sat. Eva continued standing, back of Beth, her free hand resting on Beth's shoulder.

Arthur said, "You mentioned on the phone you like my work." He waited.

"Kim, at CUT - RATE - CUTS," Fred said, "was showing off the work in progress."

"Kim," Arthur said. "Kim sent you?"

"Not exactly," Fred admitted. "But we were talking…"

"Kim." Eva seemed to nod her head vaguely. The name didn't raise a ripple from the other woman, Beth, who was looking Fred over.

"He's the right size," Beth said. "What's he got, eight inches on Eva, about six on me? He's broad, but not fat. That's good so far." Her look removed Fred's clothes.

"And you've seen the baptism picture for real," Arthur said, disregarding Beth and concentrating on Fred. "You know the guy? Piero, you said? What I always wanted to know, reproduction doesn't give you a clue. How big is that painting? The real one? That's the first thing I want to know."

"Stands about six feet tall," Fred said. "If I remember, and I do. Four feet wide. The figures come out about half life size."

Arthur said, "Take out that crazy tree. That's easy. I always wanted to do a back piece, those three characters on the left, there's a guy with his arm leaning on his chick's shoulder, I think it's a chick, and the both of them talking to an angel. It would go perfect. You take out the tree? If it isn't a chick in the middle, I'd make her a chick. So you get one of everything: a man, a chick, an angel. The bases are covered."

"Do a devil on the front," Eva suggested. "Or lower down, in back, where he belongs."

"Or she," Beth said.

Fred said, "The picture's in England. You're right, it's old. I wasn't clear. London, *England*. In a museum."

"Shit," Arthur said. "A museum? Those places give me the creeps."

"Me, too," Fred said.

Chapter Thirteen

"Guy your age, you've already got a lot of your work done," Arthur said. He sipped coffee. Beth lit a cigarette. "I don't see anything. On your arms." Arthur glared at Beth and shook his head, but he was talking to Fred, intent. "You've been in the service?"

"That's the quickest way to describe it," Fred said. "To answer your question, I never had work done."

"Hey, Arthur, I know where you got that picture," Eva said. She laughed. "Every time I go in there, take a leak, I think, I remember that picture. I do. I saw it before. With Mr. Z. You ripped it off from Mr. Z. Mr. Z. Art appreciation and driver's ed."

Beth said, "Take off your shirt."

"Sure," Fred stood and peeled off the blue polo shirt.

"Turn around," Beth directed. When Fred complied the silence behind him was broken by Eva's voice, "The scars would make it kinky."

Beth said, "Arthur can work them in."

"No hair to notice," Eva added. "Buttloads of hair would be worse. It grows out again, that poor girl's a gorilla."

Fred put his shirt on again and sat. Beth and Eva's shared speculative looks verged on the conspiratorial.

"Mr. Z.," Arthur explained. "Back in Nashua Central. King of the art room. He'd pass a picture around from a pile he had in a drawer, tell us to write our idea what the story is, while he

stood in the corridor and smoked. Too good for the jerks in the room. Whatever a person wrote, he doesn't read it."

"Mr. Smooth. Mr. Cool," Eva said. "Most of us, we called his class Waiting for Lunch. Some of the pictures—he had a stack of them—I liked. "

Arthur said, almost in reverie, "I'd look at them and remember them and look again at them at night, in my mind, project them onto my bedroom wall, remembering all the lines, the colors. Because I can do that. Fuck Mr. Z. The beautiful things he had, he didn't care, as long as he got them back. Fuck him. I own them all. Listen, Fred, I have to get back to work. You have a design in mind? What you want?"

"No," Fred said.

"I do. He's right for it. I've decided. Show him the back piece," Beth demanded. She went to Arthur's work table and rooted out a clip board on which was a tablet of white paper. She handed him a pen, one of those throw-away fountain pens. With lightning strokes, the two women now standing behind him, Arthur sketched out a sinuous, standing, naked female figure, facing front, poised in an S-curve, one arm and hand raised to conceal a breast, the other modestly clothing her genitals with a swirl of her riotously blown and curling hair. Arthur finished by drawing, under her feet, the suggestion of a scallop shell.

"This is the plan," Beth said. "Her feet go over either side of your butt crack. Her head comes to your neck, some of the hair blowing around it to the front. Arthur's plan, tell you the truth. Or it's mine, or maybe Eva's. The whole thing's in three parts. Turn around, Eva, so we show Fred the idea. It's cool. One side, that's Eva," she lifted the robe from her partner, "has this girl."

Fred now could see what he had interrupted. In outline, only. The woman on Eva's back was facing forward, standing half-turned toward her left (therefore Eva's left), her own voluminous garments roiled by the same wind that whipped her own hair, which seemed an extension of Eva's. One foot, on tiptoe, rode low on either haunch. She was reaching out with a blowing garment whose folds wrapped around Eva's sides and shoulder.

The woman's head, in profile, rested between Eva's shoulders. Her upper arm had been cleverly modified from the original in order to cross Eva's shoulder, offering the leading edge of the fabric above Eva's left breast, in front.

"OK. That's one side," Beth said. She dropped her robe and stood in miniscule black underpants, turning quickly to put herself next to Eva. Her own, broader, back decoration seemed finished unless there were details unresolved. Two naked youths, both male, in air, entwined, winged, floated on a diagonal that left their confusion of feet extending around Beth's left hip— she pulled down the waistband of the underpants on that side so as to disentangle them—and their heads conjoined over her right shoulder blade. Wings extended from their shoulders and wrapped across Beth's side and front, even her neck. The clothing of the floating youths was blown in the opposite direction to the fabrics Eva's passenger wore or carried. The youths appeared to be blowing flowers that scattered here and there on the rest of Beth, front and back. When Beth and Eva stood next to each other, with Eva on the right, it was clear how Arthur's drawn figure belonged between them. *The Birth of Venus.*

Fred said, "It damned near takes my breath away."

"Our plan," Beth said, readjusting her pants and getting into the robe again, "and we love this idea. The piece Arthur drew for you? We want to know that's on a guy we don't know, out in the world, going its own way. The guy going *his* own way. Meanwhile it's part of what we have. We, Eva and I—we stay together. Do you love it?"

"I love the Botticelli," Fred said.

"No, no, no," Eva said. "Nobody's wearing shoes. I'm ready, Arthur. Let's pick this up again before I start to feel it, OK?"

Arthur said, "The lining's about done. If you're good for another hour—you OK with that? Feeling all right?—I'll get some color on, start shading in the reds and pinks of the robe she's reaching with. I want to start with the heavy color so we can judge how to fill in the girl's dress. Then there has to be some color, or shading, on the girl's skin, but, like I say, her skin should

be your skin, Eva. That's how I see it. Like her hair is going to be the same color as yours. Fred, I don't know why you're here. I can talk while I work. We'll start with your back, Eva, then get to the left side and front, so be ready to roll or—we'll work it out. Figure on three more sessions, to be safe."

The group adjourned to the work area. Eva lay down again, under the lights. Arthur pulled on a fresh pair of gloves and busied himself with the equipment, saying, "For the color and shading we use a broader spread of needle. Feels the same, goes faster." He tore off paper towel from a roll and wiped down Eva's back with a squirt of green soap, "You've been wandering around since we worked. And there's Beth's smoke. Doesn't hurt to be careful."

"Who's Kim?" Beth challenged. "You never mentioned Kim."

"Kim changed her name," Eva said, into the couch. "She was Ruthie in the old days. I've told you about Ruthie. We were all in the same school, same class." Beth had dragged her chair to the side of the couch opposite Arthur, in the direction Eva's head was turned. "You can imagine. Ruthie Hardin, she was. The fun the guys had with her last name. Came down to Massachusetts, I happened to run into her, she's changed the whole name, now she's Kim Weatherall."

Arthur said, "Ready?" He dipped the needle end of his tattooing machine into the ink he'd selected, stepped on the foot pedal, and the machine's mild chatter started as he began to apply color, beginning smoothly from the left hip.

"Ruthie Hardin. I don't remember that name either," Beth said.

Eva continued, over the mechanical buzz, "It doesn't matter. Like Arthur improved his name. I couldn't believe it, but I love it. Arthur Pendragon." Her giggle mixed well with the sound of Arthur's machine.

"Don't move," Arthur warned.

Fred said, standing back far enough not to interfere either with the work or Arthur's light, "I'm like you, Arthur. I love pictures. I love to see them out in the world. In a museum…"

"A museum is a fucking bank," Arthur said. "Museum's a fucking hospital. A fucking morgue, is what a museum is. Some

pictures, you see them everywhere. Like the one I drew for you. Advertisements, chocolate box tops, calendars. I figure, on a person, I set it free. It's walking. On the move. You're going to tell me that's another old one? Another one frozen back under glass in a museum? That naked chick standing on the shell? The one I'm doing now, part of it, on Eva?"

"'Fraid so," Fred said. "I've seen that one, too. It's Botticelli's *Birth of Venus.* Venus in the middle, obviously. The character you're working on, on Eva, is a servant or friend, at the ready with clothes, since Venus is born naked. Those flying boys on Beth are winds. You did them beautifully. And the flowers."

"Arthur's the best there is," Beth confirmed. Arthur kept adding color, the needle passing smoothly, allowing a three-dimensionality to develop in the turbulent drapery. "It'll move when Eva moves," Beth said. "You move nice, honey, when you move. But not now. While Arthur's…"

"You're gonna tell me this one's in England too," Arthur complained. "But go ahead. How big is the real—see, when Mr. Z passes the sheets around, you don't think about much except, well, hell, it's high school…"

"Except getting Tippy Artoonian to take her top off," Eva said. "Picture like that goes around the room, that naked girl made out of white chocolate, you can almost see the desk tops rising up, the guys' dicks getting into it. Guys look wildly around the room wondering, which one of these girls will show us how much she appreciates art and take off her clothes like the big-foot girl in the picture. Mr. Z. He's in the corridor, lipping his Parliament, that filter tip. Ready to open up like an umbrella and offer secret culture to some lucky girl, he's been all around the world, thinking who'll it be next? Tippy? Ruthie?'"

"Which some of us figured, the way he talked, he must be gay," Arthur said.

"The painting's in Florence," Fred said. "The figures are almost life size. Venus stands about Eva's height. Five something. Florence, Italy."

"You don't think of a painting as anything real, solid and heavy," Arthur said. "Mr. Z didn't say anything about that. His whole deal was pieces of paper, and what the stories seemed to be. You see a real painting, it's like the difference between a picture of a storm of rain, and standing in one."

"Kim mentioned a painting you had here," Fred said. "You were working from. A dirty old wooden painting?"

The soft chattering of the machine stopped short.

Chapter Fourteen

And started again as Arthur depressed the pedal. Arthur shook his head, keeping the needle moving smoothly. "I work from memory. One of the reasons I hate flash. That, and the designs of flash are old and crappy and yesterday and dead and everyone already has them and you could put them on in your sleep. One problem, the client sees something, immediately that's the *size* the client starts thinking. Me, I have the girl you call Venus in my head, I can project it any size I want. *I* know she can fit on your shoulder, your back, I can wrap her around your leg, hell, upside down if you want. But *you're* not gonna know that unless you come in, you say 'I want something this big on my shoulder, or this big on my back,' the rest of it, I draw out my sketch and then you are already imagining how big the lines are going to be, since you know the dimensions. I see those three characters on your back, Fred. The ones from Piero's picture. I honestly do."

"And he'll sell them to you," Beth said. "Don't think he won't. I came in, I wanted, what I had in mind, a picture from a kid's book I loved, the old woman who lived in a shoe, all over my back. I even went home for the book. Connecticut. Eva was with me, she's Arthur's friend, she never was gonna get ink at all. Hated the idea. But Arthur sold us. Because Eva knew Arthur from before. The whole thing, including the concept of the stranger, who would have to be a man, carrying the middle around we might never meet."

Arthur dipped his complex of needles and applied it again, like a brush. The color, a deep salmon pink, continued rippling up Eva's back. He said, "Turn onto your right side and hold still. Prop her with cushions, Beth, if that helps. I still like the idea you never meet him. Unless by accident. You're at the beach, maybe a convention in Nevada, somebody says, and *that* somebody's someone you don't already know, 'Hey, wait, you should meet…' and runs into the crowd, comes back with whoever it is."

Fred said, "I like paintings. The real thing. You ladies, the way you collect, the art's on your skin. Arthur has, it looks like, a phenomenal collection in his head. From the class with Mr. Z. But more than that, Kim happened to mention, when she was showing her work, an actual painting she had looked at with you here, Arthur. On wood, she said."

Arthur shook his head. He'd had too much time to think himself into a closed box of denial. "Doesn't ring a bell," he said. "Thanks for the coffee." He talked smoothly enough, but Fred's questioning, and his denials, had disturbed his concentration. "I can't stop now. I don't know what you're talking about, and I have to work."

Fred was dismissed. "I'll think about that back piece," he said. "The Piero. A thing like that, what would it cost me?"

"We can talk about it," Arthur said. "Some other time."

This was going no farther. "I'll be off then," Fred said. "It's great to meet you all. Arthur, you do beautiful work."

Arthur continued his shading. He said, "Whatever Kim said, I don't know anything about a painting. Beth, lock the door behind Fred. I can't be interrupted. It's tricky, the next part."

◇◇◇

Arthur's denial was absolute. High school had given him good training. A lie is easy to disregard unless it happens to block an avenue of inquiry. "Doesn't ring a bell" was the easiest kind of lie. Its identity as a lie was immediately exposed by Fred's being given the bum's rush.

"Arthur *Pendragon,*" Fred said, reaching the foot of the stairs. "The guy's a romantic. And, by the way, something like a genius, not only to reproduce Botticelli's *Venus* like that, from memory—but freehand, with ink. To execute that reaching female figure accurately, again from memory, on Eva's back—that guy is a genius for sure and true. Sandy Botticelli himself couldn't have done it. It requires genius little short of autism."

He tucked his car next to Clayton's in the designated parking area and was horizontal again by four, the birds of Beacon Hill having greeted his return with their moderated dawn chorus.

"Something to ask Molly Riley," he mused, recognizing the lacuna in his education. "Was Arthur—King Arthur to be—the natural son of Uther Pendragon, so that his patronymic would have been the same—Pendragon? Or what loins *did* young King Arthur spring from? Was he another miraculous hero birth? There's so much the tattooer Arthur doesn't know, how did he get the name Pendragon? Not from books.

"These kids don't need books. They get all the education they want from electronic games and fantasy. For all I know, Pendragon is the name of a galactic superstar.

"I should not have told him that Piero della Francesca was dead, and that his painting was on the other side of the Atlantic. Should have kept Arthur on the hook. But he had me fooled. I could not accept that a person who could draw like such an angel could at the same time be so dirt pure ignorant. He doesn't know the name of the painter who composed *The Birth of Venus*? Doesn't know where or, give or take a century, when? And yet he can paint the thing from memory on a girl's back. A pretty back, at that, which might in itself distract some artist craftsmen.

"Why does he deny the existence of the gremlin painting? What's the point?

"What was he afraid of when he called me?

"*Was* he afraid?

"He thinks about scale the way I was thinking about it myself earlier, down by the river. Again, or still, with reference to the relationship between an image on a sheet of paper—and the

relative size it is obliged to take on as soon as it becomes part of the human body. The screaming skull with candles in its eyes, if it takes up the whole of a fellow's front—the way it did in one of those magazine photos—that leaves us no recourse but to fantasize the skull as missing the skeleton of an eighteen-foot giant. With that head as the central focus, as a head always will be, the remaining parts of the figure—legs, arms, and vestigial teeny hands or feet—become the appendages of a kind of odd crab whose head is also its body, like Odillon Redon's spider.

"What happens to this guy if he's arrested for defying the Commonwealth's laws? Who cares? Is there a Department of Sanitation that gets offended, or who is it? Do they fine him? Jail him? Ride him out of Cambridge on a rail? They can't take his license away if he doesn't have one.

"What's my next step? I'm hooked. They've got me interested.

"Everyone in this has an alias. That's refreshing. Everyone but Mr. Z. Maybe Eva and Beth. Flash for sure. I don't see anyone his age coming into the world and being baptized by the happy parents as Sammy Flash.

"Who happens to be in my bed. What am I thinking? Keeping him close.

"What is the painting? Unless I want to get arrested, I can't go back to CUT - RATE - CUTS and ask Kim to show me the work in progress so I can figure out what I'm looking for. A Victorian fairy painting—if that's it, I've already wasted too much time.

"If I only had Arthur's skill at total visual recall.

"What did I see? It was too fast, and I was inhibited by being a gentleman, or *in loco parentis* or whatever slows me down. Impression of interwoven figures, birds, animals—but not in arabesques. So, not Victorian, maybe. Nothing pre-Raphaelite or art nouveau. And it wasn't the imitated Celtic knot work that, from a brief perusal of Sammy Flash's magazines, a lot of young people today find evocative. If anything, I'd say it was medieval. A gremlin, Kim said, like an egg with two heads and chicken feet."

The description rang a bell, to use Arthur's term of art.

The chorus of birds grew less as they settled into their work day. Vehicular and foot traffic was providing a rhythm that was leading in the direction of a fitful doze when Fred sat upright with a gaping jerk. "I've seen that gremlin egg. Or something close enough to be its brother. Pieter Breughel? Could be. The elder. No. It's smack in the middle of hell. Hieronymus Bosch. *The Garden of Earthly Delights,* so called."

That would jolt Clayton Reed when he came home.

Fred shook with the possibilities—unless it was the room shaking.

Chapter Fifteen

Sleep had become unlikely. After a couple of hours and a trip into the world for coffee, Fred's desk became the mess-in-progress that gave him as much comfort as it gave Clayton cat-fits. Books, periodicals, and sales catalogues from Clay's extensive collection were laid out in a rude semicircular heap, like a squirrel's nest the raccoons have gotten at, leaving only a ragged entrance for Fred. Clay wouldn't have a Post-it note in the place, claiming the mild gum damaged paper. Therefore the books and catalogues were porcupined with slips of paper.

"Of course I haven't seen the damned thing," Fred kept reminding himself. "If I set out to discover America or the lost city of Atlantis on the strength of this much evidence—to wit—a hostess in a barber shop told her friend in my presence that there was a dirty old wooden painting, and that the same painting was the source for an emblem that was the basis of her tattoo of an egg with two heads and chicken feet, which she characterized as a gremlin. That is what I know. Also, the tattooist denies the existence of the item in question. I know that too."

Meanwhile—here it was. That egg, or a version of it, everywhere. Specifically, as an evocatively surrealistic image, it was all over the work of that elusive painter who had bobbed like an inflated egg to the surface of Fred's liquid mind: Hieronymus Bosch, famous in song and story—if not well known at all.

Jeroen van Aken—his Christian name would be Jerome in English. The Latin form, Hieronymus, attached to him once

he became significant. He was born in around 1450 and was recorded as buried (one hopes already deceased), on August 9, 1516. His town was 's-Hertogenbosch, a slightly inland port city that was at the time the capital of the Duchy of Brabant, a neck of the woods that has since become the southernmost province of the Netherlands. No record exists that Jeroen van Aken ever set foot outside the town. On the seven paintings that he signed, and that are known to be from his hand, the signature he chose was *Hieronymus Bosch,* an alias partially, and legitimately, derived from the last syllable of his native place. Hieronymus Bosch was as made-up a name as Sammy Flash, Kenzo Petersen, Arthur Pendragon, or Kim Weatherall. Jeroen's friends in town, and in his club, the Brotherhood of Our Lady, presumably called him the equivalent of "Jerry."

His paintings may be part of the Western world's general iconography, but they are very few, and tend to be found off the beaten track, and are often so large that reproductions leave us helpless to follow what is happening. Of the twenty-five paintings that are generally accepted as being his work, *The Temptation of Saint Anthony* is in Lisbon, *The Garden of Earthly Delights,* a monster triptych seven feet high and thirteen feet long when its wings are extended, is, with several others, in the Prado in Spain. An enterprising child might count as many as eleven dozen figures—human, bird, animal, God and angels—and still fall short of the total, baffled, as the work went on, to find no children anywhere in the mix that, whatever it represents, purports to stand for the world.

"But of course I haven't seen the damned thing," Fred repeated.

However, he'd confirmed the image that lurked in his memory, from the *Garden of Earthly Delights,* and drawn out by Kim's vestigial description. The right-hand inner panel of the triptych—a hinged contraption whose doors, when closed, displayed a black, grey, and white vision of the earth in process of its formation, on around the third day of creation when dry land is coalescing out of the chaotic planetary soup—that right panel

exhibited a surreal mixture of events as grim as it was lively. At the top of the seven-foot panel a city seen at night, beleaguered by war, is burning. Beneath that a grisly juggernaut, seemingly a weapon of war, advances across naked victims, despite the fact that the machine consists in no more than a pair of ears clasping a vicious tilted knife blade. Its stamped hallmark proves it to be from a maker in 's-Hertogenbosch.

Beneath that stands the dreadful egg Fred was remembering—a hollow monster doubling as an inn for the hopeless and condemned. It stands on its own legs, bleached trunks from which long thorns pierce through its shell. The egg's shell serves as body to the being because the egg has a human head, as death-pale as the shell. This head is by far the largest human visage in the triptych and seems cruelly alive, given its circumstances. It is a portrait—male, humane, perhaps even with a sense of humor that adds poignancy to his despair. Portrait or, perhaps, self-portrait.

Then you proceed downwards. The legs of the monstrous being rest tentatively in small boats that tilt in the surface of a river whose thin ice gives illusory support to naked persons speeding toward their doom on skates and sleds. Down further to persons impaled on their musical instruments; bird-headed Satan devouring a sinner from whose frightened anus crows escape; and things deteriorate from there.

The egg, though. It was the egg Fred wanted to follow. Here were a number of Bosch's drawings from Oxford's Ashmolean, representing monsters made up of oversized human heads with feathers and the legs of chickens. Here, in the painting *Concert in an Egg*, the painting itself lost but two fair copies extant, a surface four feet square is filled by the empty shell of a gigantic egg in which fools, both clergy and laity, join their inane caterwauling to the music of an ass and a monkey while a chorus of birds looks on silently. And here again, and maybe finally—exhibit A, was a grimly lovely drawing of that same "Tree Man" in the collection of the Albertina, Vienna. "Vienna *Austria*, Arthur, you jerk," Fred muttered. "You can't get there from Boston on a bus."

In this drawing the legs' thorns were comparatively reassuring and innocuous-seeming branches, although they still pierced the empty shell that, in this version, was more allied to the kind of tree hollow in which one of Bosch's signature owls might raise a brood. Indeed, an owl perched on one of the branches. The man's huge head continued to stare fixedly at you.

Behind this apparition stretched a placid, even charming vista of harbor, villages, steeples and an uneventful cloudy sky. In the foreground a deer you'd want to pet; a placid heron balanced on one leg watching for fish to appear in the broad river in which the monstrous tree man contraption floated in its two rickety rowboats. Anyone could see it as a gremlin.

Someone at some time—the drawing, like the painting, had been around five hundred years—trying to be helpful—had written in the lower left corner, "Breughel." But the drawing was by Bosch.

Most of what Bosch ever made was lost. Given the general run of what he'd imagined, an egg with two heads and the legs of a chicken would be perfectly in keeping and character. Not that there weren't other painters in his vicinity, followers perhaps, who might run to the same imagery. That northern European version of fable-like surrealism was broadly based and popular. The painting Kim had hinted at, if Fred's guess as to its age and origin were anywhere near the mark, still might be by any one of a couple dozen worthy painters.

"But I haven't seen the damned thing," Fred said.

Fred's quick search through the auction catalogues turned up a recent Sotheby's London sale of Old Master Paintings that offered a "Workshop of Hieronymus Bosch" painting, oil on wood, not large, in poor condition—a so-called *Paradise of Fools*—that bore some resemblance to the Louvre's *Ship of Fools*, and was estimated at $150,000 to $200,000. Clayton, musing through the catalog's pages, had marked it with a star, adding, in his insufferably neat hand, which resembled Greek letters more than it did English, "Lacking in the fantastic. Condition a problem."

But he'd considered it despite the fact that, reading between the lines—and everybody knew this—Sotheby's disingenuous "Workshop" attribution meant they couldn't guarantee or even ascribe the painting's authorship to anybody. Despite that, in addition to the dicey condition of the picture, the estimate was still good money. Part of the reason for that was the remote critical association that could be drawn to an important painter, Bosch, whose authentic work was now, essentially, never available for purchase.

"Find the painting," Fred said. He'd let his coffee get so cold he went upstairs to Clayton's kitchen to add ice.

Chapter Sixteen

Dynamite is an effective way to bring fish to the surface, but if you are after a particular fish, it is very likely to appear in fragments. Fred could get the same effect by marching a second time into Arthur's apartment, now that the existence of the painting had been denied, and suggesting that it was worth money. Arthur was already hopelessly out of his depth. Genius though he might be, he was uncontaminated by education or broad experience. The austerity of his life, and the illegality of the means by which he made his living, made it impossible to guess how he would react to such a stimulus. Other than the myth of money, Fred had no purchase or fulcrum.

If the painting was in the apartment it was not displayed—that much Fred knew. Potential hiding places were few. It was possible for Fred to bide his time and enter surreptitiously when Arthur was out, but there was no satisfactory rationale for breaking in. Curiosity alone wasn't enough. But the curiosity itched. Also Arthur was afraid. That fact might have nothing to do with his denial, but it was curious also. And it added to the itch.

Fred timed his arrival at the library for nine o'clock. There were other libraries, but only the Broadway branch of the Cambridge Public Library had a reference librarian who intrigued him. Today's mission was not going to look like much after his last one.

Molly looked up and smiled. She was occupied with a boy who wanted information about giant squid. Eleven or ten years

old, he was almost trembling with fear and hope. "But they're true," he was insisting. "Aren't they? They can be true and still people are writing lies about them. Like Atlantis."

"I'll show you books where you can start," Molly said. "Those books will tell you about other books, and you go on to other books from there. If we don't have something here, we'll order it from another library. Be with you in a minute," she told Fred, smiling again. She led the boy into another part of the library.

This early in the day the library hadn't warmed up. A few older clients sat at the long tables, reading newspapers. The library's own staff was getting started, moving things around, stacking books, sorting periodicals, tidying in a variety of displacement activities. Molly reappeared. "The day is coming," she said, "and soon, when I can send that kid to a computer in the corner and tell him, 'Go fetch.' Heck, the day's likely coming soon enough when the military-industrial complex sees to it that the kid has a computer of his own. Never has to step out of his bedroom. Has nobody to steer him around among the information, helping him distinguish between the sheep and the goats. I didn't have time to look at your question again."

She was wearing green again today: a summer shift, almost shapeless, over a long sleeved white blouse. Her own shape underneath was...

Fred said, "I'm driving to Nashua, New Hampshire, and I don't know a thing about the place."

"Guide book? Tour book? Camping?"

Fred said, "Figure me for a blank slate. I want to pass for not a complete hopeless stranger, without spending hours boning up."

"Be right back. Don't follow me. It slows me down."

Her own shape underneath was—graceful, wholesome, unemphatic, businesslike, symmetrical, brisk, and decidedly, frankly, female. There. He'd figured that out. And no, no wedding ring.

Molly reappeared with a couple of slim camping and hiking guides and a rueful expression. "Nashua, New Hampshire, is a well kept secret. Looks like the secret, though, is as exciting as my breakfast. Only interesting as long as it's a secret."

"The romance of secret pleasures," Fred said.

"Exactly. Until the secret pleasures turn out to be Cheerios with Nu-Form milk."

"My secret was coffee," Fred said.

"I know." Molly paused, possibly debating whether to color, or to smile, at this intimacy. She did neither. "You want business-type info, like real estate, crime, statistics. I pulled this off the Internet. Population close on sixteen thousand, average house value a hundred thousand, population black two hundred, Hispanic five hundred, Asian seven hundred, five Hawai'ians; average income per household fifty thousand, average household 2.36. I haven't had mine yet. I am dying for a cup of coffee."

Fred said, "My theory is, there's plenty of protein in coffee, so long as you drink enough of it. I'd offer to bring you some, but they'd probably…"

"Not probably. They'd *certainly*," Molly said. "We have a fat book, I can see it, *New Hampshire, An Explorer's Guide,* but someone's filched it or taken it out or shelved it wrong. Given a book's an object, it can wander anywhere."

"You have a newspaper from Nashua?" Fred asked.

"*Nashua Telegraph.* No," Molly said. "*Union Leader's* not based there. We used to subscribe, but these days…"

"Or a map of downtown," Fred said. "What time do you take your break? I saw there's a Starbucks…"

Molly shook her head. "Gilly called in sick so there's only one person doing reference today. If I can find five minutes, I don't know when it will be. Town of sixteen thousand, you are not going to need a map to find downtown."

"I know it," Fred said.

Molly had printed a page with the statistics she had quoted, apparently from memory. She held it out. "If it's any use to you."

Fred accepted it. "Average household 2.36. I'll remember that. I'll just drive north until I see five Hawai'ians. Then I know I've reached my destination. That's two Hawai'ian households and some change."

"The point twenty-eight remainder is their Hawai'ian dog," Molly said. "Do the Hawaiians eat their dogs? That would wreck the statistic. Have a good trip, Fred. I'll go help that kid with his squids."

◇◇◇

Nashua turned out to be another disappointed New England mill town: its river no longer harnessed to power idle and vanished looms; grand industrial architecture gone to rack and ruin; seedy if hopeful attempts to make something of the wreck that might attract tourists until such time as a building and design renaissance transformed the little city into a worthy echo of its former modesty. The god of naming streets had thrown the same names onto the land here as in every other town in New England including Grover's Corners: Maple, Main, School, Elm. But the ghost of Thornton Wilder shuddered at what had happened afterwards. An hour north of Boston, Fred had arrived in, if not the third, at least the second world. Once you got through the strip malls Nashua was not a dead end, but not much better than a crossroads.

Fred found a place near City Hall whose honest hamburger was not contaminated by a wine list and frills. Conversation at the counter and in the booths behind him was vacant and unfocussed. His fellow diners were familiar to each other but not friends. Nashua was too big to be a small town, too small for camaraderie between strangers. You couldn't help but feel, with any teenager worthy of that designation, "Help! Get me out of here!" The phone book had given an address for Kenzo's in one of the malls outside the city's swinging center, stuck between a pizza parlor and a gift store specializing in fake rusticity. The cardboard sign in the door had said *Come Back at One P. M., maybe 2.*

That left time to dawdle over lunch.

The waitress was the right age. Fred took a lucky stab, "Nashua Central?"

She blushed. "People remember," she said. "Me with the pompons, right?"

"How could anyone forget?" Fred dropped a few names across the counter as the woman worked the service up and down, while dickering with the pass-through into the kitchen.

◇◇◇

Kenzo's, in fact, opened at 1:27, when an aging young woman, whose tank top allowed a generous display of several people's work, turned up with keys. The lower body was concealed in jeans. Fred watched the place from his car while the shades went up, lights went on, the hanging cardboard sign was reversed to read *YES, WE ARE*. Fred gave it a few more minutes. When he walked in the woman, a telephone pressed to one side of a pile of hair bleached to a uniform blond, held up a hand in either welcome or dismissal. She continued talking while he took one of the waiting area's unmatched chairs, purchased from the going-out-of-business sales of foreclosed motels, and looked around.

"West Palm," she was saying. "Skinny Louie's. Before that Tampa, first Carlotta's Steam Mirage, then Road Runners, but Tampa was too…West Palm's livelier and I was with someone there turned out…So then, but now I'm here."

Pause.

The storefront, maybe ten years old, was broken in the middle by the reception desk where the woman sat surrounded by brochures and magazines and ring binders of samples—whatever it might be. Windows overlooked the parking lot, but Fred faced inward. Make a few quick shifts of decor, the place would function as well for dog grooming, bakery outlet, real estate office. A license to practice prominently posted on the wall displayed the power of the Licensing and Regulative Services of New Hampshire's Department of Health and Human Services, next to poster-sized photos of things people had paid to have done to themselves.

"If you want barbecue," the woman told the phone.

Pause.

There were enough chairs for five clients to wait in, and a table with more of the kind of materials Sammy Flash piled

in his waiting area. The place could also be a dating service or no-nonsense dental office, with the name *No Holds Barred.* The visible clues spoke of the low-grade persistent viability of a whole industry. At the desk the woman held up her hand in a gesture that meant "You didn't make an appointment," or "What can I do? She's my mother."

Chapter Seventeen

"No. Yes. No," the woman said.

Pause.

The groaning sound was an air conditioner in back, struggling to catch up to radiant heat the parking lot had leached into the unventilated space during the night. The place was designed to be intolerable without air conditioning. The woman's arms and shoulders, her chest above the halter top, and her stomach and back below, were fully decorated with competing arabesques of color that opened here and there like mandorlas—those haloes that appear in paintings of medieval sky, like white holes, to reveal significant symbols. The woman's symbols were precisely executed but tended toward the trite: the skull, the heart, a lion's head, guitar in flames, chrysanthemum, a shark, snake, puppy, the Eiffel tower—that was surprising—spiders, and words Fred didn't read.

"He'll show up. Not until I have my license. Why I want the hundred fifty…That's what I told you. That's what I said. The risk, it's not fucking worth it, they're getting…and besides…"

Pause.

Fred said, from his chair, "You expect Kenzo?"

The gesture of her hand meant, "Who knows?" or else, "Kenzo owes me seven dollars." But it was accompanied by a nod.

"They catch you without a license, you know what they can fine you? Do to you? And in case something goes wrong?…

That's what I said. But, like I said, if you want barbecue, forget the east coast."

Pause.

"Maybe South Carolina. Near the coast. Small places. Not the chains."

Fred's doze was interrupted by the closing slap of the door. That coincided with the clank of the phone hastily coming to rest. The man entering had to be Kenzo: burly, late middle-aged, in white muscle shirt and ripped jeans, broad arms swarming with color, a pony tail reaching down the center of his back, the top of his head balding. Heavy scarred black boots.

"Stephanie," he growled, looking toward Fred.

Stephanie's hand gestures, which the new entrant disregarded, meant "Please don't fire me," or "These people—where do they all come from?"

"C'mon in back," Kenzo said. "Stephanie, the phone's been tied up forty minutes."

"Get call-waiting," Stephanie said. The relationship must be complex enough so firing was not an option. Having both hands free, she started putting the surface of her desk in order. Kenzo led Fred behind the partition separating his work area from the front of the store.

"Fellow your age, if you want ink, you already have it," Kenzo said. "So, next question…"

"I came up from Massachusetts."

"Right."

The work area had in it a padded recliner with a black surface of fake plastic leather—that would be cleanable between clients—as well as a couple of rolling stools, on one of which Kenzo sat, next to the table that contained supplies. What was visible on his arms and neck, and in the scoop above his shirt, was Japanese in flavor. There was more to the building but it was closed off by heavy double curtains that had to mask a passageway leading to storage and rest room areas, maybe a kitchen.

"You have ID?" Kenzo challenged.

"The ID I have won't prove the negative. Meaning, I may look like law. But I'm not law."

"Which you can't prove," Kenzo said. "What we'll do, for the sake of argument, I happen to be free, my two o'clock's not here, say what you came to say and I'll consider it as if you're law. Meaning I'll listen."

"Young guy named Arthur," Fred said. "Talented guy…"

He paused. There was no visible response. "Draws like an angel," Fred added.

Kenzo broke the silence. "Prosecutors like that trick. In court. You get the choice, jail or answer the question. Like they're pitching, they set up their rhythm, first easy questions, yes or no, simple. Then they start making statements, the poor goof keeps on answering. 'I take it you own a watch.' 'Yes.' 'I take it you own a pair of shoes.' 'Yes.' 'I take it you were running out of the bank carrying a sack of money.' That's not a question, it's a statement. How does the goof know if the prosecutor takes that or not? He can't answer. But the judge goes along with the prosecutor, pretends it's a question. If the goof says 'Yes, you take it,' it sounds like 'Yes he did it.' So, to answer the question you didn't ask, 'Yes, he does.' If it's the Arthur used to hang around the shop here. Arthur draws like a fucking angel."

"I take it you have an interest in Arthur," Kenzo added, after a pause. "Unless your interest is in fucking angels."

"Arthur's tangential," Fred said. "My interest is paintings."

"The man's in the art business," Kenzo marveled. "Where's the suit? The shoes?" He looked down at Fred's well-scuffed loafers, the absent socks. "What are you, in disguise? Another fucking art dealer, but this one's in disguise. I love it."

Given that Fred had nothing, there was nothing to lose in the modified, limited hang-out, as an old master of deceit had used to call that feint. Fred said, "I ran into a girl from up here, with the start of some ink Arthur is doing, based on a painting…"

"Who's the girl? Tell me about it," Kenzo said.

"On wood. Fantasy stuff. Weird figures…"

"I take it you want this painting," Kenzo said.

"I want to see it."

"Why?"

"I'm curious," Fred said.

"I will take your curiosity under advisement," Kenzo said. Stephanie, poking her bleached head into the compartment, said, "Your two o'clock, Kenzo."

"Leave your name and the rest of it at the desk," Kenzo said, standing. "This was fun."

"Wherever it is, I'll drive up to take a look," Fred said. "Any time."

"If I'm interested," Kenzo said. "A girl with the start of some ink, you said? From up here? Friend of Arthur's? Go on, talk."

His tone managed to be both lazy and menacing.

"Shooting the breeze," Fred said. "I get distracted. What I heard was, Arthur was working from a painting..."

"Beats me," Kenzo cut him off. "If I think of something I'll have Stephanie call you. Leave who you are. What firm you're with. The rest of it. If you have one with you, a card. What are you, Sotheby's? In case I give a shit. Or remember something. Or run into something. Or you give me a better idea how interested you are, this painting you haven't seen, you drove all the way up here to ask about, that I haven't seen. I'm busy. Tell Stephanie."

The arriving client, a large man, clanked with chains, his leather squeaking. He growled as he entered Kenzo's work space, "Fucking bluebirds are a mistake. She wants vultures."

◇◇◇

Fred had not expected Central High to be in session, but the gross brick building was actively inhabited. Summer school. The pick of the golden youth of Nashua was inside seeking redemption for past sins in retaliatory summer classes. Only as a last resort would Fred seek help from the office bureaucracy. He had no standing beyond curiosity.

In the parking area back of the building he pulled in next to the ancient white sedan on whose roof a triangular sign balanced as if it delivered pizza. The sign warned, STUDENT DRIVER. A

young girl dressed as jail bait climbed out of the driver's side—small shorts on long legs, a skimpy top, the skimpy braids that claim, "I turned thirteen."

"Same time tomorrow?" she called and ran around the building. More slowly, from the passenger's side, a skinny man, also dressed for summer, was unfolding himself. White polo shirt, tan pants, white tennis shoes. Worryingly tan of skin with too much white hair that someone had styled to go with an expensive car. He was not, to look at him, one of the five Hawaiians.

"Mr. Z?" Fred strode toward him, holding out his hand. "Zagoriski. Am I right?"

The waitress had even spelled the name out on a napkin.

"If you're with that van's insurance company, move on," the instructor said with a distinctness meant to irritate while it impressed. Despite his precision in pronunciation, he was maneuvering quickly to outflank Fred. "I've told you people, I don't talk to you. I talk to the school's lawyers, the school's lawyers talk to you. The matter is out of my hands."

"Fred," Fred said, his outstretched hand still ready, "Insurance? I know nothing about insurance. I'm doing a story. Research, talking art appreciation in the hinterlands, your name came up. If you're done for the day, I'll buy you a drink."

Mr. Z stopped cold, staring. He took Fred's hand and shook it in a perfunctory way.

"My project. I'm from Boston," Fred said. "The way I see it, art appreciation is as vulnerable a subject as you are going to find in the public school systems, more vulnerable than music, am I right? Things being like they are these days. That makes the teachers of art appreciation a dying breed unless we reverse the trend. Where's a quiet place we can sit? Unwind?"

The man had gotten half Fred's bulk into about the same height. He posed, where standing would have done the job. It was remarkable, even based on this brief encounter, that his high school students had not eaten him alive.

Mr. Z studied the stranger, pursed his lips, shrugged, and concluded, "A drink I could use. And entertainment. Goodness,

a new face! In these benighted parts. We take your car. Call me Z. First name's Zoltan. Z covers it. My own car—it's a long story."

Fred's old brown car wobbled and creaked as the two men climbed in. "We'll go to Tina's," Z said. "If you're from Boston you don't know it. It's all there is. I'll direct you." He leaned back and sighed, accompanying his directions with gestures that were insistently, unnecessarily, graceful.

Z took them north of Nashua center and into another mall whose establishments looked more aggressive in their expectations of the customers. The take-out barbecue joint was called *High on the Hog.* Z guided them to the Moonglow Lounge. "Back door," Z instructed, after Fred parked the car. Fred followed him around the free-standing building that stood at the edge of the mall. The building's design hinted that it was a failed Ground Round. Z opened the back screen door leading into a kitchen, calling, "Tina?"

"Come on in, Mr. Zag." It wasn't possible to tell which of the three middle-aged Asians had spoken. Vegetable prep was in progress. A woman, coming forward while wiping her hands on a stained apron, said, "Ms. Tina not here, but you come in, Mr. Zag, you want drink." The two men followed her through the kitchen into a dark lounge area at one end of which a raised stage promised disposable music and—because the architecture clearly suggested it—pole dancing.

"They call me Zag here," Z said.

"We not open," the woman explained to Fred. Z chose a booth. Fred sat across from him in the cool darkness. "You drink something," she told Fred.

"Hot as it is? Beer. A local beer."

"Anywhere else in town, I am going to run into a student of mine," Z said. "Here, Tina won't hire girls until they graduate, and prove they did. She comes to me for references." His cheeks developed deep vertical chasms that passed for a smug grin, or rueful dismissal. "Wait a minute." Z checked his watch. "I need to make a call."

The pay phone into which Z dropped his change was not near enough for Fred to overhear his end until his voice, after a muted beginning, gradually rose. "And have it with you. I'll see you there."

Z sat down again with gestures of apology. "Could be my ticket out of town. I'm wasted here. Like everything and everyone else. Between you and me, I've thought about Boston. Place like Northeastern, Suffolk, if I have to keep with the teaching. Not like I haven't tried. It's too late. Forget it. There's too much competition in Boston. People want to be where there's a life..."

The woman from the kitchen returned with a tray bearing a lowball glass of crushed ice, another lowball glass with a good three fingers of amber liquid—scotch by the smell of it—and a small pitcher of water. For Fred there was a bottle of Old Brown Dog from the Smuttynose brewery.

Fred said, "What interests..."

Chapter Eighteen

Z held up a long hand, forcing a pause in conversation. The elaborate preparations he commenced suggested an almost masturbatory appreciation of the onset of his first drink of the afternoon. After organizing water, ice, and alcohol to his satisfaction, he lifted his glass in Fred's direction. "Art appreciation," he said. "Whatever your angle is, it can't hurt. What paper you with?"

"I'm freelance," Fred said. "Working on spec."

Z shook a Parliament from the pack that rode in his breast pocket, and lipped it. "Do you mind," he declared, careful to avoid any hint of inquiry as he applied the match.

"*Art Appreciation*," Fred said, musing over the projected title, "*An Endangered Species*. What's your secret?"

"My secret? The Nashua Teachers Union. Ha ha. Strike that." Z's chuckle was designed for the waning moments of the symposium far from home. "My secret? You mean to suggest that mossy phrase, The Secret of my Success? How did you come to select..."

Fred interrupted. "You want to know my angle. What with cutbacks, retrenchment, the federal government getting into the act, the rest of it...and it's not as if Nashua is in the middle of the urban art scene. The students of yours I've met...well, I'm impressed. How do you do it?"

"Students of mine," Z started warily. He took possession of a lungful of tar and nicotine and hung on to it, waiting.

Fred said, "I don't plan to interview current students in your art appreciation class. That would have to wait for the school year. Unless—you're not doing make-up summer classes, people who flunked art appreciation?"

Damp smoke colored and scented the reply. "Summers I'm off. Nothing official for the school. Summers I moonlight. Privately. Driver's ed, helping the kids get through the permits. I am wasted here. There is nothing in the arts. You might as well try caviar as chicken feed. Caviar? Half these kids wouldn't know what a chicken is. Sure, there's the occasional damp kid with a spark. But they can't get out from under where they are. The spark goes out. Can't catch. I used to try. Maybe I still try. But it's hopeless. You mentioned graduates. Alumni of Nashua Central. You've met them? Where? In God's name, why?"

Fred said, "The way I see it, the arc of the piece goes from art appreciation with Mr. Z at Nashua Central, which we agree is the wilderness, to a profession in the arts that nobody would ever have predicted. And you planted the seed. Mr. Z. Right here. Again, what's your secret? As an educator?"

Z leaned back and became expansive, waving the cigarette with his right hand and, more carefully, the drink with his left. "I help the ones I can. My secret is self-expression." He slid into a reverie that focused on his glass.

"Self-expression," Fred prompted.

"Not *my* self-expression. Theirs. You think kids want to know what Mr. Z thinks? One condition, all right? I insist. I reserve the right to approve your final text before you publish. It's a tricky time for me. This other thing doesn't work out. The article could help, but I'll be the artistic director. As long as that's agreed, I can talk straight. Save time. Sometimes, saving time, my phrasing is abrupt. OK, then? Gloves off.

"You imagine the kids care what I think? Mr. Z? Or have to say? About anything? What I do, I make them write. They hate that, but they know it's better than math. What they see in a picture. What's going on. Not slides. Carrying stuff around. Projector. Slides, I tried that. Dark room, guys and girls start

feeling each other up. High school. Plus you stand in back, go out of your mind, flicking the switch."

The elegant precision of his pronunciation did not change to match the comparative brutality of his words. It was unnerving.

"No. I keep a stack of pictures. Bring it in. Reproductions, prints, some from magazines. Looking to find or strike a spark, but it's hopeless. What are the people in the picture thinking? What do they want? I don't care what the kids write, so long as they write something. Beauty? They could care less. History? Culture? What they are looking for is easy credit in a gut course. I don't make it easy. What the artist has for breakfast? Whatever, they have to write. Pick up the papers, end of class, you know who was there, check it off, attendance. They didn't write, it means they didn't show. That means detention. Next class, make them read what everyone else wrote. The ones that can read. That's a joke. End of the day. Scratch that. Everyone reads in Nashua Central. Pass it around the class. After you read the paper, write your name down on the back. When everyone's read it, there's your attendance on the next class. You taking notes?"

Fred tapped his forehead. "Up here. Hate to inhibit a witness." Mr. Z, not even halfway down his first drink, had given the floor to his evil twin.

"Tell me your own training," Fred said.

The question caused a frown that was quickly eclipsed by a petulant smile. "For the record, I love art. Also I love the kids." He did not need to add, "And I feel the two belong together." He took a drink. "You mention alumni," he said. "I am interested. In the Boston area?"

Fred said, "No, *I'm* in the Boston area. Maybe three years ago? All in the same class. Eva? Arthur. Kim. They mentioned another classmate, Tippy Artoonian."

"Tippy?" Z exclaimed. "Not a success of mine. Poverty makes them blind. They can't get past it. I thought, I still think, in a few years—but it's hopeless. She'll turn out like the rest of them. You could call it one of the arts. The fine arts. Dance.

"I would have thought her reputation not much more than local, though she travels. North of Nashua. I guess you can call it art. What she does. I can't exactly take credit…someone like Tippy, maybe I help her get started, we all have to eat, but…your article…we won't mention…given some pending issues. There's no reason to hand Mary…I don't know the direction she's going to go…the superintendent…I'm in enough…even my union…"

Fred said, "Arthur's the one I'm following more closely. I mention Tippy because her name came up. Arthur…"

"Sure. Arthur Schrecking. Did drawings for the yearbook. Posters for class election candidates. Had a setup where he painted bikes after school. T-shirts. Head stuff. Something came of him? What's Arthur doing? Arthur went to Boston? I've been wondering. You invest so much in a student, then he's gone. How would I get in touch? You mentioned Kim. Kim? Kim who? Most of these kids, unless they join the service, never get out of town. I'd have thought the west coast for Arthur, but you say Boston?"

"*I'm* the one in Boston," Fred said. "What Arthur has, and I haven't seen anything like it…"

"What does he have?" Z asked sharply, sitting forward and looking intently across his glass.

"He has perfect recall of images he has seen," Fred said. "He can draw from memory—I saw him do it—for an example, that Botticelli painting, *The Birth of Venus*."

"The one on the half-shell?" Z chortled and took another sip, relaxing. The aesthete had gone completely and been replaced by a Rotarian hopelessly seeking a friend. "That's a huge favorite. Eye-opener for them, get away with that porno in a high school class. Not in Texas, you wouldn't. Kids love it. They tried to sneak it, Arthur's drawing, into the yearbook. Not on your Nellie. Not without a bikini. Arthur's making a living? In Boston? Doing art?" Z's surprise was not feigned.

"Tattoos," Fred said. "What I thought would give you some professional satisfaction; he's using images that come out of your class."

"Makes sense," Z said. He drowned the butt of his Parliament by pressing the wet filter against its smoldering ember. "Good luck to him. You mention a couple other names. Eva. I recall Eva. Redhead. That can change, but hers was—she'd be a fool to change that hair. Eva's into art? My influence? You never know. Who else?"

"Kim," Fred said.

"I don't recall a Kim. I mean, there's a hundred thousand Kims, but not in that class."

"Hair stylist," Fred said.

"That makes sense. Hair stylist. Art. Applied art. I don't remember a Kim from Arthur's class, though. They get mixed up."

"There's a rumor," Fred said. "One of that group, maybe it's Arthur? Could be in the business."

"The business?" Z said.

"On the side. Dealing."

"They all deal. What's new?" Z said, impatient.

"Art, I mean. Arthur. Dealing art. I'm looking for a painting."

"A painting," Z said.

"Old. On wood. It's complicated. Lots of figures. Gremlins. Fairies."

Z leaned back and rubbed his face. He signaled with a long arm into the dark room. "Arthur," he said. "Eva? Kim?"

"On the off chance," Fred said. "You being the art appreciation teacher, them being not long out of Nashua Central, I figured if Arthur bumped into a genuine painting, wanted to understand what it was, he'd come to you."

"All this bullshit about the article you're writing, that's bullshit, then," Z said, following a long pause.

Chapter Nineteen

Fred took a swig from the Old Brown Dog.

"You're working for her," Z tried.

The silence in the room was interrupted by the entrance of kitchen staff starting to lay tables. The afternoon was waning toward the moment when the Moonglow's doors would open.

Fred said, "Not only am I freelance. I'm independent."

"Right. Working for my wife's attorney. You son of a bitch. If you think I'm paying for these…"

Fred laid two twenties on the table, tucking them under the ash tray.

"Tell her, whoever walks out, all bets are off," Z said. "She's the one walked out. Remember that. You creeping around with a fake magazine article and the rest of it?" He took an exasperated sip from his drink.

Fred said, "Not important, but I didn't claim I was writing an article. You drew that conclusion. I didn't set you straight, so I let it become a lie. What I *said* was, I'm working on a project. I am."

"The one thing I know, if Arthur's doing tattoos, he's not in Boston," Z said, treating Fred to a smirk. "It's illegal, tattoos in Massachusetts. What is your so-called project?"

"I told you. The painting I heard about. I want…"

"If you're not working for her, you're what? A professor? With the IRS? Customs? That program they do in England, *Antiques Roadshow*? What's my line? What is it worth to you, this painting?"

Fred said, "Since I haven't seen it, nothing. I can't find it, maybe it doesn't exist. I heard about it, I'm intrigued enough to spend a day in the back country. I want to look at it, learn the story of where it's been. I thought, since your name was mentioned, and God knows in Nashua there aren't a lot of people who would understand…"

"You got that right," Z said. "It's valuable or you wouldn't be here. I'll make this easy for you, Fred. If that's your name. And don't give me a card. Anyone can print cards. I don't know a thing about this painting." Z paused, gazing across the glass where his pale drink clicked its ice. He raised a hand, signaling to someone out of Fred's line of sight. "As long as you're buying. You?" Fred shook his head.

"Who else you got, besides me?" Z asked, as the woman arrived with a repeat of the same setup. She looked toward Fred, who shook her off.

"Dead end," Fred said. "The former students I mentioned, for some reason, won't talk. As far as they're concerned, they never saw it."

"They've got their own eco-niche," Z agreed. "And you won't tell me where they are. Cute." He arranged containers and ingredients. The process required his complete attention. When he was satisfied, "So," he said. "You're in the art business. Have a gallery? Work out of the trunk of your car? As long as we're here, as long as you're buying, tell me more about the picture you're chasing. To buy it, obviously. What else is there? Sell for a profit. So you buy it cheap, am I right? You married?"

Fred shook his head.

"The absolute butt hole of the known world," Z said. "Nashua. You know what I expected when I came here? From Hartford? Cows and chickens. Gorgeous leaves on the trees in the fall. Grandmothers making apple pies for everybody. The pot of gold. Turns out Nashua, New Hampshire is the absolute butt hole, pardon my French, *pot*hole of the world. That's how I have to talk to high school students. Thirty years ago with my life spread out in front of me like a gorgeous…me here for a job

I figured I'd move on from after three years, move up from high school to college, but that's not a route people follow."

Z reached a finger into his drink and stirred the ice. He sucked the finger. "They trap you," he said. "Don't listen to them. You married?"

Fred shook his head again.

"Every time," Z said. "Children?"

Fred shook his head again.

"That's one blessing," Z said. "Either she couldn't or she wouldn't or I couldn't. Whatever, we didn't. So, when she walked out she didn't take the precious burden with her and she didn't leave me with it, because there was no precious burden.

"The end of the marriage? I get home late. The note. Joint account empty. Savings. I'll tell you where to send my stuff, she says, but she never did. New York. You believe it?"

Z knew what he was doing with his booze. And he wasn't as good an actor as he hoped.

"Left me the mortgage and the house to sell she says, we'll divide that. I get the car free and clear, and the car payments as well. Now the car's impounded," Z continued. "You want to know my secret, the Moonglow, this home away from home? They're so happy to open the door for me? Enough about me. In case I can help. Tell me about the painting you're looking for, these kids found. That's the story? These kids found it?"

Fred said, "The hell of it is, I don't know much. Maybe you can visualize this. There's an egg, but it has two heads, legs like a chicken. Supposed to be painted on wood—but something like that can fool you. There should be lots of figures around it; animals, birds. Why I have to see it to know what it is. What looks like an old painting sometimes is a print on paper, glued to a board and varnished. You, with your background, know that."

Z drank impatiently and spluttered, "Tell me how you heard about this painting. That you say you haven't seen. What happened, Arthur drew it for you?"

"Something like that," Fred said. "Chewing the fat."

"And now you're interested. Sorry, can't help you. I'll ask around, see what I find out. There are people in town think they know about art. Don't waste your time. Give me your number. Tell you what. You know so much about that class, the class Arthur graduated with? Where's Arthur now? Tell me this. Where's Ruthie Hardin? Did you talk to Ruthie Hardin about this business? For your so-called article, whatever it is you are up to? What's her angle? Have you interviewed Ruthie Hardin?"

"Who?" Fred said.

"Ruthie Hardin. She was in Arthur's class. While we're at it, where *is* Arthur Schrecking?"

Fred shook his head. "I keep my sources confidential."

◇◇◇

When Fred left the building half an hour later Z angrily refused a ride home, instead signaling for a new drink.

Fred sat behind the wheel and did a quick inventory. What he had gained so far: There was or had been a painting, old, on wood, which two men in Nashua were familiar with. Kenzo Petersen, by the quality of his proclaimed disinterest, admitted his knowledge, as did Zagoriski, the art appreciation teacher from Hell. Neither, apparently, knew where the painting was. Or what it was. Though Kenzo's inadvertent mention of "another" art dealer in the mix, and Zagoriski's disingenuous denial of knowledge, combined with his self-pitying declaration of impending divorce, left interesting questions. If Z knew nothing about the painting, why did he immediately suspect his estranged wife when he had cottoned to Fred's interest?

What else had Fred learned? Arthur's original patronymic was Schrecking. The adopted alias, Pendragon, was for romance.

Zoltan Zagoriski would like to know how to find Ruthie Hardin, and did not know that she had changed her name. Fred had referred to her only as Kim.

The high school was closed up tight. Fred stopped in four diners before he found one whose phone book had not been ripped from its chain. No Hardins were left in town.

"Schrecking" gave him the address of a pocket-sized house on a street lined either side with pocket-sized houses stamped out by the same die and painted in similar peeling pastel colors. A rusting white van with the company name *Schrecking Electric "if it don't work we can fix it"* sat on blocks in the bib of dirt that set the house off from the road and from its neighbors.

A hefty man, shrugging into an undershirt in response to Fred's knock, answered Fred's question with almost commendable brevity. "I do not know where Arthur is, I do not care where Arthur is. Arthur moved out, I can't help you."

Chapter Twenty

The dress—would a woman call that a jumper?—was the same green one today, but she'd changed the shirt under it to a short-sleeved one of deep yellow. "Chrome," Fred said.

Molly looked up from the desk where she was standing. "I'm sorry?"

"That yellow," Fred said. "Chrome yellow turns up in a painting, you know the painting can't be older than 1797. Frenchman named Vauquelin discovered you could make paint with chrome, but it didn't catch on until the early nineteenth century. If someone tries to sell you a painting by Vermeer and the woman in it has a shirt like yours, chrome yellow, don't buy it. It's a fake."

"I'll remember," Molly said. "Given Vermeer was dead by, what, 1675? Fred, I picked up something for you. In case…"

Fred said, "This is going to seem off the wall. There's no chance your library is going to have it. By the time I got to thinking about it, it was too late and I was on the road back already. Can you get—no rush—do they do interlibrary loan between states? Without driving up there again, can I get copies of the yearbooks from Nashua's Central High School going back three, four, maybe five years?"

Molly said, "I'll look into it. What I picked up…"

"There's no chance the Boston Public Library would carry such a thing," Fred said. "Chances are, even in Nashua, nobody cares."

Molly said, "It might go quicker—Nashua's what, an hour and a half away? somebody's got to be working in the high school—the office, the library—that you could ask."

"Thanks. There are many things on my list ahead of a second trip to Nashua. To be truthful, I wanted…"

"It's a good thing since, if you didn't come in, what was I going to do with this?" Molly reached under the counter and fumbled, her eyes on Fred. "Walking over, with time to kill, I was browsing Out of Town News. My eye fell on…wait." She bent to peer under the counter and pulled out, "Today's *Nashua Sentinel.* They had the one."

Local Man in Hit and Run, blared the large headline.

"Gilly, your colleague's, still out sick?"

"Yes, but they have to give us a half hour for lunch," Molly said. "I can push it to forty-five minutes." She corrected for apparent eagerness. "I didn't mean…"

Large grainy photo of Mr. Z's square face and excessively styled exuberant white hair. The sub-headline: "Beloved teacher from Central High."

"What time?" Fred asked. "Tell me what you like. I'll get us a sandwich. We can eat by the river."

Molly reached the newspaper toward him. "I brought stuff in a sack," she said, "that nobody would want to eat."

"That doesn't disqualify you from picnicking. What time?"

Molly held out the newspaper. "Eleven forty-five?"

"Here? Or out front?" Fred took the paper. Quick scan of text. Z hadn't been the driver. He'd been killed. "If I bring chips will you accept one?"

"I'll fight for my share," Molly said. "The articles never tell you anything, beyond the name of the mayor and so forth, but sometimes you get local color from the advertisements. Meet me out front in that park. You'll recognize me by my chrome yellow shirt."

"I'll be carrying a copy of the *Nashua Sentinel,*" Fred said, "for which I owe you thirty-five cents."

"I'll take it out in chips."

◇◇◇

"Reckon we're all beloved once we're gone," Fred said, taking possession of a ragged wooden bench under a maple tree in the park where the assignation was scheduled. The newspaper article attempted to make up, with breathless brevity, for what it lacked in substance. Zagoriski, "known to generations of students as 'Mr. Z,'" had been hit by heavy moving machinery, hard enough to cause multiple trauma from which he had "expired" before help reached him, close to midnight, in a part of Nashua known for its historic mill buildings—an area that was not much frequented because it was presently being developed. Zagoriski was said to live alone. The photo was credited to Nashua Central High School archives. Someone from the paper had raised somebody over there. Beyond the "victim's" home address in an outskirt of Nashua that meant nothing to Fred, there was no further information.

"Merits thought," Fred said. "Any coincidence does."

This bit of Cambridge was an oasis. The shade of the park protected against the day's heat. Harvard University and its museums, which congregated toward the nearer corner of its campus, made a blockade not only against the river—whose nearby presence was not discernible except for occasional seagulls overhead—but against habitations. An institutional pall discouraged human propagation, despite the fact that the city's big public high school sat next to the library and shared the park. The high school, like Nashua Central, was open for business, with people of both student and faculty ages appearing from time to time. They moved between pools of shadow and sunlight in the same way as the birds did, but haunted by the proximity of large buildings whose presence discouraged liveliness.

"Coincidence, hell!" Fred said.

He worked his way through the newspaper as if preparing for a quiz. Issues of city sanitation, liquor licenses, an appeal for a large "water park" possibly in trouble, bond issue concerning the construction of a new elementary school to replace the one

damaged last fall by fire. Advertisement for an upcoming pan-cake breakfast at a Baptist church; a chicken fry at a VFW hall; so-and-so's used cars—in fact, so many so-and-so's used cars that the only way they all could possibly subsist was by selling used cars to one another. Insurance brokers. Magander's House of Rest, a funeral home. Hospital, car wash, seven pizza joints, and a dozen restaurants offering "something extra" in the way of romance. A retirement village, Bide-a-Wee, "Where Life Begins!" Get that one past the truth-in-advertising people.

Not much in the way of bookstores, but lots of movies, though they tended to stack up one on top of another, so that you could spend a week of entertainment without leaving a single complex. Move Magander's House of Rest into the same building, you'd never have to step out of the complex again until the mortal portion of you exited by way of the chimney in a bad puff of smoke.

"Did I stir something up?" Fred said. "Or was something already stirred up, and I stepped into it?

"Events do not conspire. Nor do they have a purpose, a reason, or a cause. I do not accept coincidence as a naturally occurring phenomenon. Hit and run. Small world. Zagoriski and a moving vehicle at the same place at the same time. Who'd have thought? Sure. Happens all the time. But events do not conspire. People do."

Granted, if Zagoriski had continued down the same road Fred had left him on in the early evening, by midnight he should have been pie-eyed. Well, so what? According to the scrap of phone call Fred had overheard, he was scheduled to meet someone.

Fred had put questions to him and Z had dodged away from them. When Fred had left him, Z had been well into dodging mode. Granted, his coordination might not have been at peak level to avoid a moving vehicle. Especially one that had taken aim.

"Not that it's any of my business," Fred said to himself, or to the birds, or the dusty shade under the maples, "and not that I care how that calculating fellow met his appointed destiny, not my business, but I notice that I assume that his death was

purposeful and malicious. My curiosity was piqued already. It remains piqued."

Was it part of his dodge, or had Z actually wanted to know where Ruthie Hardin was? Z hadn't known enough to ask the accompanying question, "*Who* is Ruthie Hardin now?" since Z appeared not to know of Ruthie's change of name.

"Which allows my curiosity a certain latitude," Fred decided. "Next thing I do, I talk to Ruthie, who has become Kim, administration at my hairstylist. That painting's somewhere. Next thing, I talk to Kim."

After lunch.

First things first. Fred turned his full attention to the prospect of luncheon on the grass with Molly Riley.

A painting is only a thing. It could wait. Although this one might not be his business, he was interested anyway—more so when a variety of people set out to hide it from him. Zagoriski, also not his business, beyond the fact that he had been a fellow human, would not become any less defunct, nor any closer to being Fred's business, if Fred took time for lunch with Molly.

And he faced a serious test in which he would prefer to earn a passing grade. By his own act, he had condemned himself to choosing the chips.

Chapter Twenty-one

Across the street from the park, the Broadway Supermarket offered a depressingly large variety. How make the choice? How define the overriding tactic?

Dismiss, at the starting line, the mischievous temptation to buy two little bags, perhaps even two brands, and offer Molly a choice. Such a move would declare Fred to be indecisive, ungenerous, and spendthrift: worse, too dull-witted to take a hint. It might suggest that he was not inclined to share, or declare that Fred suspected that Molly herself was greedy and indecisive, pretending to want not some, but all of a pack.

Her proposition had introduced the possibility of shared intimacy. Hold on to that. One bag, one serving, to share.

Next question. Baked or fried?

A baked potato chip is an abomination, a hypocrisy, proof of the persistence of the delusion that one can have one's cake and eat it. The only excuse for a baked chip is to allow the client to pretend that there is no caloric consequence. Worse, sometimes they hold the salt.

What did Fred know about Molly? Damned near nothing. As far as her own prospective lunch was concerned, all he knew about that was what she'd said: that she had "brought stuff in a sack" that "nobody would want to eat." That could mean leftover macaroni-and-cheese from last night, or a ritual penance of carrot sticks and yoghurt, because she was critical of her mass.

Suppose she was, like many women in the West who are not suffering from immediate poverty, slimming?

Well, what if she was?

Offer a baked fry, he'd suggest the condemnation, "You're too fat." Nothing Fred might ever say afterwards would make up for the implied insult. The fact that he found her delicious—not his business—would not come up. How could it? It would be offensive to signal his appreciation of her physical presence. Not gallant. In fact, obnoxious. Let that be assumed, not stated or implied.

Whatever chip he selected would be, more than a signal of his reading of his luncheon partner, a self-portrait. By their chips shall you know them. Molly would appreciate genuine flavor. Her eyes had lit up at the prospect of chips. Nobody's eyes light up at the prospect of *baked* chips. Her mouth wanted sparkle, crunch, and flavor. That meant fat and salt.

No dodges and no frills.

Lurking somewhere out of sight and out of hearing, exactly where he could not find them, were lines that obliquely justified his choice: *I have no cunning in protestation...these fellows of infinite tongue, that can rhyme themselves into ladies' favors, they do always reason themselves out again. What! A speaker is but a prater; a rhyme is but a ballad...*

"A plain man carries a simple chip," would be Fred's motto. He found a bag of Cape Cod chips and caused the deli counter to slap together a turkey sandwich that was less healthily pretentious than what the sandwichista had in mind.

Next question: wine?

"You're kidding, right? She's going back to work, she's got at most forty-five minutes, I might as well turn up in a stretch limo while I'm at it, carrying a hundred long-stemmed roses."

Fred stepped into the Starbucks next door and purchased two black coffees and a handful of fixings.

◇◇◇

"Three blocks, there's grass," Molly said, meeting him five minutes late.

"We'll sit on your paper in case it's…well, more like five. Maybe six blocks. I'll grab coffee on the way."

Fred held up his paper Starbuck's bag.

Molly said, "As long as it's not iced." Fred shook his head. He hadn't thought of ice on this hot day. Well, good. That was a piece of luck.

Molly started walking, fast, in the direction of the river. The capacious black bag she carried over her shoulder did not even try to be leather. It was hard cloth, waterproof, and closed with a fat zip and a clasp that did not pretend to be a brand name logo. "Most of the time it's dull enough," Molly said.

"Weather so nice, you expect more people on the street," Fred said.

"This part of town, they've gone home to Omaha," Molly said, "If it's students, which is most of who lives nearby. Or if they're local, families, getting older now, they're already in Nantucket."

"What's dull?"

Molly dodged in front of a bus it might have been more prudent to dodge behind, and Fred stuck with her.

"What people want," Molly said. "In general. More of the obvious."

"At the reference desk," Fred guessed. "In the big world, what people want could be your money or your life."

"Which can also be dull," Molly said. "If it gets repetitive."

In five minutes they reached the grassy margin between the river and the big roadway that had been named Memorial Drive in honor of someone whose identity was concealed by this one-size-fits-all monument with cars on it. Molly took Fred's paper from under his arm, opened and dismantled it and spread doubled pages out across a shady patch of grass under what might prove to be a cherry tree.

"Unless you'd rather a bench," she said. "But lined up side by side like that, with the traffic behind you, you can't spread out and besides, it feels like church, and you're in the sun. The sun isn't my friend. You mind?"

Molly had made an island five feet square. Fred slipped off his loafers and sat on a corner of it, choosing a half-page ad for Smylie's Used Trucks and Equipment. *Cheap and Dependable. Folks keep coming back. Try us, even if you didn't think you want a truck.* Fred said, "It's perfect, as long as I don't get mayo on an article I want to read."

Chapter Twenty-two

Molly knelt and lowered herself with graceful frankness to the sitting position forced on women by their skirts. "Coffee," she demanded. "The river runs right to left," she observed, as Fred laid out the contents of the Starbucks bag.

"Or, you could say, downhill," Fred said.

"What I was going to remark," Molly said, "this prejudice I have, caused by the amount of reading I do, or have to do, or would do anyway—I see anything moving in a line, maybe it's traffic, or the river, my intuition is to expect it to go left to right, like the words on the page."

"Except the words don't move," Fred said. "You do. Your eyes do. Left to right. If you're from the West." Molly opened two packets and poured sugar into her coffee, disregarding the pink envelopes of the substitute brand Starbucks had a deal with. She paid no attention to the containers of cream. She stirred. "And stirring's clockwise. At least in the northern hemisphere."

"If you're right-handed," Fred pointed out. He hauled out his sandwich and the chips, tore the bag open and spread its mouth invitingly toward his companion.

Molly unzipped her bag and rooted in it, pulling out a waxed sandwich bag that held a half sandwich on dark bread, and another bag in which were carrot and celery sticks, along with half moons of red and green pepper. "Tuna," Molly said. She reached for a chip and ate it, musing, "I noticed today, I was preoccupied, the way we train our children, so much time

in school, eyes on the page, left-right, top to bottom, at least for me, I think I got an instinct trained into me that substitutes such a learned behavior, the pattern that we get from reading, for real observation of natural law." She ate another chip.

Zagoriski's body was cooling on a slab in Nashua, New Hampshire.

The river was active with small boats, shells, and canoes. This bank was filled with people picnicking, reading, sunning. Though there were a few couples, most were solitary. A young woman careened past them on a bicycle, narrowly missing Molly's edge of the newspaper island. She chose a spot in the sun glare, laid the bike on its side, pulled a yellow towel out of a knapsack that she shrugged off in almost the same motion that relieved her of the short orange dress, leaving her in a green bikini bottom. She lay on her front to bake.

"Thus we refute Afghanistan," Molly said. "She's probably got half an hour, like me. Doesn't want to waste any of it. Speaking of natural law, and law, and the question whether law and nature ever belong in the same sentence. Well, my question anyway."

Fred said, "Stepping off the sidewalk in London, you're much worse off."

Molly paused a moment before shaking her head. "I've fallen off somehow," she said.

"If your instinct is to expect traffic from the left," Fred said. "Like words on the page. London traffic is ready to do you in. Also Ireland, Japan. You're in trouble."

Molly pulled the half sandwich from its wrapper, pried it open and inserted five chips, closed it, said, "Feel free," slipping the bag of cut vegetables in his direction. "How was Nashua?"

"In real estate terms," Fred said, unwrapping his sandwich, "I would describe it as *in process*. Kind of a wasteland. I kept thinking of an old friend of mine. Much older man. Dead long since. Professor of classics finally, though he'd done other things. He'd been in what he called 'The War.' January '44, with the 143rd Regiment of the II corps, 36th Division, crossing the

Rapido south of Monte Casino, and so on, in that assault. You're sure?" Molly's nod gave him additional permission to raid her vegetables. "The whole area was already blasted apart by the Germans, then blasted again by Allied bombs, then blasted by both sides during the assault. He told me, all he could think, for days, looking out across this wreck of phenomenal land-scape—he couldn't get out of his head the music, Bach's *Sheep May Safely Graze*. Hell, there probably were sheep there—I never asked him—nonbelligerent sheep, poking around in what was left, trying to pick up a meal."

"Not much in the way of fences to prevent them," Molly said. "Not after all that. Paradise in a way. Until they stepped wrong and blew up. Your business went OK, then. In Nashua. Or, since you're talking about all this wreckage, maybe not so much?"

Fred said, "I'm about where I started, I guess. Maybe a step or two back. I don't think I'm making progress."

Molly said, "My job, do you know how we measure progress?"

Two boys with a Frisbee started working through the crowd, using the sedentary people on the bank as interesting obstacles, shouting and laughing.

Fred said, "Aside from the paycheck, whatever you have that sounds like tenure, the retirement points, all that?"

"All that aside," Molly said, shaking her head. She turned the mouth of the bag of chips toward Fred and shoved it gently toward him.

Fred said, "Aside from finding what you're looking for? I guess I don't. How do you measure progress?"

"I'm supposed to recommend something," Molly said. "For the efficiency people. It sure beats me. What I think. Or what I wonder. Does certain music wear a channel in your brain, which your thoughts and observations are happy to fall into as they come, like reading left to right and top to bottom?"

Fred said, "Now maybe I've fallen off."

"Your friend. Standing in all that dangerous ruin, and haunted by the Bach music that is almost a guarantee of eternal peace."

"Peace with menaces," Fred said.

They went without speaking for a short while. Fred worked at his sandwich. Molly had made short work of hers and now dawdled over the chips and vegetables.

"Sometimes," Molly said, "I amuse myself by trying to figure out the trajectory from A to B."

"Can a straight line be a trajectory?"

"It's seldom a straight line. If, let's say, I were plotting out a work of fiction, and Point A was the question 'How much was the *Mona Lisa* worth in today's money, back in fifteen whatever,' and point B was a handful of yearbooks from Nashua, New Hampshire's, Central High School, and I had to make a coherent route between them…"

"Or figure out point C," Fred said. "Because if there's a credible direction, it has to carry past point B, doesn't it? Most of us, even when we die, we at least thought we were on our way to somewhere else. Something else. And when you add to that the problem you raise, of measuring progress…"

Molly said, "Meaning that anything eternal is menacing?"

Fred started, "I'm not…"

"Your phrase, *peace with menaces*. It's a good phrase, I guess. But I don't like it. It's cynical. It's…bitter."

It had been Molly, though, who brought up the image of sheep browsing the blasted pastures below the ruins of the monastery, and blowing up. But her vision was direct and natural. It was tragic. What Fred had said was arch, facile, and cute in an ugly way, where cuteness was not called for.

Fred said, "It's true. I'm sorry, on this pretty day." He took a chip.

Molly said, "I think I ate them all."

"Not until you get to the crumbs and salt inside the greasy envelope," Fred said. "Please do the honors. I had what I wanted. I ate most of your vegetables. I forget about…Have you eaten enough to stay alive till supper?"

"Most of us sheep are only doing what we can," Molly said. "The best we can." She was still angry. "Sheep have to eat. And there would have been lambs. At least, before…"

She picked up the empty package and fished inside it with a licked finger. Fished again, enjoying. Her eyes flashed.

Chapter Twenty-three

"My friend never got over it," Fred said.

Molly licked a last crumb from an index finger. "I shouldn't have said bitter, maybe unhappy," she said. "Gilly's out. I have to get back." When she stood her shoulder bag tipped and knocked against Fred's cup, spilling coffee across the paper. Fred, rising to keep her company, stooped to attend to the puddle. He'd need the paper.

He snatched paper napkins out of the Starbucks bag and began mopping.

"That won't do it," Molly said. She reached into her shoulder bag and handed Fred a little T-shirt—red. A Red Sox shirt, very small. "Go ahead," Molly said. "It'll wash out. Then spread the paper in the sun. This heat, it'll dry in five minutes." Impatient, she took the little shirt out of Fred's hand and blotted at the paper. "There."

"There's a lamb," Fred said. "I'm slow and stupid, Molly. Not wanting to be rude, I didn't ask."

"Not lamb. Not a lamb, singular. The shirt is Terry's. She'll be seven in the fall. Sam's ten." Molly wrung out the shirt and draped it across her shoulder bag. "Your papers will blow away if you don't watch them. I'll get back to work on my own."

"The sun will follow us," Fred said, starting to gather the wet newspaper's leaves together. "I wouldn't care except—page one took me by surprise. This is point C." He held out the photo of Mr. Z. "A guy I talked with yesterday."

"Killed," Molly said.

"One of the sheep," Fred said. "Or maybe. I don't know. Maybe in sheep's clothing. I have to look into it. If only as an interested citizen. Tell me about your children. We have six blocks."

Molly had already started walking as if assuming solitude. "You're married?"

"Never. No wife. No children, to my regret."

"Take a block, give me the story of your life," Molly said.

"Born in the Midwest in a state that starts with I. For some people that leaves out Ohio. Attended Harvard for six weeks. That makes me an alumnus when they can find me. Did things for our government here and there in the world that would get me jailed if I disclose, and I grant you, some of the things I did, or saw, or failed to do, left a bitter taste. You kindly allowed the word 'unhappy' as a dodge though a man doesn't like to be called unhappy since it sounds weak. I have a house in Charlestown that I share with other people, men, mostly in transit, some not easy company. Got blown away by art when I was a student, and my present occupation is working for and with a collector in Boston. I have what passes for a car. What I don't have, and it's a failing in this culture, is the profit instinct."

He hadn't managed to exhaust a block, but there was no more to say. Molly walked on in silence. As they crossed a street she observed, "You're a curator or art researcher, then. Sort of in wolf's clothing, if I may make a personal comment. As an alumnus of Harvard, you are permitted to use their libraries for a laughably small fee. Harvard's Widener, or the Fine Art Library..."

"I have my card," Fred said.

"Harvard's got much, much more in every way than anything we have at Cambridge Public." She looked sideways at him. Fred refused the bait, leaving the ball in Molly's court.

"My block," Molly said. "Terry finished first grade. As far as she's concerned, she's literate. She's tough and gregarious. I sent the two of them to a summer camp in Cleveland. My sister's out there. She's a ditz with a good heart, but enough on the ball

to visit them weekends or save them if they need saving. Sam's more likely to need saving than Terry is."

"Their dad?" Fred prompted.

"Decamped. We grew up in Cambridge, Ophelia and I. My mom still has her house here, the other side of Harvard Square, which I use as my official home address given the present requirements of the Cambridge City Council. It'll blow over but for the moment it is prudent for people hired by the city to show home addresses here. I have a house with a little garden and a big mortgage in Arlington. The package fell to me in the divorce settlement."

"That's a lot to walk away from," Fred said. "Not meaning you. I'm clumsy, don't want to trip over suggestive compliments. I mean, the children. Every morning I'd feel, if I did that, as if I was walking away from them again. No judgment, I don't know the guy, and if he was yours…he had to be…has to be…A grown woman—people go their own ways. I know that. If it were me, though. The children? It would make a hole in my heart. I've done some hard things, but I don't know if I could do that."

They were walking briskly enough that no pedestrians were liable either to pass them or to keep up. But fragments of their conversation must intrude on pedestrians coming in the opposite direction.

Molly said, "Men I bump into, or that my friends introduce me to, who aren't married, and or who don't have children, we get down the road a certain distance—candles, wine, an entrée I could have made for a third as much, and besides I'm paying the sitter—it never fails, they reach across the table to hold my hands in the crumbs, look into my eyes, their eyes liquefy, and they say, manly as pie, 'I could never take responsibility for bringing a child into a world like this.'"

Fred held his peace.

Molly said, "Men have been using that line against women since the Cro-Magnons."

"What's 'Terry' short for, Teresa?" Fred asked. "Sorry, I got distracted."

"Terry's the long and the short for Terry," Molly said. "Believe me, it's all she needs." They'd come to the big crossing of Massachusetts Avenue at the Trowbridge traffic circle, where vehicles were inclined to show considerable and chaotic determination. "I didn't see the man's name exactly. Zagriski? The man in the paper. He's connected to the *Mona Lisa* question?"

Fred said, "That question was left over from an earlier project. Never anything I had to know, I'm—not only curious. I'm in fact genuinely pissed off when some historian or art historian announces, 'This house or horse or barrel of lard in 1487 was sold for a mere forty pilasters.'" He doesn't know and you can't judge what else you might have been able to buy for the same money, so he hasn't told you a thing beyond he happened to see a reference that, when he cites it, makes him look, because he has a number, as if he knows something you don't. It's not research. It's one-upmanship. It's prancing and preening. It's…"

"Did you try Braudel?" Molly asked.

Fred stopped short. "Who?"

"I've gotta get back to my desk. Fernand Braudel. Three volumes. *Civilization and Capitalism, 15th – 18th Century.* You can get into Widener? That's where I was going to look, but I haven't had time to get over there."

Fred said, "That's nice of you. Above and beyond. I'm not even a resident of Cambridge."

"I get interested too," Molly said. "I'm sorry about your friend."

"My friend? Oh, Zagoriski. I never met him before yesterday and I can't say I liked him. Don't mean to be callous. On the other hand, I can't claim any loss."

"That's good," Molly said. "Try Braudel. I don't know when I'll get a chance although, with the kids away, I have free time, especially when I stay at Mom's. I do her mail and her plants. I meant to get to Widener. They allow me through the gate as a fellow librarian. But I don't know when—Mom's traveling. This is me." They'd reached the library's entrance. "Sorry what I did to your paper. Give it five minutes' sun. I enjoyed…"

She didn't finish the thought.

"I did too," Fred said. "I'll try Braudel. If you write the reference I'll pick it up next time I come by? Right now I have to figure my approach to point D. May I come by again?"

Molly's smile made the sun pale.

Chapter Twenty-four

"Kim's at lunch," Fred was told by a middle-aged male stylist from whom the scent of powder wafted across the intervening fifteen feet of space. The man was working on a customer, as was Claire, Fred's operative of two days ago. She looked at him with a blank recognition that could be either recognition or blankness or both at once.

Fred had stopped at the empty Welcome podium at CUT - RATE - CUTS to ask the shop, since she was not visible, "Is Kim around?"

"I'll wait or come back," Fred said. "Unless you know where I can find her?"

"She mentioned Grendel's Den," Claire said. Her customer was so concealed under drapes that he or she might be expecting surgery or childbirth. "They do a salad," Claire said. "Grendel's Den. It's a place, it's around, you go…"

"I know Grendel's Den," Fred said.

The man said, "You don't find her, we'll tell her…a message…"

"If I don't run into her this time, I'll catch up later. It's not important."

◇◇◇

Grendel's was enough of the place to be this lunchtime that a line was backed up on the sidewalk next to the dirty little park the city maintained on the corner lot next to it. Fred told the hostess,

"I'm meeting someone," and strode past. Kim's white-blonde hair was easily spotted across the crowded area in the central dining chamber. She was holding her own at a small round table most of which was occupied by a confabulation of vegetation that replaced nourishment with colorful fiber. Against that Kim was pitting what looked to be a no-nonsense chocolate milkshake.

"Is this seat taken, Kim?" Fred asked, sitting in the uncomfortable café chair across from her. Kim looked up from her meal with practiced outrage and interest. The flutter of concern she made provoked the attention of a waiter.

"Coffee," Fred instructed. "And bring me the lady's bill, when she's ready. If you don't mind," he added to Kim. Kim's mouth had been hanging open until she closed it, looking severe and discouraging, but curious.

"Something about you," she said hesitantly. "I almost recognize…" She was startled by this large man's intrusion, wary, but not, apparently, feeling vulnerable in so public a place. She reached her fork into her salad and speared a slice of beet. She was pretty enough that she had to have learned long since how to fend off unwanted advances.

Fred said, "Background check."

She stared at him, the pink coloring of her face flickering as if it might sink away.

"Tippy Artoonian," Fred continued.

Denial struggled against Kim's lips, but did not pass them while she was thinking. If she had hoped to be in hiding, this close to her home town, and relying only on a change of name to conceal her, she had to be struggling to confront the fact that she'd been found, and also that her discovery was only tangential to this large stranger's purpose. But there was no reason to assume that she thought she was in hiding. All Fred knew was that she was presently going by a name she preferred to the one she had been known by in Nashua.

She temporized. "Tippy Artoonian," she said, as if the syllables were familiar, but in a different arrangement. Fred waited while her attention shifted to a deep swig from the milkshake.

"You don't use Ruthie Hardin any more," Fred said. "I understand. We're asking around, people who know Ms. Artoonian."

"What did she do? Or, no. She wants to borrow money, like that?" Kim asked. She was shaking her head, perhaps involuntarily. She added, "Rent an apartment? Credit check? I'm not saying...She gave me as a reference? Tippy? Tippy wouldn't..."

Fred said, "We have to keep this confidential. I'm sorry to interrupt your lunch." He paused significantly while the waiter clicked his coffee onto the table and left them alone again. "I didn't want to bother you at work."

"Or, no. What's Tippy done?" Kim asked, her curiosity tardily getting the better of her caution. At the same time she continued to stare at Fred, half canny, half bewildered.

"Normal background check. She's not accused of anything. Another name," Fred said. "Zoltan Zagoriski."

"That son of a bitch," Kim exclaimed, pushing her chair back. Their neighbors looked toward them. "What are you...?"

"Let's keep our voices down, OK?" Fred said.

"A thing of beauty is a joy forever, for a few weeks," Kim said, gazing bitterly across the room. "Him, I can't help you. I haven't seen..."

"I don't want to upset you. Maybe you hadn't heard." Fred laid this morning's *Nashua Sentinel* face up next to Kim's colorful salad.

Kim's face went pale as ash. She said, "I know you from somewhere. Where do I know you from?"

She reached over and took the paper from him, turned it around, staring at the photograph and the headline. "Who did he kill?" she asked then, before she took the time to set her interpretation straight, reading the sub-head and skimming the article. "Mr. Z," she said. She worried at the salad with her fork. "Poor Mr. Z." She looked up and across at Fred now, squinting, allowing her features to settle into an expression both cheap and canny. "Who are you with again? It doesn't matter. Tippy," she said. "It's not like I ever saw her after graduation. Never did trust her. Where do I know you from? Do I know you? What's your name?"

"Fred."

"No. That's not it." She took a big bite of her salad and chewed it, regaining her composure and letting the color rise to her cheeks again. "First thing I heard, I mean, when I see the headline, *Local Man in Hit and Run,* I figured Z must have run over somebody. But you could never catch him with a bottle. In class, in the hallway. That hair. Mr. Perfect. Double Z. An accident, the way he drinks. What else? So everyone thinks Tippy…?"

She was wearing a long-sleeved shirt of thin white fabric that barely allowed you to see, if you knew to look for it, the decorations swirling on the skin of her arms and upper chest, above the opacity caused by the T-shirt underneath. The shop she worked for probably had a policy against the aggressive display of body modifications and décor.

"So they want to talk to her since I heard she finally moved in with him," Kim asked finally. "Tippy. Is that what this is about? Who are you, cops?"

Fred said, "Let's change the subject. I'm going to repeat something I heard the other day, see if it means anything to you. I think I can get it exactly. 'But then I saw what he had kicking around there, like a dirty old wooden painting, and he and I fell in love at the same time. With the idea.'"

Kim gaped at him.

"The dirty old wooden painting interests me."

"Shit. You're that guy," Kim said.

"Tippy might be part of the story," Fred said.

"The guy there when I was practically taking off my shirt. Claire said after you left, 'That guy can have your job, he wants to, showing your skin, your tats, showing your, practically, your tits.' Mister, I'm sorry." She'd had the presence of mind to let her voice drop by the end of her protest, almost to a whisper. The whisper, if anything, caused greater interest from their neighbors than voices raised in outrage might have.

"You could get me in big trouble," Kim said. "And I'm already…the thing is…there's the big windows and everything.

And we got talking. What do you really want? And don't think, because you…"

Fred said, "I'm not here to hurt you. I'm not here to push you around either, though you must feel like that's what I'm doing. Sorry about that. I think you could help. What we could do—I bet these folks wouldn't mind freeing up a table—let's ask them to package the rest of your lunch to go, we'll take it outside, maybe find a bench, talk where we can be more private. I've muscled in and interrupted your lunch. The least I can do is pay."

"No strings?" Kim demanded, waving toward their waiter.

◇◇◇

They claimed a bench from a bunch of sparrows and pigeons who were sharing the remains of someone's boxed lunch as gracefully as Serbs and Croats. Kim had exchanged her metal fork for a plastic one. She set to work again, checking her watch nervously and talking through the vegetation.

"Listen, the thing is—Fred?—that's your name?…management, when you apply for a job, they can't make you, like, strip. But they ask do you have, like, tattoos, and that? Piercings? And of course I said, wanting the job, no. Because the reason they would ask, you figure out—the only reason they would ask, is if you say 'Yes, I do,' they say, 'We're not interested.' Go fish. Not my favorite game since I turned six. So you haveta lie. They make you. Then the lie's down on their form, they keep the form somewhere, central office wherever it is, forever. It's a chain? I think Tampa? If they like you, you want to move, say, Phoenix, you build up seniority one place, CUT - RATE - CUTS here in Cambridge, they call ahead. Say, Phoenix. One of our people is moving there, see what you can find for her. Hair. Facials. Massage. Pedicures, nails. Receptionist. It depends where in the country. New England the women don't. Other places where most of the year your feet are out in the weather. Like in the Southwest, since I plan to move west. It's my dream. I get the money together."

It was as if, for her, talking was as efficient a way of getting food started along the alimentary canal, as chewing was for other

people. A time-saver. Even though talking had not become for her an efficient way to process ideas.

Kim said, "So if anyone was to tell them…."

Fred said, "It isn't fair to you. We both know I am in a position to hurt you. It isn't fair that it looks as if I could force you to do something by making you afraid that I could cost you your job. Hell, it isn't even fair that I'm bigger than you."

"Then here you come out of the bushes with Tippy Artoonian, out of the blue, I never even saw you before that one time…and this terrible…newspaper. Mr. Z. It happened last night? It's a shock. I have to get back!"

Grendel's had transferred her milkshake to a cardboard cup from which she drank before making a decision. "Listen, whatever you want, whoever you are, whatever you think you know, you're wrong. It's not like that. Before you do anything, listen, I'm not off till four."

"I'll meet you at the shop," Fred said.

Chapter Twenty-five

"Claire's coming too," Kim announced defiantly, joining Fred on the hot sidewalk at four-fifteen. "She's finishing up. Old lady, can't make up her mind what she wants, like getting your hair cut is a entertainment. Some people."

"Fine," Fred said.

"What I've been thinking." Kim had a large green cloth bag she carried over her shoulder. She was wearing long white slacks and sandals. "We'll go to my place. As long as Claire is with us."

"Fine," Fred said.

"Whatever you want," Kim said, "you're not law, to start. Claire's my friend. She's going to stick around. Don't try anything. You got that?"

"Fine," Fred said.

"As long as that's clear."

"You got it," Fred said. "Whatever you want."

"Show me that paper again."

Fred handed the *Nashua Sentinel* over. If anything, Zagoriski looked worse than he had that morning. Coffee will do that, and being picnicked on, and riding around under a person's arm on a hot day. Kim studied the photograph and what there was of the article, her lips moving, while pedestrians pushed past. An elderly woman came out of the shop looking as if she had made seven kinds of mistake at the same time, all of them applied to what was left of the pinkish hair curled limply against her scalp.

"Next week, then, Mrs. Glamerty." Kim gave the woman a practiced smile.

"Of course, dear. Heidi will be back as usual?"

"That's a promise."

"I don't like the other girl. She doesn't make up my mind."

"Heidi will be here," Kim promised, moving to tuck Fred's newspaper into her bag.

"I'll keep the paper." Fred reached to take it back.

Claire emerged from the shop. She gave Fred a healthy glare and said nothing. She was coming along as the heavy.

"I'm not far," Kim said. "I lucked into a place. Sublet. Hot, but it's cheap. I take care of the cat. Plants. The guy...one the advantages...Cut - Rate - Cuts...people all the time...you hear...and then the next guy...and, but we're unisex, you don't want to pay women's prices. You'd never find, place like this... afford..."

She walked them briskly, babbling along as if, for her, talking were also a form of locomotion. Their direction was parallel to the river but not in sight of it until they came to a large three-decker in indifferent shape on Mount Auburn Street, in an area that was dominated by the hospital.

"He's a investment lawyer or like that, is what I think." Kim keyed open the heavy front door. "Or financier-type mogul. He has money but he doesn't *have* anything. Wait while I punch in the code." She stepped into the hallway leaving Fred in the company of a vigilant Claire. Claire, minus the shop's regulation pink long-sleeved smock, was dressed for the weather in a thin red skirt that ended above the knees, and a pink cotton shirt that buttoned tightly across a minimal foundation garment.

They climbed to the third floor, Fred following Kim, and Claire, alert as Nemesis, keeping the rear. Kim said, "The jerk, there's another box for the apartment also, you have to punch in. Which is a pain in the ass, except it's the same code. The guy's birthday. Weiner. Ernest Weiner. Wait while I do it." She concealed the panel with her body while she punched numbers

and, on the mouse-like signal, keyed that door open and eased in, saying, "The cat. Give me a minute."

"Man has a cat," Claire said, "I say forget it."

Kim reappeared, holding firmly a cat that exhibited more long white hair than Zagoriski had owned, though with less lacquer. It struggled to make a break through the open doorway. The apartment, under the building's flat roof, was very warm.

"Cheap bastard says, 'Use the air conditioning all you want. You pay the electric.' Ernest Whiner I call him. Sit down. I gotta…" Kim dropped the cat, motioned toward a bleak living room into which a good deal of money had been thrown in the form of matching gray armchairs, similar things on the wall, a couch, and a setup where you could simultaneously watch television and listen to music and mix a drink—all oversized—before windows that overlooked the river. The cat surveyed the available personnel, made a decision, and went to lie under the couch. "I'm going to change," Kim said, and wandered away again.

"He's in Hong Kong," Claire said. "Kim lucks into stuff. Like she lucked into you, if you can call that luck. If it's true you randomly happened in. Which Kim doesn't…" Claire took over the couch, putting her back to the river and the daylight. "My experience, a single man with a cat, you can't get more single than a single man with a cat. I told Kim, forget it."

Fred said, "You live nearby?"

Claire arranged her bag at her feet. She wore white sneakers, like a nurse. She did not respond.

"Let's open a window," Fred suggested. "It must be eighty-five degrees in here."

Claire shook her head. "Fucking cat," she said. "Claws the screens."

"Open them at the top," Fred said.

"Fucking cat jumps up there," Claire said. "We tried that."

"Maybe an inch?"

"Leave it," Claire said.

When Kim came in she was Hieronymus Bosch all over. She'd thrown off the fetters, the nunly purdah of her working day, and

was mostly clothed in tattoos: arms, legs, belly, upper chest, and what could be seen of the back on the areas not covered by the bright green halter top. She wore short denim cut-offs low on the hips and high on the thighs. The swirls of intricate color reached from under the shorts almost to the ankles—she was barefoot. The designs reached around her arms, down to the wrists. Color was missing on the arms and torso, front and back, the whole upper body in fact, where Arthur still had significant tracts of vacant skin waiting for decoration. But there was no possible doubt now, none at all.

If you insisted on thinking about it in these terms, this girl was wearing evidence of a lost painting that should be worth millions.

Fred had taken the time to study. Nobody else could have painted them. These figures all must come from a painting by Hieronymus Bosch—and it wasn't a painting anybody in the art world knew or had published. There weren't that many known paintings by Hieronymus Bosch, and Fred had studied them all.

What Kim was walking around in—she a work in progress— was an unknown version of Bosch's best-known painting, the Prado triptych known as *The Garden of Earthly Delights.*

Not that Fred cared about money—but he did take notice. In today's market, if you had control of a credible original painting by Hieronymus Bosch, even a small one, you could count on selling the thing, if you wanted to sell it, for five million dollars at the least. If the provenance was solid, a good deal more. Museums would fight against each other for it, as would the dealers and the big collectors, some of whom would bid either for or against the same museums whose boards they served on. These silly children—to look at the situation from the financial point of view, they were playing with fire.

"I've been thinking, Fred," Kim said. "And what I want to know is, you sneaking around, and everything you said, one minute it's Tippy Artoonian, but you couldn't care less about that skank, who could? And then that terrible newspaper, and

you're not the cops, and the rest of it, and I've been thinking, and what I want to know is, what in the fuck do you want?

"And also, no. You are not gonna get a drink, and we are not gonna smoke a joint, so don't ask.

"Next question, and I decided: What in the fuck do you want?"

"And say it straight, no tricks," Claire chimed in.

Fred had chosen one of the oversized chairs. Kim sat at the other end of the couch, with Claire. Its rich gray cover set off the early sixteenth-century colors on her legs. The painting itself might be dirty, but Arthur had found a way to compensate, rendering the colors as clear and fresh as they would have been five hundred years ago, when Bosch painted the original. What looked like a *Judgment of Paris* on the top of her left thigh, three naked goddesses standing, impatient, demure, all outlined but tinted with the coloring of Kim's own skin. They were set off, not by the Trojan prince whose job had been to choose among them, but rather by a fourth woman, also naked, but clad in a rich black skin. She held—what was it? A fish? A small bird? Not the prize golden apple, anyway. The figures were about six inches high, clean, clear, with a suggestion of bright green grass around their feet. Enough green to capitalize on Kim's own coloring. Arthur was a genius, or certainly Bosch was a genius.

Fred said, "There's too much happening at once. I can see that."

"And don't tell me it's a coincidence, either," Kim said.

Arthur had been careful. Everything on the legs—the thighs, calves and knees—at least what appeared while Kim was seated—had been drawn in appropriate scale. Baboons dancing in a ring; a fish blowing a trumpet; birds; was that a camel?

"When I saw Zagoriski," Fred said, "he mentioned that he wondered where you were. When I say *you*, who he asked after was Ruthie Hardin. I didn't tell him."

Chapter Twenty-six

"Him and I," Kim said, "We never had…"

"Who is Ruthie Hardin?" Claire demanded. "Slow down. Kim, you don't have to tell this guy anything. He can't make you…"

On the right calf—Kim crossed her leg to rest the right ankle on her knee—a stout little man bent forward to allow a cloud of birds and flowers to exit his anus. Next to him a glass jar held enormous beetles copulating while devouring coins.

"Ruthie used to be my name," Kim said. "Fred, that was you in the shop two days ago. Claire recognized you. Start there. How come?"

Fred said, "I don't believe in coincidences either. Kim, you and I are on the same page there. I also don't accept destiny as an explanation. So I can't tell you. I don't know how come. I needed a haircut is the answer, but given everything afterwards, the answer isn't good now."

Above the right knee a dark, turbulent pond extended around the cylinder of compact muscle. Its banks crawled with lizards. Fish looked out of it. A boy swam upside down, or else was drowning there, his legs poking upwards in a V shape.

Claire said, "This is going to sound like my mother. Your answer isn't satisfactory."

Fred said, "So we all three agree. I'll tell my story. It isn't satisfactory, but it's where I have to start. Maybe it only seems like a coincidence because of how things went. I noticed it had been too long. So I stopped into Cut - Rate - Cuts."

"Shouldn't let it go more than a month," Claire scolded.

"Two days ago," Fred continued. "Here's something about me. I love paintings. Whenever there's a painting to look at, that's what I'm going to look at. Not the crap in this guy's house. That's mechanical decoration that's more or less an extension of the rugs and window treatments. Claire was working, nobody was in the shop, everything quiet, I had become an ugly part of the furniture. Kim was talking. For me, with the mirror there, and the two of you having your conversation, it was like being at the movies. It must be like that for you, too. You're what the real thing is, and your conversation goes on all day. These other folks, the clients, me, we come and go like the shadows of clouds on a windy day. Who notices? Who remembers?

"Kim mentioned she's working with an artist, and I happened to see—no offense, there it was on the mirror in front of me—some art I liked she was showing you, Claire, that she was wearing. The tattoos. When she said, about the artist, that he's working from a dirty old wooden painting, and since I like paintings, and I like the way those figures are drawn—I hope this doesn't feel like an invasion of privacy."

"I'm proud of my tats," Kim said. "They are a big effing investment. Money and time and itching. So all right. So fine. Where does big Tippy Artoonian come into it, and the rest of it?"

"And he hasn't said what he wants," Claire said. "I am listening to hear him say what he wants."

"I want to see that dirty old wooden painting," Fred said.

"And then what?" Kim said.

"Spend time looking at it," Fred said. "If that leads to something else, see where it leads."

"Fred likes to see where things lead," Kim said. "That much I know. He was following things yesterday as far as Nashua. How come? If all you want is to see that picture?"

"It does seem kind of roundabout," Fred said. "But that's not all. You mentioned Arthur."

"I talked to Arthur this afternoon," Kim said. "Him and I are in touch all the time. He knows about Mr. Z. I told him, don't

try and pull the same trick on Arthur, with the newspaper. He already told me about you. How you'd been in and out and in again and everything, and interested, and asking questions, and now Tippy Artoonian. And Arthur told me, we figured it out, that was you, you'd been there, you went to see Arthur after, two days ago, after you were in my shop, and what the verdict is, it's not your business."

"Arthur said he didn't have the painting," Fred said.

"Arthur would know," Kim said.

"No. That's not what Arthur said." Fred thought back. "He was afraid about something. Something had spooked him before I ever saw him. I mentioned how you had referred to the painting on wood he was working from here with you, and he said, these are Arthur's words, 'Doesn't ring a bell.'"

"When I drove over there that night, he was working. He invited me."

"And when he found out you wanted the painting, Arthur threw you out," Kim said.

"Who owns the painting?" Fred asked.

Kim, opening her mouth to answer, Claire put a swift foot in it. "You don't have to answer, Kim."

Kim said, "I was about to say. This dirty old wooden painting you keep talking about, you must have made it up. Arthur never heard of it. I never heard of it."

Fred said, "For God's sake, Kim, it's all over you!"

"And more, and, but also," Kim said, as smoothly as she could say anything, "Anything you heard me say, I didn't say it. And I have witnesses. That I didn't. Claire."

"Right. This painting that doesn't exist," Fred said. "Who owns it?"

"Sneaky," Claire said.

"Try it another way," Fred said. "Who *doesn't* own it?"

"And another thing," Kim said. "What were you talking about with Mr. Z? When you saw him before he died. What did he say? Poor Mr. Z?"

Claire said, "I have to get home. My kid brother. They want to go out, I have to be there. My bus. I have fifteen minutes."

"Can I get you a Coke?" Kim offered. Claire shook her head. "Beer?" The head continued shaking.

"Zagoriski wanted to know where Ruthie Hardin was," Fred said. "And where Arthur was. How interested he was, I couldn't say. We're not going to find out now."

"Him being dead," Kim said impatiently. "That terrible accident. No, I mean about the painting."

"That doesn't exist," Claire said.

"What did he say?" Kim demanded.

"I asked him about the dirty old wooden painting you talked about, the one that has what you call a gremlin in it, an egg with two heads and the legs of a chicken, like the one you have on your back under that halter top. He said, the first thing he said, pretty much like you, is that the painting doesn't exist."

"Which is suddenly worth money," Kim said, smirking. "Even when it doesn't exist. And strangers like you are interested. Go on."

"Then the next thing out of his mouth, Mr. Z wanted to know where you live. You and Arthur. I'm like you, Ruthie. Or Kim. Coincidences don't do it for me."

"So, Fred, we're out of here," Claire said, standing. "I am not leaving you with Kim, alone. I promised."

Kim sat, staring, seeming to be speculating, caressing the group of figures on her left thigh. "Unless you promise we'll only talk about something else," she said. "Like money, maybe."

"Fred's coming with me," Claire insisted. "Don't be an asshole, Kim. He's not staying."

Fred shrugged and stood. "I'm easy," he said. "I'm interested, but I'm not about to start pushing people around or waving money."

"How much?" Kim said.

"I can't stay," Claire insisted.

"Here's my phone number," Fred said, "in case you think of something. What I speculate, suppose you conclude that there's

no reason to—no, I'll say it this way. If you think of a way for me to see the painting, if you remember that painting, and maybe where it is, or anything that might help me—give me a call."

He turned over an envelope from the absent mogul's telephone company and wrote in large print his name, Fred, and the phone number at Clayton's. "That's where I'm staying," he said. "Or I'll stop by the shop when I happen to be passing by."

He left the envelope on a glass coffee table where Kim's absentee landlord must rest his feet while he watched TV whenever he didn't happen to be either in Hong Kong or at the office. God knows he wouldn't waste time looking at the art on his walls. It was worse than anything that might appear on the TV.

Claire led Fred down the stairs. She did not speak.

Chapter Twenty-seven

Fred followed Mount Auburn back to Harvard Square. Hopeful young people, sensing the onset of evening and the possibility of street theater, were beginning to gather in a desultory way. He found a pay phone and raised Zeke's dangerous-sounding growl at the desk in the entrance to the Charlestown place.

"Fred," Fred said. "Checking the home front. How are things?"

"Hot."

"Here too. I'm on the street. That character I sent. Sammy Flash. He's working out all right?"

"Haven't seen much of him," Zeke said. "His hours, whatever they are, and mine…"

"No trouble?"

"Nothing noted."

"If he's in, put him on."

"I'll check your room," Zeke said.

The phone clacked onto the desk. Fred listened to Zeke's heavy tread moving across the small vestibule—barely big enough for the desk—and up the stairs. Fred occupied the small room over the stairs on the second floor in the front of the building, that some called, in these New England houses, the "borning room," since it was ideal for the new baby. Fred needed room for nothing more than the foam mattress on the floor, a chair, and a table with a lamp in case he was wakeful and felt like reading.

The pay phone he'd located was in front of a flower shop that had put its hardier offerings outside on the sidewalk. Bees had found them. Their presence added conviction to the display. Fred watched the passers by, pedestrians and a few on bicycles. A pleasant aimlessness seemed to motivate his fellow humans, relaxed by the beginning relaxation of the day's worst heat. Many carried ice cream.

That regular thump in his ear was Zeke descending the staircase.

"Not in," Zeke said.

"Any sign of when he'll be back?"

"No sign of him at all," Zeke said. "Room's empty. I'm wrong. Pair of pants. Brown corduroy. Those yours?"

"No," Fred said.

"Thought not. They're damp. Hung over the radiator. He'll be back. Otherwise nothing."

"He carries a shoulder bag," Fred said. "Leather. Beat up."

"Not in the room. It wouldn't be, if he carries it."

"Right. You didn't—not to be paranoid about it. Flash drinks. I don't want the place burned to the ground. You didn't, in the room, smell cigar smoke or see butts or ashes?"

"Guy leaves the room funky," Zeke said. "Why I took a moment getting back to you. I opened the window more, turned on that fan to blow out, ventilate some. I'll go up in an hour or so. I don't think he smokes in there. You know how it is, general funk."

"Thanks," Fred said.

"I don't want to forget and leave your window open forever, in case it rains. No sign when the guy is coming back and the next man on the desk—well, the window's my responsibility. I'll take care of it."

◇◇◇

Rather than commit to the subway, wasting the start of a pleasant evening underground, Fred stretched his legs, walking the long mile and then some to Central Square. He'd left his car in

Clay Reed's parking space. No use fighting for unpredictable and temporary meters as long as his local business focused on areas easily reached from stops along the Red Line.

Central was more crowded than Harvard Square, hotter, its evening more advanced. Lighted windows promised seedier fun or cheaper shopping. Fred glanced into the G Spot. It was doing a brisk after-work business, even to the point that a double line of customers stood drinking at the bar. The men's look was lumberjack out of uniform. The women dressed as groupies who would be attracted to such bait.

Fred pushed through the street door leading to the apartments and started climbing. Already, six stairs up, the place felt wrong. By the time he reached the third floor landing, the feeling was confirmed. The three metal folding chairs were still in place, but everything else was gone: the scruffy piles of magazines, the pinned displays of flash and photographs along the wall opposite the railing above the stair well. Only the window showed no change. It was still painted shut.

"Our friend Flash has decamped," Fred said. Wasn't that the word Molly had used earlier today? He'd mentioned her children's father in an interrogatory fashion and met her single word response. *Decamped.* It was an efficient word. And final. Sad. Much left unsaid.

Fred knocked at Arthur's door. No answer. He waited, knocked again.

There was a choice. Should he follow the trail back to Charlestown and wait for Flash to reclaim his drying trousers? Why? Because his sudden absence made Flash interesting. Flash was a familiar here. What had he seen? What had he overheard? Did he know the painting?

Or should Fred keep to the plan and wait to enjoy a second interview with Arthur?

Or seek a middle ground, given that he was hungry?

He went prospecting until he found a Middle Eastern place that would fill a collapsible metal tray with an assortment of edible materials to keep him busy while he waited. He'd take the

opportunity as well to leaf through Molly's introduction to the garden city of Nashua, New Hampshire, under the unwitting front-page keynote patronage of the late Zoltan Zagoriski, R. I. P.

Fred was spread out on the floor of the landing, eating and scanning the paper, when footsteps mounted the stairs and kept coming past the second floor landing. Male feet. He made no move to shift position. Let him appear to be settled down comfortably for the duration.

The head first—a young man's, wavy hair, blond, recently cut. No. *Styled.* It had cost him seventy-five bucks to do that to his head of hair; then dark suit jacket, summer weight, across narrow shoulders; white shirt; necktie in blue silk with white stripes bending *dexter*. The rest of the suit. Fred gazed at him until even the black Oxfords reached the chipped brown-painted floorboards of the landing.

"Take a chair," Fred said.

The young man, ignoring Fred's invitation, knocked on the door. He put the attaché case he was carrying next to his feet and knocked again. Fred ate an olive. The collection of edible materials included hummus. He dipped a triangle of flatbread into that and ate it. Then a fat slice of red onion. Another olive. The new client, waiting, had New York written all over him. If the hair had been a little shorter, he had New York *Lawyer* written all over him; but a fellow this young, still gunning for partner, wouldn't want to stand out within the firm as someone having time and energy to waste growing hair. That would brand him as expendable, in terms of the big picture.

Fred said, "If you're looking for Porky Pig…"

The man knocked again without acknowledging the intrusion.

"Or the Cat in the Hat," Fred said. There was lamb in the mix, sliced and warm. He had some. He'd picked up a bottle of Rolling Rock. He wouldn't lift that unless he needed the emphasis. With the food, the beer, and the newspaper spread out, it must look as if Fred planned to sleep here too, when he got around to it. It was a possibility. The G Spot next door would provide for his other modest comforts.

"Don't like to eat in front of a hungry man," Fred said, offering the tray. The newcomer in the suit looked over, making no further move to acknowledge the gesture. Fred continued, "Take a folding chair. That puts you closer to the door than I am, but don't forget. I'm first in line."

The suit knocked once more and waited.

Chapter Twenty-eight

"Back door doesn't look like he uses it," Fred said. "So much crap piled in front of it in the yard. Refrigerators. This is the door he'll use. Unless he's already blown town. As a matter of curiosity, how much is he into you for?"

The suit recognized that he must stoop to an exchange of words. "I'm looking for Arthur Schrecking," he said.

"Right. I'm Fred," Fred said. "Not Arthur. You've got the right place, though. Arthur works late. But he's unpredictable. Not like Kant. You don't want to set your clock by him."

"Kant?"

'Immanuel Kant. I wasn't clear. Arthur is the one you don't want to set your clock by. Kant is, except he's dead. I'm ahead of myself. Kant is, to philosophy, what Philip Glass is to music, or Jules Olitski to painting. Tedious but persistent. Pointless, but redolent of inferred significance. Spend enough time with any one of those boys, they finally wear you down, you find yourself saying, 'I could have thought of that.' Then you decide they're smart. Since they agree with you. Kant was even more regular than Philip Glass. My point was going to be, folks said they could set their clocks by him. Kant. Glad to help. You're what, looking for the rent check? Arthur's overdue? Call me Fred."

"Lexington Orono. Lex," the suit said, sighing as it sat its man onto one of the folding chairs. The one farthest from Fred.

Orono. Interesting.

"You know Olitski's work?" Lex Orono said. He could not suppress an undertone of appalled disgust. Hearing the painter referred to in this context, by this apparent derelict, must be for him like listening to Joseph Goebbels discussing the virgin birth.

Fred said, "Don't you think Olitski could supply interesting motifs for a whole new approach to patterns for the tattoo phenomenon? Or am I thinking of Cy Twombly? Which am I thinking of?"

Interesting because that name, the patronymic, Orono, was among the big movers and shakers in the New York art world. The Pieper and Orono Galleries was a large concern, occupying prime real estate not far from the Metropolitan Museum of Art. The gallery did not specialize in any particular school, preferring to associate itself with individual works that could command staggering prices. They were as happy to offer a Monet *Water Lilies* as a Rembrandt or Franz Hals. Or a Jackson Pollock. When their own expertise couldn't explicate an object's provenance or credibility, they were happy to fill in for the missing expertise with gall.

"There is no similarity at all between them," Lex declared. He placed his attaché case on his knees and opened it.

"In terms of the person wearing the tattoo," Fred persisted. "So many images that the client chooses only make sense when both the client, and the viewer, are vertical. It abets the tyranny of gravity. The client stands on his head, all of a sudden, there goes your eagle. Upended. Flying upside down with that shield on top of him. Even the client must mostly see the pictures upside down, unless he's passing a mirror."

"I am supposed to be in Paris." Lex flicked at his lapels in exasperation before pulling a folder from the case. Its leather was so immaculate it must never in all its existence have gone for a ride in the subway.

The man was too young to make sense unless—this had to be it. There were no longer Piepers with the Pieper and Orono Galleries. Arsène Pieper had sold out his share in the partnership long ago, leaving only his name with the firm. Glendon Orono,

the wily old founding pirate who had controlled the firm single-handedly in the years since, must have brought in a son whom he had first smoothed and finished with an Ivy League education and the concomitant Ivy League friends and associates.

Glendon Orono had been so solidly ensconced in the business for so long, his existence was taken for granted in the landscape. His operations reflected the collaboration, often unwilling, of other major firms and contractors. He was willing to spend too much for a prime work of art. It couldn't hurt him, because he was regarded, even feared. His bullying action set a new "high" for the artist in play; he might be fronting for one of his hidden clients anyway; and if he was not, when he came to sell, the price he had paid, either out of his own pocket, or in collusion with a hidden cartel of fellow pirates, was so well known that the eventual buyer recognized the premium that must be paid to allow Glendon Orono the profit he demanded. The entire edifice must crumble if all did not collude in assisting the principal players to save face. In its own way it was not unlike keeping the big banks alive. The art and the mortgage look much better when viewed through the roseate prism of otherwise blind faith.

Orono's overhead was huge, his profits astronomical. There were well-discussed hints of cozy dealings between Orono and such other major players as the two big New York auction houses and their runners-up, and flagship galleries in Berlin, Berne, and Paris.

"Arthur does beautiful work," Fred said. "I read you wrong at first. Read you for a bill collector and thought, Good luck. But you're here to get ink. Am I right?" Lex Orono opened the folder and began checking its contents. Fred went on, "Or I should say, to get *more* ink. Like a lot of the bankers and trades-men now, you live a secret life under the suit. For a guess, it's not butterflies or fish.

"I'm so easy to spot, people tell me I don't need any more what they call identifying marks. I never went in for it, I'm so scarred up already. What I hear, these days a lot of the young professional people, God bless them, day jobs, paychecks, keep

the economy going—bankers, lawyers, accountants, insurance adjustors, even the women, you roll up their sleeves, the white shirts, the men—as the case might be, the women—get a look at the small of the back there, roll down the back of her, at the top, you get a chance—because a woman in the office, she likes to be free to have her arms bare, her upper chest, calves, and the rest of it I'm not being clear. Hot weather like this. Uncover the skin, these days, everyone's carrying art. Is my point. You a collector?"

Lex Orono jumped as if he'd been goosed with something lively.

Fred continued, making no acknowledgement of the hit. "Whiling away the time, waiting for Arthur, I don't size you up as one of the common herd. What you wear, tell me if I am right—under the suit—is simple, bold, stands out from the other end of the beach, like a rune, but a rune that means something. Like the letter Pi, but who cares about Pi? E over MC cubed. Who cares any more? Who ever did? Or understood it? The trouble with symbols in our culture."

While Fred talked he was gathering together the pages of the *Nashua Sentinel*. They had become scattered as he glanced through the paper while he ate. He re-assembled them and folded them together as they would first have hit the stand, with Zagoriski face up and fully visible as Fred, in a gesture that seemed lackadaisical, exposed the front page to his companion.

"Hit and run," Fred said.

Lex Orono had turned pale. "Show me that paper."

Fred shook his head, "It's for Arthur. *The Nashua Sentinel.*"

"I see what it is," Orono said carefully.

"New Hampshire," Fred clarified.

Lex Orono stared and drew himself into as small a man as he could manage. He reconsidered and blew himself out again, into as large a man as he could manage. "What are you?"

"Eliminate what I'm not," Fred said. "I am not a coincidence." He fanned himself with the folded paper. It was hot up here. A flapping Zagoriski provided relief. "I'm going to make some observations," Fred continued, moving the paper slowly,

keeping his eyes on his companion. "You, Lexington Orono, are familiar with Nashua, New Hampshire. You recognize the features of the dead man, Zagoriski, and you know his name. Except for the fact that the words came unexpectedly out of my mouth, and out of context, you are not uncomfortable with the names of the contemporary painters Jules Olitski and Cy Twombly. I invite comment."

Lex Orono put his file back into the attaché case and snapped it shut. He said nothing.

Fred said, "Another comment, as long as we are chewing the fat. All you can see from this newspaper, from where you sit, is the ugly picture of Zagoriski. You can't see his name, and yet you know it's Zagoriski. Next, all the headline tells you from there is *Local Man in Hit and Run*, which easily could put this character *behind* the wheel. Not under it. Yet you show no surprise when I let drop the fact that Zagoriski is dead. Again, I invite comment."

Fred waited, friendly, interested.

"To quote a Nashua character," Fred said, "No, to be accurate, to adopt his manner of conversation, I take it you already know of the mishap in Nashua."

Lex Orono stared and fiddled with the attaché case.

Chapter Twenty-nine

"Who are you with?" Orono demanded. "Who are you acting for? I don't know you. I haven't seen you. You're not New York or I'd know you. You're something in Nashua. Fred. Fred what? Camped out on the stairs like a bum. A trap. Who do you represent? Olitski, Twombly, what do they do, play golf?"

"Medium nice try," Fred said. "But late in the game." Lex waited for more, in vain. And finally asked, "You looking to deal?"

"Not necessary," Fred said, spreading his hands. "It's been fun chatting with you. I don't ask questions. Observations are more efficient. You get a lot of information from a lie, but it takes forever. I'm ahead of you, believe me. When Arthur gets back, I go in with him and you stay out here. Afterwards, if he wants to see you, which I doubt, I'll be there too. With him. If you want to tell me your business with him, fine. Your business. Your offer. Up to you. If you want to…"

"Fuck you," Lex said. "You're telling me who you're with is Arthur?" He opened his attaché case and removed one of those pads of notepaper they leave in the hotel room—the goodwill bribe to keep you coming back. This one from the Charles Hotel in Harvard Square. He scribbled on the top sheet, ripped it free, folded it several times, wrote on the outside flap, stood, bent, and slipped the message under the door.

"I was supposed to be in Paris," he complained, and took himself down the stairs.

Had the matter at issue been more serious than the satisfaction of his curiosity, Fred could easily deal with Arthur's locks and go through the place. But there'd be no justification for the move. He wasn't saving anyone from anything. He couldn't even find the ominous pricklings of anticipation that, in the movie, might be accompanied by worrying organ music, putting two and two together—one man dead in Nashua, another missing in Cambridge. So what?

Well, two men missing in Cambridge, if you pushed it. Still, so what? Arthur had gotten fed up and told Sammy Flash to move on? Why not? In due course Sammy Flash would get back to his pants drying across the radiator in Fred's room. Arthur could have decided to take a few days cruising the scenic waterways of Lowell, Massachusetts. Why not? It was a free country. Why shouldn't he be missing?

Yeah, yeah, yeah. Here was the matter newly of interest, and it added enormous credibility to the painting Fred had only seen represented in fragments and outlines on the body of Kim, who denied that the painting existed—that denial adding its own significance.

Lexington Orono had been diverted from a Paris venture in order to make a play for the painting. Nothing else explained his presence here. New York, or at least Orono's corner of New York, had gotten wind of the painting, and he wanted to get the gallery's hands on it before competition became an issue. If Orono could land it cheap, he could worry afterwards whether it was any good.

Lex Orono hadn't been able to poke hard enough to learn whether Fred knew about the painting; but he did suspect, and must worry, that Fred knew enough of his business to be very much in the way. And Fred had planted in his mind the misapprehension that Arthur and he were acting in tandem. Or, once Orono's suspicions got the better of him, that Fred had first refusal.

"Another fucking art dealer," had been Kenzo's words, while he maneuvered to block and sideline Fred's inquiry on the

Nashua end. So someone, Lex Orono? had been at Kenzo's asking after the painting whose existence everyone now denied.

"With an art dealer you have a choice," Fred said. "He tells you nothing or he lies." He leaned back in the corner he had chosen over the landing and continued his supper.

The last thing this situation had needed was the entrance of the man in the suit. The story as Fred saw it started: once upon a time a bunch of youngsters, clowns, finding themselves mysteriously in possession of a painting that entertained them, played with it, utterly unaware of its significance. Lex Orono, coming into this happy scene of innocence, introduced phero-mones of danger, distrust, and greed. He must seem—to any of the characters who had been associated with the painting, whether Stephanie and Kenzo Petersen in their Nashua tattoo parlor, or Zoltan Zagoriski if he'd got that far– had Orono already managed to make contact with Kim, or Arthur, here in Cambridge?—must seem like a predator so alien it would be comparable not to a wolf appearing among sheep, but to an ogre—or worse, a killer whale. Not only a nightmare, but a nightmare beyond comprehension. From the point of view of the sheep a wolf, frightening enough, could be expected to play by a wolf's rules. Even an ogre made sense in a fairy tale.

But Lexington Orono, the killer whale—his uniform black and white what with the suit, the white shirt, with his styled hair and his briefcase—represented an alien class of power, prestige, and secret cut-throat deals, any one of which could be imagined, by the uninitiated, to have the lottery's power to make you or destroy you utterly, perhaps both. Happy Valley might be doomed forever.

If these innocents had any experience dealing with devious people in this world, people who wanted something from them they'd regret—and who has not?—as soon as Orono's shadow crossed the threshold their initial instinct would be to deny everything. People are frightened when they learn unexpectedly that something they own, and have been comfortably disregard-ing all their lives, is worth a fortune.

Suppose they happen to *have* it, but don't own it? A worthless thing gets passed around. Islands in Maine used to be exchanged for poker debts. Nobody cared. After a while, it is hard to remember who owns which island, one that suddenly a realtor from Boston is willing to buy for the price of a good pension. The entire ecology is upset. Friends fall out. Families become strained and siblings cease speaking to one another. Everyone starts to scramble in the crawl space for lost scraps of paper that will justify their claims, and make them someone. Someone with a title. Title to an island property nobody cared about before.

"Arthur, my friend," Fred said. "You'd make this easier if you'd show me the picture."

Where the outlines had been colored in, on Kim's skin, the dyes were sweet and clean, as Fred had noted, sitting across from her in the apartment she was house-sitting. Had Arthur had the sense to compensate for centuries of dust and smoke and grime and discolored varnish? That had been Fred's instinct—that Arthur said to himself, "Screw this, grass should be green, not brown."

But there was another possibility. What if Arthur sent the picture to be cleaned? This crowd could not have found, much less paid for, a professional conservator whose skills were worthy of the painting. Even a cheap hack could strip the accumulated surface crap away until he found color. The danger was that the stripping didn't stop there.

At least, thank God, Hieronymus Bosch had done his work in oil paint. Imagine the damage that could be caused by an inexperienced conservator, or someone who only claimed to be a conservator, should the paint be tempera, and water-soluble.

Any conservator, even a hack, given the nature of the object Fred was imagining, and wondering about its source, if imbued with a larcenous streak, might go the next step and call the attention of a dealer to the work, anticipating a cut of any action that developed. Dealer drops by, takes a look, tells the conservator, "It's worth X to me if you'll tell the owner you had a client drop by the other day who saw the piece on your easel where you

were working on it, and wants to buy it for her husband. The husband likes weird things."

He'd keep the offer low. Mention a high price, or a fair price, and the owner stampedes. He figures the intent must be to cheat him. Ideally what the dealer does is to ask the unwitting client, "What will you take?" If the seller suggests the price and the dealer accepts it, no crime has been committed, even though the dealer knows he is buying candy from a baby. The dealer has made no misrepresentation. It is not his responsibility that the seller is ill-nformed. But when the dealer makes an offer, he is at the same time extending his experience as an appraiser. This is true even though he colors the offer by saying, "To me, the piece is worth this much." In this case, the dealer may be committing fraud.

So, although the dealer wants to own the piece, its fair cost would be high, and there may be no prudent way around acknowledging that price. An alternative, after alerting the owner to the painting's value, is to receive it on consignment if the seller is willing to wait to cash in.

Supposing the owner is willing to sell.

The trap above all traps the dealer wants to avoid, and it is not easy, is the alternative voracious, proximate lure of the auction house. The auction house has going for it the great advantage that it can appear to be a disinterested party. It seems to act as the balance point between buyer and seller, in a transaction so open, so public, so fully witnessed, so transparent, everyone believes that the value to be established by the winning bid, which has been forced by the next bid down, is determined by "the market" in its purest form. The ignorant owner, surprised and gratified by the news that against all odds he has something valuable, accepts first the assurance of the auctioneer, and then the hope not only of gain, but also of participating in a show. And with a sure thing rather than relying on the alternative route: consigning a work out to become shopworn while it fails to attract its asking price, plus the dealer's hefty commission.

Of course the owner will also find himself responsible for his assigned portions of the costs of the auction house's regular

business expenses: printing, storage, photography, shipping, insurance. Also, between them, the seller and the buyer must fork over the auction house's commission. Somebody has to pay for the buildings, the staff, the catalogs, all that razzle dazzle, the receptions...

Meanwhile the winning bid might be suppressed by collusion amongst buyers, who then auction the work privately among themselves.

Footsteps on the stairs. A woman's. Fred heaved himself upright, rolling the *Nashua Sentinel* into a cylinder.

Chapter Thirty

The hair was red in a welter of fat curls. Aside from the wig, the woman was underdressed. Stephanie, from Kenzo's in Nashua. Bright yellow cut-off tank top; red shorts that barely qualified, with tendrils of colored patterns wreathing out from under them like pubic hair gone berserk. The opaque gray plastic military raincoat she carried was cruelly unnecessary in this relentless heat. Fred, at the top of the stairs, stepped aside to give her room. Stephanie stared at him blankly, swinging a string shoulder bag.

"Kenzo sent me," she said.

Having disguised herself in the red wig, Stephanie had become so much another person that she failed to recognize the man who had been in her shop only the day before.

"Kenzo?" Fred said.

"Don't fuck with me, Arthur," she said. She made it sound cute, but with an edge of dangerous irritation. Then, trying a warm glance that originated somewhere in the shorts, she suggested, "Let's talk inside. I'm Angela."

Fred said, "I'm going out."

"Because," Stephanie maneuvered against him on the top stair, "there's not so many people in the country can do the kind of beautiful work you do. When he called the other night, that didn't go well. He admits that. Taking you by surprise. But see, Kenzo had been wondering where you are. You're not easy to find since you changed to your new last name. I like it. Pendragon. It

sounds like out of *Star Wars*. What he says. Kenzo. What Kenzo says. Well, listen. Can we talk? Inside?"

Fred sat on the top stair and motioned her to sit next to him. Instead she backed down a couple of stairs and stood at a level that would put his eyes and her calculating breasts at the same level. She said, "Go ahead. A person like you. I heard all about you. Kenzo keeps saying…what happened…and it was all a mistake…and I'll bet, I know, what you know, you could go over my whole entire body and pick out Kenzo's work from all the other ones. Like on this breast"—she uncovered her right one—"the chrysanthemum…"

"That's Kenzo all right," Fred said. It was very Japanese, an embracing, supporting cup of pink and red petals in carefully shaded gradations. The nipple held the flower's center.

"Kenzo's, like, sorry," Stephanie said. "What he said, and taking you by surprise. And old times. Those other things…"

Not Fred's business, but the chrysanthemum was well done, and a good fit for the breast, itself better than adequate for the purpose.

"Getting everything coordinated," Fred said. "It must be a puzzle for a person who moves around the country. To me, looking quickly, I see hints of Tampa, West Palm Beach. But I have to say, some of your collection is so generic…"

"I started young," Stephanie said. "What Kenzo wants…" she trailed off. "He's sorry," she decided. "Hot temper. There's nothing to worry about. Can we go inside? And don't be surprised that Kenzo found out where you are now. A person that works like you do. Word gets around. It's a small world."

Fred said, "I've got nothing to hide."

Stephanie covered the breast as if it had been forgotten until now. "As long as I'm here," she said, "can I see some of your work? Show me—it's famous—the Zen circle Kenzo put on your shoulder that time, when you broke your cherry. It's famous You're famous, Arthur, in Nashua. You'll be famous in the world, Kenzo says. He can help. Listen, Arthur, Kenzo says he's sorry. What he did. What he said. Let's go inside."

"Life is complex," Fred said.

"Because you know how he can be. Flies off the handle. Maybe, he says, he didn't. What he says now, the Zen thing. Tippy. Old history. Nobody's worth…A person should be able to share. Things. Talents. Money. He'll work it with you, and you need him. He admits he was, there was, jealousy involved. What Kenzo said, no hard feelings, and what he says is he's sorry, what he did that time, and we should, he should, learn to share. Even people. Me."

"You mention Tippy," Fred said. "Tippy Artoonian."

Stephanie leaned closer. The smell of old hot buttered popcorn emanated from her wig; from the rest of her, an advancing scent of woman. "How many Tippies can there be? I'm new in town, but I've seen her dancing at the Moonglow when we happen to go there even if it's cheaper to drink at home, quieter. Kenzo told me, 'Tell Arthur, no hard feelings. Show Arthur there's no hard feelings. Zen. No jealousy. Do whatever he wants. The Zen thing. All those positions?'

"Then we'll talk business. First I thought, 'I don't mind saying, who does Kenzo think he is?' I'm not like that, but, now I'm here, everything I've heard about your talent—Arthur draws like God would if he'd been to school, everyone says—So, now I see you…can we go inside?

"Also, we're getting to know each other, starting to, this other idea I have, and I'll pay for it. My right butt cheek. I've been saving it for something it sounds like you can do, not Kenzo's style. Kenzo's all Japanese. I'm a mixture. I want something old fashioned like you do, but weird."

Stephanie lifted a foot and placed it between Fred's loafers, thereby inserting a colorful knee between his own. "The truth is, that picture Tippy gave you, that she had…"

The knee made contact. Stephanie's head came closer to Fred's.

"I'll come in, have something cold, look at ideas. Drawings. Tippy's painting. Kenzo says—first get to know each other better. I didn't think you'd be this big, Arthur, from what Kenzo said.

I like big. I go for big in a big way. After, if you have time, I'm free, we'll think about the place I've been keeping for you on my butt. Kenzo *is* jealous. He told me you were kind of weedy."

"This hot clear day, why the raincoat?" Fred said.

"Some places, shit, you need a quick cover-up," Stephanie said. "Like on the bus? It's not like there's a law, but public places, straights see your ink, they look at you like you're an escaped convict. I have never done hard time. It's fiendish hot, you got that right. I can't wait to get…also, can I use your phone? I'd love a drink. Listen, you are not catching the hint. A lady likes to beat around the bush, see how the land lies, all that. But now I see you…Kenzo says, 'Look the guy over first, sure. Then decide. He looks like he doesn't but don't worry, Arthur goes for women. He's slow to pick up the idea? Tell him flat out, Kenzo sent me, 'Kenzo said. It's a Zen thing. I'm a peace offering. Whatever you want me to do.

"So can we for God's sake go in? I have to take a leak. Use the phone. Tell Kenzo it's OK again, between you and he. Between him and you. You can do a deal, after all. Between the both of the two of you."

Chapter Thirty-one

"I don't have a key," Fred said. "I'm waiting for Arthur."

"Shit." Stephanie drew back hastily. "Shit! You're not Arthur? I waste the whole fucking spiel on some random guy. When's Arthur due?" Sweat trickled from under the wig, down the sides of her face. Nevertheless she had become chilly, distant, almost businesslike. "Do me a favor. Forget everything I said. I'm a practical joke. Stripagram. Doesn't mean...You see Arthur before I do, I want to be a surprise, OK?"

Fred shrugged and spread his arms. He said, "I'm slow catching on. Don't worry about it." He started down the stairs, squeezing past Stephanie to do so.

"Shit," Stephanie said again. "Listen, I saw black people in the street and sidewalks. What black people means to me is barbecue. You happen to know, around here, a place I can get decent barbecue? I'm waiting for Arthur? Where I can also take a leak?"

"Ask a local," Fred said. "I'm not from around here."

"Shit. Are you Nashua? You're, now I look at you...Do I know you?"

"Doesn't seem like it," Fred said.

"I'm coming back after I take a leak, get something to eat. I'll tell him you were here. What was your name again?"

"That's OK," Fred said.

◇◇◇

Fred's car was pleasantly cooled by forced air, as long as he cranked a window open. That also helped with the smell. He'd jostled back to Charles Street on the subway, then walked to Clayton's on Mountjoy for his car. He reached the Moonglow Lounge before ten o'clock, and easily found a place in the parking area of the mall, whose businesses were mostly closed down for the night. There might be seventeen cars and pickup trucks parked within the glow of the Moonglow's corona of diffuse light.

The place had been intended for a larger clientele, and must do better on a weekend. Fred found a little table "next to the action," as the hostess said. Three geriatric male musicians—tenor sax, a string bass, and an anomalous accordion—stood in the shadows next to the empty spotlighted stage not far from the end of the bar. Their offering was grotesquely amplified.

Fred ordered an Old Brown Dog, his usual drink at the Moonglow, leaned back and let his antennae reach for whatever they might pick up. The clientele was middle-aged and male. It rustled knowingly at a change in the music that was lost on Fred. Curtains at the back of the stage opened. A young woman strode out, simultaneously dropping a scarlet cape like a stage wrestler's. Her figure was so lush as to be almost Victorian, and the major part of it was visible. She wore, in total, a scarlet sequined thong and scarlet sequined pasties over the nipples that rode her heavy breasts. Scarlet high-heeled shoes. She approached a steel pole that stood front and center and addressed it as Samson did the pillars of the temple.

She was enthusiastic, energetic, and she made up for her lack of grace with bored athleticism. Black head of hair cut so short it was almost butch. Aside from the shoes, the scarlet thong and the pasties, she wore twenty disks of scarlet nail polish on toes and fingers, cascading sparkling earrings, a silver bangle pierced at the navel, and on her right buttock when it happened to turn in Fred's direction, clenching and working with the effort of her exercise, the rendition, roughly five inches high, of a glass jar in which colorful horned beetles were devouring coins, while copulating. The same emblem, but in smaller scale, had been on

Kim, mixed amongst the many others. Here, in isolation, placed as they were to take advantage of the muscle, their movements, both while copulating and while eating money, were exquisitely lifelike while the dancer moved. It was almost like watching them in a nature movie. Arthur was a genius.

Fred's waitress appeared with his beer and a bowl of popcorn. Fred told her, "Tippy Artoonian?" And as involuntary assent showed in her eyes, he added, "What stage name does she go by?"

"You walked past it on the bill," the waitress said. "Scheherazade."

"I saw that," Fred said. "My mistake. I thought Scheherazade was going to be a belly dancer."

"What Tippy figures, week-nights, never mind the preliminaries. Anyway, the band, Bob and the Bobbsey Twins, not what they call themselves, that's what I call them, retired cops, they can't do that snake charming music. You imagine all that Neenah Neenah Deedle Deedle on the accordion?"

Fred said, "I see what you mean."

"Normally we use CDs. You'd say that's cheaper, but Bob and the Bobbsey Twins work for love. Figure they'll die slower, they have something to do. So Tina figures, whatthehell? You gonna eat?" the waitress asked.

Fred shook his head. "Popcorn will do me."

The variations in Tippy's dance were exhausted long before her session had expired. She drifted into "repeat" mode. Fred picked up his drink and wandered to the bar, taking the end farthest from the commotion of the performance. The bartender stood there in the comparative calm, a middle-aged balding man, built to fill out his apron. Fred said, "I thought I might see Tina."

"Not till later," the bartender replied.

"Zagoriski," Fred said. "Zag," he remembered. "Sad."

This observation raised a nod.

Fred said, "Friend of the firm."

This observation prompted a less enthusiastic nod. Tippy, twenty feet away, was making up for the barman's stolid demeanor.

"I don't believe I know you," the barman said.

"Fred," Fred told him. He shook his head. "Hit and run," he mused.

The barman added a footnote. "Sure, call it hit and run when it looks like the son of a bitch driver went over him three times. Once forward knocked him down. Then, what they figure, backed over him to make sure, or take a look, Oops! what was that? Then forward one more time to celebrate, or just to keep going wherever the hell the son of a bitch was going, is the way I see it. SUV or a truck, looks like to me, whatever. He didn't run till he was damned sure what he'd hit, is how I read it, and how bad he'd hit it."

"So," Fred said. "What the boys like to call vehicular homicide."

"You want another one of those?" the barman said.

Fred shook his head. "Gotta pace myself. May I buy you something?"

"I wouldn't mind."

"What that means to me," Fred said, "is why aren't there cops crawling all over interested in where he was, what he was doing, the rest of it. If they're talking homicide."

The barman, pouring a generous slug of bourbon over crushed ice, said, "There's homicide, then there's vehicular homicide, which is something else. Accident or maybe spur of the moment. What it sounds like, the theory they're going on, given Zag was fried when he left here, gorgeous redhead, maybe they're looking for her, good luck! Ask did she see anything? They figure, some cluck hits him, a car, maybe it was a truck, whatever, doesn't make a whole hell of a lot of difference to the guy, backs up to see, takes off, it starts, it was an accident. That's what it sounds like to me they're thinking. It starts, it's an accident. Afterwards, hit and run."

"Gorgeous redhead," Fred said. "You see her?"

"What's it to you?"

"I go for redheads," Fred said. "No offense to Tippy."

The barman took a consultative sip from his drink. "You sure know your way around for a guy I never saw in my life before. Everyone's nickname. Tippy? Tina? Zag?"

Fred took a swig from his Old Brown Dog. The bar had its own supply of popcorn. Fred reached into a bowl and selected a handful, eating the stiff, bloated kernels one by one. The band played golden oldies. It made no difference to Tippy's random gyrations. Were those tears?

"I'll go enjoy the show," Fred told the barman and went back to his table.

It was true. The pathetic display was rendered poignant. Tippy was weeping while she danced. The nature and content of her large muscle display made the fact of her tears so disjointedly irrelevant that it was passing unnoticed. The baubles sparkling under her eyes and tumbling to the stage were like the bangles that clattered under her ear lobes, or the one that flickered below her navel.

Fred went back to the bar. "If house rules permit," he told the barman, "would you tell Tippy, when she takes her break, I'd like to buy her a drink?"

"It's a free country," he said. "You want me to tell Tina you're here?"

"Maybe later."

Chapter Thirty-two

The tables were spaced far enough apart to allow dancing—was that the plan?—or private conversation. Or were they spaced out so as to make the business seem better attended than it was? Such places are often fronts for something else. Enough customers were eating. At least the restaurant was functional. But even if the band was free, the Moonlight Lounge was losing money tonight.

At the small tables conversation proceeded as if nothing was happening in the way of entertainment. The fun was set aside, a tedious alternative to weather. Fred ordered another beer. He didn't have to drink it, only to do his part to maintain the fiction of revelry.

Bob and the Bobbsey Twins continued their musical complaint. Tippy kept up her melancholy dance until, after she had filled a half hour, she retrieved her cape and was supplanted by a leggy blonde accoutered in scraps of blue sequins, fabric, and nail polish. "We'll be back," one of the Bobseys said. He and his cohorts angled off. The new dancer fiddled with a CD player until it delivered a throaty beat through the band's warm amplifiers, followed by music that developed the theme, "You can take this pole and…"

The new dancer began to follow the music's suggestions. She worked as if she had been awake for all of seven minutes. For this she had been obliged to finish high school? Some time back, from

the look of her. In five minutes or so Tippy, in a black sheath dress, came to Fred's table. "You're the one?" she asked. "Fred?"

"I appreciate your stopping by," Fred said. "Can you sit for a minute?"

Tippy took the chair he offered. "She knows what I'll have," Tippy said. "What I do is dance. Period."

Fred nodded. "I'm sorry about Mr. Z."

She'd washed her face and applied makeup. But this hint of courteous sympathy from a stranger threatened the new construction. Fred went on, "It could be a coincidence. I don't know you, and I don't know your relationship with Mr. Z. The least I can do is show some respect. I was with him yesterday. If you were close, I'm sorry."

Fred's waitress appeared with a tall glass in which ice chattered. The color was ginger ale. A cherry bobbed halfway down, suppressed by ice. "Thanks, Linda," Tippy said. She looked at Fred for a half minute before she said, "Talk for a while. How do you know my name? Start there. It is going to be a goddamn mess. In fact it's started. It already is."

Fred said, "That's too bad."

"I have to move out."

"That's rough," Fred said.

"She's coming back. She's bound to."

"It's rough," Fred said.

A silence fell between them. Tippy looked absently at her moving colleague. "Rough, the man says. You can say it's rough. So, Fred? What's your story?"

"Time like this, my story's got to be a distraction," Fred said. "It's a small thing when you compare...backing up. My story. I ran into some folks from your high school, Nashua Central. Maybe even your class. Eva is one. Ruthie Hardin..."

"You know Ruthie Hardin?"

"Arthur Schrecking," Fred said.

Tippy was nodding. "You're from down south," she said. "When Arthur took off that's where he went. South. He got out

of here. Out of Nashua. A lot of people, they never do. A state of mind. Like me. So far anyway. I never…"

"Arthur did your ink," Fred said.

Tippy smiled for the first time since Fred had first laid eyes on her. "You like it?"

"It's brilliant," Fred said. "I hope I didn't seem to be staring at it while you were dancing. I don't want to be rude."

Tippy gawped at him over her drink, letting her mouth hang open as if he might be the first man she had met in the world, in all her life, who did not want to be rude. Who did not, in fact, take being rude for granted as a natural right. She was suddenly hopelessly lost in a foreign land.

"Glinda doesn't know what she's doing," she said, gesturing toward the stage. "Calls herself Glinda. I call myself Scheherazade but it never took. Everyone knows me. I could of got away with Sherry. No. They want you to be exotic, so Gail took Glinda. She's not from around here, who knew? Everyone calls her Glinda. The Good. Out of the movie. She's good for ten more minutes, then she gives out and I'm on again."

Fred said, "If you have to get ready…"

"How long can it take to pull off the dress? He's in Boston, yes?"

"Near enough." Cambridge was Greater Boston.

"That's what he said he would do. Boston. Get some money together. Then maybe out West. San Diego. Arthur. He's good, but he's not aggressive. Needs an agent. Like everyone else. It's the agent gets the money, but who can find one? Arthur, like I say, has trouble with the commercial end. I told him…" Whatever she had told him didn't surface.

Fred said, "That design Arthur did for you, the jar…"

"With the weird bugs. I love them," Tippy said. "I look at them every day. Best I can, where they are. I have names for them. If I could feed them…"

"They come from that painting," Fred said.

"Sure. No, look, she's giving out. Didn't eat yet. No stamina. Glinda falls down, she gets herself canned. Listen, I have to take

over." She stood, taking a long drink from her glass. The girl on the stage looked pleadingly toward her.

"Can we pick up on this at the next break?" Fred said.

"Swing by at midnight," Tippy said. "We'll take it from there. The door around back. So I don't have to say hi to my fans."

Three minutes later, Tippy walked onto the stage again. The audience had grown slightly larger. It managed indifferent applause as she joined Glinda and the two moved together for a full minute, massaging the pole until it might disregard its affiliation with the mineral group. Then Glinda retired in haste, wobbling, almost collapsing when she bent for her cape.

A square woman approached the table. Late middle age, large black and white clothing, thin rusty hair in a complex lacquered sweep. Eyes that peered as if they were too proud for spectacles. Until she sat in the chair Tippy had vacated, Fred stood.

"A gentleman," the woman scolded. Mid-European accent. "I like that. Also I am not fool. Not fool*ed*."

Fred sat and watched the woman lift Tippy's drink and take some into a narrow mouth whose lips barely owned enough bulge to support the weight of brilliant red paste they carried. "You ask for Christina," she said. She was not thirsty or careless. Whatever Fred was being billed for, she'd been testing to make sure Tippy had not been given alcohol.

"I talked here yesterday afternoon with Zag," Fred said.

Tina's impassive gaze took in the stage, the room, the invisible kitchen, the universe, and her unexpected companion, each item with the same amount of disinterest. She brought the focus of her eyes toward Fred. "You are a friend of Zagoriski?"

"No."

"He owes you money, then."

"No." Fred shook his head.

Tippy danced. Tina, catching the direction of Fred's sidling eyes, said, "It is not easy."

"Running a place like this?" Fred helped. "In Nashua, New Hampshire?"

"Everything. Me, Zagoriski owes money."

"May I offer you a drink?" Fred gestured.

"Lots money," Tina said, shaking her head impatiently. "You, Fred. Who gonna pay?"

Chapter Thirty-three

"Not exactly a lawyer," Fred said. Tina's expression was the moral equivalent of spitting on the floor next to his feet. "You have to collect from his estate."

Tina's expression was the moral equivalent of offering to rub his face in it. "You think Zagoriski leaves me a contract signed and with a pink bow tied around her like a virgin bride?"

Fred said, "I'm not sure I can help. Z and I were not close."

"Your business with Zagoriski?"

"I never got to my business. I met Zagoriski yesterday afternoon for the first time, had a drink with him. Came back to Nashua this afternoon, pick up where I left off, found out about the accident. Fellow human. Thought I'd learn what happened. Came back here."

Tina heaved herself up from the table until she was standing. "Lots money," she said. "He told me last evening he was about to get. Look what he gets instead."

Beware of the enemy who does not make threats.

Her hands, pressing against the tabletop as she rose, obliterated something metaphorical in a grisly and excruciating way. "Lots money," she repeated.

◇◇◇

Fred had more than an hour to kill. He checked the incomplete scraps of fact that had appeared in the article in the *Nashua Sentinel* and drove into town, nosing through the streets until

he came to the area of old mill buildings near the canal. The snarl of yellow crime scene tape must mark where the body had been discovered. It was a part of town that any man who had ever seen a movie would have known better than to visit late at night, unless he was either pure of heart, bewildered by a gorgeous redhead, or at least half in the bag.

Or blinded by the expectation of "lots money."

Almost the last thing Z had said, on the phone, first thing at the Moonglow, before he and Fred got chummy—"and have it with you." What was that about?

Grand old red brick mill buildings on either side, and between them a clear run for the vehicle that had knocked Zagoriski down, backed over him, and—after a pause long enough for the driver to climb out? Take a good look? Open the passenger door to admit a gorgeous redhead?—drive over the body one more time, to make certain of the job. What I tell you three times is true.

In other situations and other contexts, and supposing it were Fred's business, he might make note of the coincidence: Z's death, and the fact that Z owed Tina "lots money." Had Tina despaired of collecting and decided to cut her losses by making Z, at least, an advertisement that might at minimum encourage others? Was Tina's diplomatic visit to Fred's table meant to signal "Don't mess with me"?

Lord knows, she had access to all the gorgeous redheads she might need to bait a pie-eyed Zagoriski into the path of a moving truck.

"Table it," Fred said. "You're only interested in following one trail. The rest of it? Take it all under advisement. But watch your back."

◇◇◇

Tippy came out of the Moonglow's kitchen door after midnight. She stood in the heat reflected from the mall's blacktop, wearing jeans and a thin short-sleeved shirt of vertical blue and white stripes. She carried a paper grocery bag from Food Dreams. A tiny purse hung from her shoulder.

Fred swung the car around and leaned across to open the passenger door.

"Sorry about the smell," he said as Tippy climbed in. "My guess is, the previous owner kept a dog in the car. I open the windows when I can."

"Go that way," Tippy pointed. "You save me finding a ride home, then being expected to pay and getting into all that, or waiting an hour for Glinda to get off. Turn here. No, right."

Fred followed her directions past malls, subdivisions and abandoned farms waiting to be obliterated, until they arrived at an older development of identical houses with identical lots whose owners had tried to make them appear unique by variations in paint color or planting.

"Right here. Now left. Around the circle and stick it in this driveway," Tippy instructed. "That's my car. Behind my car. Mr. Z's was impounded. Mine needs a new battery. Forty dollars. Listen." Fred had stopped his car behind the one Tippy described as hers. She swung around in the seat, the grocery bag in her lap, and looked him in the eye. "We talk in your car, or we go inside if I can trust you. Keep looking at me and tell me I can trust you."

"You can trust me," Fred said.

"That's all?" Tippy demanded. "You're not going to prove it? No argument?"

Fred shook his head.

"OK, we'll go in. I'm dying to get rid of the butt floss. Sequins. Can you imagine?"

"Now you mention it, I'm trying not to."

"I use the back door," Tippy said. "We go in, finish our talk, then I pack." The lot's little back yard was derelict, down to the cracked ceramic birdbath. A light had been left on over the back door. "Cops, earlier," Tippy said. "They almost made me move out last night, looking at everything, but it was me let them in, and I live here."

"Zagoriski's house?" Fred guessed.

"I thought you knew," Tippy said, turning as she keyed the door open. "Mr. Z lets me use the room upstairs. Used to. Wait

down here. Don't poke around. There, in the living room, he calls it."

The house was stale and hot. The former presence of Zagoriski's absent wife—"Mary," hadn't he used that name?—could be inferred, but no longer felt. The house felt like a violated grave. Tippy led Fred through the kitchen and along a small hallway to a room in which every surface was crowded with objects that illustrated the concepts "unnecessary" and "decorative." What it felt like: the wife had left, and Z, the husband, had roamed the house gathering objects together that he could either throw or sell, piling them up like the damaged groceries that go cheap. Odd things, like gilt wedding presents, jostled with cruets and figurines, waiting for the last raffle that signals the end of days. The room, the whole house, smelled of the aggressive neglect imposed by a weak man upon the memory of his wronged wife.

"Him being dead, I don't dare open the windows or turn on the air," Tippy said.

"Take a seat. I'll be right back. It's how I eat. Extra shit from the restaurant they can't unload." She carried the grocery bag in the direction of the kitchen they'd come through, leaving Fred in the Zagoriski living room.

Fred tried an armchair and exchanged it for the couch facing a TV so large and so incongruous that its purchase must have been an act of revenge against the absent wife. There were no books to look through. On the walls nothing but framed needlepoint. Scratch that. *Reproductions* of needlepoint. In cheapo gilded frames. *God Bless Our Home.* Samplers. One of those mournful memorial things with maidens, under a willow tree, flanking an urn. It was a collection. Souvenirs of the failed marriage. If Z used the room, it was like a ghost who refrains from rearranging furniture. His interest in art didn't show here. Unless the few rectangles on the wall stained by absence spoke of nice things gone. People live together, their tastes might jostle. Here, other than the samplers and the outsized TV, the room wasn't a compromise any more. It was a defeat. Mary Zagoriski had been stricken from the record.

Tippy came in again. She'd exchanged the jeans for a cooler pair of Bermuda shorts. "When you say she's coming back, and you'll have to move out," Fred said, "you mean Mrs. Z."

Tippy nodded. "There's Cokes in the kitchen, the fridge. They're mine. I'm not gonna offer anything belongs to the house. Mr. Z. Whatever. Ice is OK, I can make more. I'm having a Coke. You want one?"

"That would be great." Fred moved to follow her to the kitchen but she gestured him to stay where he was.

She returned with two red-and-white cans and one glass of ice that she handed Fred. "I like mine neat."

"She's been gone for a while?" Fred said.

"Like a year." Tippy sat on the chair Fred had rejected, made a face of disgust and rose again. "Hot as it is, everything in this room sticks to your skin," she said. She sat on the floor's beige carpet, crossing her legs to minimize contact. "Before I moved in obviously. And listen, it doesn't make any difference what you believe, so I won't push it. Only, so you're straight, I and Mr. Z, it wasn't like that. What it looks like. Me living here. The spare room.

"Sure, everyone knew what he liked. Mentoring a girl, he calls it, and sure, if she lets him, he'll feel her up. Like accidentally. So he doesn't notice what he's doing. If it's late and he's been drinking. Anyone can get lonely. There was no harm to him, more like a hobby. Creepy, but there's worse things, and he could be nice. He's dead and I miss him, bumping around down here. He'd get her the job like at Wendy's maybe, or like me, you have the talent, the Moonglow. Me, he wanted, said he could get me into a junior college, in another state, maybe even the city; he believed in me. To one day be in real estate. Or dental hygiene. And he did. But I didn't.

"Dirty old man, what else is new? A girl didn't haveta and, you come right down to it, maybe he couldn't.

"Who gives a shit about art? Every year you go back, there'd be, maybe one, maybe two, girls from his class where he'd take a special interest, and by the time, after graduation, a person needs help getting started, Mr. Z was ready. To help.

"Especially like, what was my case, if there had been, and it was their fault, trouble with the parents, problems at home, they're not in town any longer anyway, Dad lost his…"

Fred said, "Mrs. Z moved out. New York, Z said. She told him, 'I'll send for my stuff.'"

"Search me. Mr. Z. I'm not going to say he was a gentleman. But he was. And he left me alone. Or I wouldn't be here. Most of the time. He might, we're at the Moonglow at the same time, people are watching, put his arm around me like I'm his, you know, people get the idea he's…"

Fred said, "I'd love to see that painting. With the bugs."

"Mr. Z gave me it," Tippy said.

Chapter Thirty-four

"It's here?"

"It was in my room? I said I liked it. Against the wall with some posters and they thought they were going to have a kid but didn't, so the parts of the crib, it's really an attic but there's room for a bed, and thank God there's windows on either side, trunks and stuff, boxes, or I'd die up there, this heat.

"The honest truth, Arthur saw it and fell for it, him and I had a thing going. I wasn't supposed to, in my room here, but we didn't want anyone to know. Besides, Mr. Z teaching at Central, so the honest truth, Arthur didn't have a place, next chance I got, I told Mr. Z, I love that old painting, and Mr. Z says, Take it. Arthur had the idea…

"So I take it."

Tippy sniffed and wiped her eyes. "I miss Mr. Z. You get used to a person. Being around. At first he was gonna charge me rent. Which how was I gonna pay? It's not my fault, Mrs. Z. Mr. Z was—we'd been seen around together, and it wasn't the first time. Other girls, the years before, everybody knew. It was how he was. A mentor. His nature. Mr. Z got me the job, the Moonglow, after he knew I wasn't going to work up the ambition to leave town. Or the money. Everything takes money.

"So I'm working there, Mr. Z one night comes in, he's almost upside down he's so upset. She'd walked out. Left a note. She calls me a stripper in the note. He showed me, he found when he got home that evening. I was working, he comes back? He

says—I'm on break—'She walked out. Took off. No warning. Note: Send me my stuff,' but he wouldn't. What he said…"

"I know what he said," Fred said. "In fact, I know his exact words. 'Whoever walks out, all bets are off.'"

"So I move in. And I have to find a new place," Tippy said. "Now Mrs. Z has the house again. Obviously it's her house. Me, she thinks I'm the reason…Glinda says crash with me for a few days, she'll pick me and my shit up tomorrow, but her boyfriend…"

Fred said, "So the divorce hadn't gone through yet?"

"Mr. Z didn't talk to me about that," Tippy said. "Well, maybe, I'd come in late, he'd be sitting here, the TV, the big glass of scotch and ice, he'd be wanting to talk. I let him talk, but I didn't listen. Most of the time he didn't listen either, what he was saying, he talked to himself. No. They're not divorced yet. How is he going to pay for the lawyer? He's already…"

"But you can show me the painting?"

"Arthur has it. I guess."

Provenance. Suppose the painting's chain of title ever came up as an issue? "But Mr. Z did give it to you?" Fred reminded her.

"It's not like anybody cared about that old picture," Tippy explained. "Z didn't want it. Arthur's the only one."

Fred poured black liquid over his ice cubes, studying the situation while he watched bubbles resolve into disintegrating foam. "Tippy, why don't you, maybe not be here when Mrs. Z turns up, but leave her a short note, offer to watch the house until she sells it? The house is safer that way, tell her. She'll see that you keep it nice."

"She hates all us girls," Tippy said. "Hell, *I* would."

"Still, it might be worth a try. Times like these, the house standing empty could be for a year, Mrs. Z maybe out of state, the place, boys come by with rocks and break windows, people start stealing fixtures, even the copper pipes. It's worth a try," Fred said. "So, you gave the painting to Arthur."

Tippy said, "Picked it up at a yard sale probably. They were always bringing crap back from yard sales."

Fred said, "You and Arthur keep up?"

"The thing. Arthur and me. We had a thing. Which I mentioned. And, but then, at the same time, I was having the same thing with Kenzo. You know him? Kenzo's the reason why me and Arthur, when we got like that, didn't want the rest of the whole world, and so we'd spend time here. Arthur didn't have a place, like I said, and besides I had a car, Arthur didn't. Drive, even. Had a bike. Like *bicycle* bike. Arthur never had money. He was at Kenzo's all the time, we'd all graduated, but Kenzo doesn't pay him? Me, for a while, Kenzo's, I did reception but I didn't want ink or, but, well, I finally hadda let him do something, I got the piercing maybe you noticed? My belly button? So the customer could see there wasn't anything to be…And you could say me and Kenzo were sort of lovers although Kenzo was never…What I mean, with Kenzo, you haveta let Kenzo…"

Fred said, "If you call Arthur and ask him, will he show me the painting you gave him? Is it like that? You gave it to Arthur?"

"Like that, or maybe you'd say, like, Arthur's keeping it for me. Who cares? Who's going to make a stink?

"When I asked Arthur about it," Fred said, "he didn't want to tell me anything. I was at his place, I asked, he said he didn't have a clue what I was talking about."

"Arthur's like that," Tippy said. "The thing, what I realized, Kenzo's too old for me. Gets mad like an old lady. He's gotta be, what, your age? Arthur's like me. What do you think? And besides, I'll tell you what I think, it's all, the whole thing, Mrs. Z."

"What's all Mrs. Z? You're losing me."

"This all of a sudden everyone wanting to know what happened to that picture. She must of found a place, wants to move in, she decides she wants her stuff, her half of everything or however they're gonna work it, but all Mr. Z says is, 'Whoever walks out, all bets are off.' *God Bless Our Home*, the rest of it. The stinking couch. Who knows, by now maybe she can use the crib. She's younger than him. Student he had a million years ago. Might not be too late for the crib, some other guy."

"Suddenly everyone wants to know?" Fred asked.

"And, shit, I don't care," Tippy said. "I have what I want, and it's alive. It's part of me." She rocked leftwards so as to pat the side of her right buttock, where colorful beetles, under the cover of her Bermuda shorts, continued to devour coins. "Sure, Kenzo wanted to know. He called me at the Moonglow—it's not like we're not speaking—I said, I don't know where it is. I move so much. Kenzo knew I had it because he saw my tattoo, that Arthur did, which is where all the trouble started, between him and Arthur. Well, and me. How could Kenzo not see it, and like a fool I thought, well, I'll…I'm not an idiot, I knew he was going to see it. It's right there!…But I thought, maybe I wasn't thinking. Kenzo being Arthur's mentor, he wouldn't mind. And wouldn't maybe jump to any conclusions. But he did. And Arthur hadda leave town.

"And that's the story, how I lost my day job."

Tippy drained the can she was nursing.

Fred said, "I'll give you Arthur's number. Would you call him? Tell him I'm on the up-and-up?"

"Give me the number," Tippy said. "I'll think about it." Fred roamed the room until he found a waste basket that contained an envelope from the telephone company. It was decorated with a fat red stripe. He wrote down Arthur's number—then his own, at Clayton's. Tippy had risen when Fred did. Fred handed the envelope over.

"Mr. Z's phone's been disconnected, you can see," Tippy said.

Fred said, "I'll take you to a place. I saw a 7-Eleven…"

"I have to think first," Tippy said. "Why everyone, all of a sudden…And my motto is, in life, don't tell anyone anything. I mean, where Arthur is? That Kenzo suddenly wanted to know, or Z? Z started asking about it too, where Arthur was and all. Forget it. I didn't know and whatever he told me his plan was, that's my business. I didn't know anyway. Where Arthur was. What you want I don't know."

Fred said, "I want to see the rest of the picture. Beyond the part of it that's on you, which I like a lot."

Tippy said, "Mrs. Z will maybe say, she gets around to wanting all her stuff, if she remembers it, it's hers. Which my guess is, why did Kenzo all of a sudden start wondering about it? Well, shit! I'd like to see her try to take *this* back." She paused.

"Look, Fred. You say you're on the up-de-up. Maybe. You're nice. I like you. Thanks for the ride. If you're working for her maybe she's not such a bitch, I don't know. There's only one thing I've learned, that I know, and which I have learned from practically everyone. Don't trust anybody.

"So, thanks for the ride."

She moved toward the hallway that would convey him through the kitchen and into the exterior darkness. Fred's undeniable function was to follow her.

"I guess Arthur and Ruthie Hardin are a thing now," Fred tried.

Tippy shrugged. "Arthur's in space half the time," she said. "The rest of the time he's out beyond it."

"Arthur's so afraid of Kenzo Petersen that he had to leave town?"

"Kenzo throws stuff and screams things like, 'I'll kill that sneaky son of a bitch.' Kenzo's sweet. Most of the time. He's into Zen. But he fired me, and he said he was gonna kill Arthur, and Arthur didn't want to hang around and find out. What Kenzo would do."

"So Arthur took off," Fred said. "What I mean, he left you."

"He had a ride. Maybe the bus."

"With the painting?" Fred pressed.

"I have had it with this painting," Tippy said. "Thanks for the ride."

"If you can call Arthur, I'd appreciate it," Fred said.

Tippy saw him out.

Chapter Thirty-five

Fred parked in front of the G Spot. Three-thirty in the morning, it was shuttered closed. He'd be all right here, at the meter, until eight.

Kim opened the door to his knock, saying, "Flash?" before she saw who it was. She was wearing Arthur's yellow *RANDOM LAW* shirt. It was big on her. "Where's Arthur?" she said. Her long white-blonde hair was too straight to get tousled by sleep, but she'd been sleeping. She stood in the doorway, uncertain.

"I might as well come in," Fred said.

Kim stepped aside.

"You're looking for that painting," she said. "It's not here. Arthur's not…"

The place, at a quick glance, was as Fred had last seen it.

Kim said, "Arthur's a baby. One time…he's a genius is the trouble. The kind of genius, I saw a program. They call it something French. *Enfant terrible.* No. That isn't it. It's French but it's not…It's…"

"*Idiot savant,*" Fred said.

"No. Not *Idiot souvent.* Not…Where they're too fucking innocent to live but they can tell you all the dates in the history of the world, but backwards, and what happened, and add them together and understand why, but they can't decide what they want for breakfast? He can't take care of himself. One time… well, I thought, I'll ask Sammy Flash, the old guy that hangs out

in the hallway, but he's gone. Like that. So Arthur's with Sammy. Is my guess. But Arthur wouldn't go anywhere with Flash. Who would? Flash wouldn't go anywhere with Flash either, except what can he do? He can't help it."

"You say you're worried?"

"Sure. Mr. Z being dead. *Killed,* you could say. This commotion about the painting nobody ever used to give a fart and a half for. You suddenly turning up is part of it, too, and running around everywhere and it's because of you I heard about Mr. Z. Wouldn't you? Be worried? And who's this Lexington Orono? If ever I heard a made-up name! It's like two fancy cars in a head-on. Lexington Orono!"

Kim turned to the table where Arthur kept his tools and picked up the folded sheet from the notepad of the Charles Hotel. "You know so much," she said, "Who is this so-called Lexington Orono?"

"Show me." Fred held his hand out for the note. A large, thick, hearty cursive designed for short notes: *Arthur* on one side; on the other, *Arthur, my business with you is worth $$. Talk to me first. I am at the Charles. Ask at the desk. Lexington Orono.*

Fred said, "You found the note on the table?"

"No. Like it was shoved under the door, I stepped in."

Then Arthur hadn't seen it. Arthur hadn't been here since Fred left.

Kim said, studying the note, "What has me worried, the people Arthur works with, does pieces for, no way would one of them stay at the Charles."

Fred walked them over to the card table in the kitchen area that served Arthur's dining needs. A couple of metal folding chairs there. He pulled one out and sat. "In case I can help," he said. "And leave the painting out of it, OK? Let's say it doesn't matter. And a painting *doesn't* matter when you stack it up against—let's say, for the sake of argument—what happened to Mr. Z. That's what you are worried about, yes?"

Kim said, "I didn't want to be alone."

"Who does?"

Kim sat in the other chair, giving a little shiver as she did so. Kim sitting across from him was like having an illuminated medieval manuscript transformed into living flesh, simultaneously, by both the good and the malignant godfairies. The miniature figures moved in their youthful, compact, swirling world.

"Tell me about Sammy Flash," Fred suggested. "First you thought Arthur must have gone somewhere with him. Then you assumed, when I knocked at the door, I must be Flash. Flash has keys, I happen to know. But it looks as if…"

"He's one of the old timers," Kim said. "You think Kenzo's an old timer until you see Flash, so old he could be a black-and-white movie. Even before talkies. God, if only. Flash will not shut up. You've run into Flash, you know. If you've got time, you start at one end of the string that comes out of his mouth, while it snarls and tangles and loops and braids and kinks, and it's caught up in the trees, before you come to the other end of it. All I can tell you is, if you have the time to wait and find out what he's trying to say, you've got more time to waste than I do. You can have that for free."

"Kenzo kept Flash around," Fred said. "In the old days, in Nashua. Why?"

"Kenzo would do the Asian stuff, and the bikers, and the hot chicks, which there are not as many of them as you think, you look at the magazines. We, some of us from Central High, Arthur, liked hanging around out front. Flash was just this old guy, like he was a big shady tree, you thought—gee, this is the real world, what it's like. History. Flash has his own line too, stuff he'll do, cartoons he likes especially, antiques. Betty Boop he calls one girl used to be popular you probably never even heard of, so long ago, boobs, some of the guys like, retro.

"So partly Kenzo took pity on the guy, partly he could use him, and partly—he didn't want to keep a dog—he let Flash sleep nights in the shop, to guard it and then Flash has a place to sleep so it works out. Flash drinks, though. And also, well, him and Kenzo go way back, and these guys stick together. Flash kept the people entertained, they waited."

"With Tippy at the reception desk," Fred said.

"For a while, but she didn't fit in, and anyway…shit! You know a lot all of a sudden! But what I'm saying, then Kenzo got pissed at Flash. There was too much missing."

"Tippy?"

"Tippy? What was there in that place Tippy would want? Hell, no. Kenzo took the cash with him, no point leaving that overnight, and what else is there? No, what Kenzo started missing—needles, ink, the odd tattooing machine, even lights. So first thing, you look at the bum who drinks, and Flash is it. Kenzo threw him out."

She paused and explained, "This is around when Arthur left. You know Tippy?"

"Not really."

"What am I supposed to do about Lexington Orono?" Kim demanded.

"What are you thinking?" Fred asked. "I mean to say, what are the choices?"

"The man says, Lexington, there's money in it for Arthur. Arthur doesn't know, and I can't find him to tell him, and if the guy is the same as everyone else in the world who stays in a hotel, he's not there for long. Next thing you know he's somewhere else, and you don't know where that is."

"I see what you mean," Fred said. "Meanwhile, there's a woman working at Kenzo's now, from down south. Stephanie. You know her?"

Kim shook her head. "Arthur and me, we left Nashua pretty much at the same time. Well, you could say, the same car. See, Arthur not driving, and he needed to get out fast, and I was ready too, have a look at the world. You don't know, you live in Nashua, New Hampshire, how big the world can be. Tippy, by that time…"

"She was with Arthur, no?" Fred said.

"But she wouldn't leave town," Kim said. "And she wouldn't go farther than she had. With Arthur. The thing on her butt was it. She loved it, but that was it, she said. Anyway she had

the gig with the Moonglow, dancing regular, and a room with Mr. Z. She was set pretty much for life, she wanted.

"Meanwhile, that painting Arthur had, the one Tippy had a little part of on her butt, the bugs—that painting, the whole thing, when I saw it I knew it—that was me!"

Chapter Thirty-six

Fred said, "I'm slow. Listen, when Arthur gets home, if he finds the two of us here, you being not exactly dressed, and us so comfortable, informal together, is that a problem?"

Kim laughed, then added, "No offense, Fred. Anyhow, Arthur's not that way."

"I'm keeping you up," Fred said. "As long as we're waiting for Arthur—and I'm thinking about your question, what should you do about Lexington Orono?—but I don't have an answer. Something puzzles me. I don't have a perfect memory for people's faces, but I'm pretty good remembering what they say, and you were talking to Claire in the shop. You remember? A couple days back. I was there, Claire was cutting my hair."

"Sure. I remember. I embarrassed myself. And you didn't take advantage of that. Or me. Not yet anyway. And it's too late. Say anything about it now, Tampa's not going to believe…"

"What you said, talking to Claire," Fred said. "I can quote exactly, because I was interested, and I thought about it, you were talking about '…the last thing he started, we call it a gremlin, like an egg with two heads and chicken feet…' in the middle of your back, you said, ' My idea' (That's you.)…'first time I went in there, because I'd lost touch with him until I happened…I wanted a pirate ship full of the pirates, the flags, the maidens. Parrot screaming. Guns, sabers…' and so on; and then, 'But then I saw what he had kicking around there, like a dirty old

wooden painting, and he and I fell in love at the same time. With the idea.'"

"You even make me sort of sound like me," Kim said. "Except I would never say 'maidens.'"

"How big is the painting?" Fred asked.

"About yay by yay," Kim said. She stretched her hands and arms to something like three feet by two and a half. The gesture stretched and distorted the yellow T-shirt and its motto, *RANDOM LAW*.

"On wood," Fred said. "Dirty."

"That's what I said. So I guess it's true."

Fred said, "From what you said to Claire, you never saw the painting until you saw it here in Arthur's place, in Cambridge, when you happened to bump into him again, after you hadn't seen him for a while."

"Claire's not like a friend," Kim said, as if this observation satisfied the contradiction. "The thing about this painting you keep talking about, in spite of you said you weren't going to. I never saw it."

"What you said to Claire…"

"So sue me. You know how, it's the social contract. You tell people what they're waiting to hear. What Claire needs, she needs to get away from her mother. Out of the house. She's a big girl, earning good enough money, have her own place, have her own life. She goes home, they're always on her about something, now she's supposed to give them something for her room? Rent? So what she needs, she gets ink where they can see it, people like that, they are gonna throw her out.

"The story I give her, if the story is good, pirates, parrots, this dive in Central Square, the G Spot, she'll let me bring her to meet Arthur and once Arthur sees her, skin like she's got, Arthur goes ape and sells her on a big picture maybe, he's got a client, she's got something gorgeous, and also the benefit, she gets her freedom.

"Also, and Arthur lets me have a finder's fee, depending, how much of a commitment Claire makes, I get so many more hours of his time. It's a win-win-win for everybody.

"Arthur has big ideas. And it all comes from Mr. Z. He roams around the world, Arthur does. Mr. Z, his roaming days are done. You think, looking at him, at Arthur out there, he's looking for real estate? He's one of those developers? No. With Arthur, what he's looking for is skin. He's a…what do they call it? *Enfant perdu*? That sounds French but it doesn't mean anything. No. He's walking around, what's in his head is the picture he wants to put on the right person. It's like he's, when he talks about it and his eyes glaze over, maybe we're in bed, I'm trying to get his attention…a projector shooting a picture out, that wants to land on the right person's body, and stay there.

"Another one he describes—he says we saw it in Mr. Z's class but who was paying attention except Arthur?—it sounds perfect for Claire if the bee on her butt can be covered or fit in, because Arthur hates competition—is knights on horseback. The horses rearing, on a pink field with roses blooming behind them in a hedge, a dead guy, spears going in all directions…"

"Paolo Ucello," Fred said. "*The Battle of San Romano.*"

"What?

"I'm betting that's the picture, *The Battle of San Romano.*"

"Shit, I wouldn't know," Kim said. "Arthur describes pictures he sees in his head, you think you're looking at them on the person."

"The painting was in your car when you and Arthur drove down from Nashua," Fred said.

"All the knights and horses?"

"The one with the gremlin, the birds and fish and naked people, and the burning city," Fred said, "that's all over you now."

"What if it was?" Kim said. "I have to get some sleep. Not with you here."

"I wouldn't mind taking a look around before I go," Fred said.

"I looked everywhere," Kim said. "Go ahead, if you'll leave after, so I can sleep. Arthur's, wherever he is, not coming back. Not tonight. Girl probably, a new back that while he's doing it with her, all he's thinking about is doing it to her, this other idea he has, a unicorn with hunters all around, spears, in a mess of roses…fuck him. He's not done with me."

Kim stayed close while Fred went through the apartment, limiting his search to any place that would accommodate a painting of the size Kim had described: the bedroom closet, back of the bureau, under the bed (Kim's clothes on the floor next to the bed); between the funky mattress and the equally funky box springs; in the tiny rancid hall off the kitchen that led to the cluttered back stairs. If the painting was two by three feet it would fit under the couch where clients lay down for certain work, but not in a drawer, or…in short, there were not many likely places for the painting here, and Fred came up empty.

"I told you," Kim said.

"I'll be off," Fred said. "He has my number—but in case Arthur wants to give me a call…" He wrote his name and number again on the note from Lexington Orono, with the message, *Call me.*

"Also," Kim said, "Arthur being such a baby…" She'd walked him to the apartment door and was talking him out. "One time…So I made up my mind. This guy Lexington. If there's money like he says. See, money is not what Arthur is into. Being a genius, and that French disease he has, the *songe impure* like they sing in that song of the Revolution, Arthur does not give a shit about money. Everyone else in the world could push him around if he lets them, and he will. Because all he cares about. This vision. There's tons of money in Arthur, I know it, if he gets played right. I mean, if he plays it right, which he'll never do on his own.

"He can't go up to a stranger in the street and say, 'Here's what you need on your back: a scene of hunting, dogs, and porcupines and one guy with a stick, a girl with a net," because the stranger will run or will deck him and run, or just deck him. Arthur needs me. And I brought him people already.

"I made up my mind, I had time, we're talking. Arthur may not give a shit about money, but I do, and I'm Arthur's friend. I do not say girlfriend because, fuck him, where is he? What I'm gonna do…

"Another thing, by now he owes me, big time...what I did for him. Big time. Forget Kenzo. I'm gonna go see Lexminster Oreo myself. Find out about the money. I want to get to Phoenix. Phoenix sounds like me. And Arthur, Arthur can do well in Phoenix is my bet. So I help Arthur do whatever he has to do, and get my cut. Does that make sense?"

Fred spread his hands. At the moment not a great deal made sense. He started down the stairs.

"And another thing..."

Fred turned back.

"This thing. Because you don't look like it. You being. The painting. Could that mean money? For Arthur? I mean to say, money from you? Are you in the bidding?"

Fred said, "I wouldn't say no."

"Because it looks like now, the son of a bitch has stashed that painting somewhere. And me getting a cut, right? How much?"

"I'd have to see it," Fred said. "I wouldn't mind being the first one to see it. Before anyone talks with Oreo would be good."

Chapter Thirty-seven

The voice was Arthur's, again finding Fred asleep on the leather couch in his office space at Clayton's. "Where can we meet?"

"Arthur," Fred said into the phone. The silence confirmed it.

"Depends where you are," Fred said. "And when." He sat up. Seven thirty. He'd managed two hours.

"I've been walking. Called my place. Kim, you know Kim?"

"Right," Fred said. "You want to meet there?"

"Kim gave me your number again. I'm not going to my place right now. She's…There's too much…There's too many…I'm not…"

Silence stretched out on his end.

"Wherever you want," Fred said. "I hope not back in Nashua, but I can get there."

"I walked across the river," Arthur said. "Then along. There was enough light. The roads along the bank. I was walking. Trying to think, but I can't. I'm at, right now, there's a big drug store, Charles Circle, near the bridge where the Red Line crosses into Boston?"

"I know it," Fred said. "In fact, I'm not all that far away. Get us a couple coffees, I'll stop by."

"I don't have much money," Arthur said.

"Give me ten minutes." Fred described his car.

◇◇◇

Fred handed a five through the window, told Arthur, "Large, black, for me," and waited until Arthur came out again, balancing two containers. "We'll go where I'm crashing," Fred said.

Outside the basement door he went through the motions of tapping code into a box concealed in the ivy. Arthur Pendragon, né Schrecking, was 97 percent an unknown quantity. There was no point letting him know of Clayton's hardheaded refusal to indulge in a security system.

The door opened directly into Fred's office. There hadn't been time to straighten things out of the way. The desk was heaped with books and catalogues, as was the floor at either end of the couch where Fred's navy blanket was thrown back.

"It's cool down here," Arthur said, gazing around. The books he disregarded as if he were a shark and they a particularly unappetizing breed of starfish. But he took note of two paintings leaning against the bookshelf, their faces inward.

Fred said, "I told you. I like paintings." He turned the two pictures around, propping them side by side on the floor. For something to do, he'd been trying to make sense of them a few days ago. He'd pulled them out of the racks in the storage area that adjoined his office. Having access to the racks was one of the pleasures that accompanied working with the insufferable Clayton. Arthur squatted down to look. The smaller of the two pictures Fred wasn't happy about. Maybe six inches by ten, it represented a still life—peaches, probably, on a plate, surrounded by background so murky it wasn't possible to guess what, if anything, it represented. The paint had been applied to canvas, and the canvas later laid down—glued, in fact—to another canvas, the second a superior linen. It was easy—uncomfortably easy—to read the signature in the upper right corner, *Renoir*. But the picture was bad.

Arthur picked it up. There was no doubt about the signature—that is, about the fact that it had been put on with a stamp. The estate had applied the facsimile of the artist's signature after his death, to pretty much anything they could find blowing around his studio, including sketches he wouldn't have used to

wrap his dog's lunch. Things he would have destroyed, because their existence contaminated the integrity of the record. So there were known and established works with the Renoir signature that were, within the embrace of this caveat, legit. But because so many of these works were truly inferior, it left room for easy fraud by unskilled forgers.

"What do you think?" Fred asked, taking note of Arthur's preoccupation.

"Working on skin, what you don't get," Arthur said, running his palm across the rough surface of the painting, "is the 3-D effect. Like here, where there's like a crust." He feinted toward a highlight with a fingernail. Fred held the hand back quickly.

"Guy I work for's kind of picky," Fred explained.

"Whatever," Arthur said. "You look at the pictures like what Mr. Z had, printed, it's all smooth. You don't get confused. If you want—and it would be a stupid tattoo, I would never do it—but say you want to do these fruits, I guess they are, rotten, places where the paint crusted before it dried, like a scab? The only way I can think to do it is raising scars on the person, which takes forever and then you can't get color onto the scar, it's dead. It's what you do? Work with these? It's here, your work? What's the work?"

"For one thing, is the painting you're holding a fake?" Fred said.

"It's ugly. Who cares if it's a fake?" Arthur's reasonable point was much to Fred's way of thinking. But the fact that the picture was ugly wouldn't kill it in the marketplace if it could be demonstrated as legitimately by Renoir. In the right sale or circumstance it would command as much as a hundred grand from the buyer who wanted that brand name to display. Clay could sell it and use the proceeds to buy five other pieces. Arthur put the picture back on the floor, its face hidden again. "That's better." If the signature, *Renoir*, meant anything to Arthur, the fact didn't register.

The second painting, also French, was rock solid. On canvas, roughly a foot square, it had been waiting in the racks while Clayton took his agonizing time to decide how to frame it. It

was a dark and crusty Daumier *Harlequin* reading his newspaper in the wings, tilting the pages so as to catch the glow from the footlights. It was not in the Daumier literature, and wouldn't be any time soon. The signature in red paint was fine. Clayton had landed it in a private sale. He would not say even what country he had bought it in.

Arthur folded his arms and studied the picture before he shook his head and said, standing, "Doesn't do it for me. The guy, you can see he means well. Artist who painted it. But there's no detail. When you get right down to it, it's out of focus. Well, you can read the name of the paper, I'll give him that. But with a paintbrush, what can he do? He's screwed. That's why I like a needle."

Fred pulled his chair away from the desk and sat, leaving the couch for Arthur, who figured that out and sat. Fred pried his coffee open and watched Arthur doctoring his. He waited. Let Arthur figure a way into the next scene. Whatever he adopted as his opening gambit, Arthur would be bound to reveal something. As far as Fred's position was concerned, everyone knew what that was, at least to start with—he wanted a look at that painting.

Fred took a drink, rehearsing what he had so far, and how it would look as an appendix in the revised updated Hieronymus Bosch catalogue. *A Paradise for Fools* [the name Fred had assigned the painting he was chasing]. Date: unknown [possibly 1500]. Support: oil on wood [perhaps poplar?], yay by yay inches [ca. 24 x 36]. Location: unknown. Provenance: unknown, thence to Zoltan Zagoriski, recently deceased, and/or Mary Zagoriski, married, of Nashua, NH, [Mary having removed to New York?], thence to Tippy Artoonian, also of Nashua, NH, thence [the issues of actual or legal ownership or title being unresolved] to Arthur Schrecking [aka Arthur Pendragon] of Cambridge, MA, with, as an interesting side issue, the interference of Ruthie Hardin of Nashua, NH [aka Kim Weatherall of Cambridge, MA]. Subject: A scene reminiscent of aspects of the Prado's triptych known as *The Garden of Earthly Delights,* including a version of the central iconic image from the right-hand, or

"Hell," panel: a hollow eggshell with two heads and the feet of a chicken. For further details readers are referred to the collection in progress on the skin of Ruthie Hardin, aka Kim Weatherall.

Arthur said, "I can't keep it straight in my head."

"We've got time," Fred said. "At least I do. I don't know your schedule."

Arthur scratched at his thick mop of red hair and the action brought to his notice the glasses he seemed surprised to find on his face. He took them off and cleaned them on the lower end of his regulation white T-shirt, then put them on again, wincing as if they hurt his face.

Among the questions Fred was not asking: Did Tippy call you? (But he wouldn't have been home, would he?) Have you talked with the dealer Lexington Orono? Did he offer a deal? Did you sell him the painting? How come did Sammy Flash move out? Is it relevant? When you first telephoned, two days back, you were alarmed about something and you thought I might be part of it. What spooked you? Kenzo, wasn't it? How much control does Kim have over you, and why? Oh, and also, where is the painting?

Chapter Thirty-eight

Arthur said, "Everything should be simple and easy."

Fred had no argument to offer.

"Instead..." Arthur said. He let the idea dwindle away to nothing. Come to that, it was a pretty much nothing idea at its point of origin. He tried again, "Once you've said one thing, and then something else, and then I don't know, and there's loyalty, and none of my business, and I don't care anyway, and sometimes it's all too much. Something else happens. And now Mr. Z is dead."

"He gave you your start," Fred tried.

That was a mistake. Arthur glowered. "Him? All those beautiful things? What he does, he holds them hostage. Mr. Z does not give a rat's ass for anything except cornering a girl and making her life better for her until he can get close enough she's bumping up against him. She's a hostage too, until then she gets an A.

"Me, he flunked. Gave me my start? They made me take business math in the summer, make up the credits. Slimy son of a bitch. He brings in these beautiful things, lets them loose in the room, like they have wings, these pictures, like beautiful birds. People waiting for lunch, they don't, he doesn't give a shit either. What he's doing, we're waiting for lunch, detention if you fuck up. Him, he's waiting for his paycheck. Smoking in the hall. Because he's too good for us. And he passes around these beautiful things he has, that he doesn't give a rat's ass about,

and, the end of the period, he collects them and what we were supposed to write which he does not have to read. Kids write anything. He uses it for attendance.

"It's art, he says. Be creative. Meaning who gives a rat's ass?

"She almost wouldn't talk to me. I figured out, well, because that's what she said, what Kim thinks, I'm with another girl. Kim's jealous and she's mad and she has my keys and I'm not even finished, my big project, I want as much as she docs, it's like, why I'm alive. I figured, she's not in the place she's staying, maybe she was with me. In my place. And I don't…I can't… they…Shit, most of the time I didn't even go.

"She almost wouldn't tell me—see I didn't bring your number with me—you can tell her, you remember, I remember that night you came by. Two girls. I was working—maybe you don't remember?"

"I recollect the scene," Fred said.

"The two girls. Beth is one," Arthur plowed on, "that I had started with, the two guys blowing flowers while they fly…"

"Got it. From the left side of the Botticelli *Venus*. The winds."

"If you say so. Yes, that's what you said. It doesn't matter. Listen, that girl Beth. Beth is *with* Eva. Eva was the other one? That was getting ink when you came? You remember?"

"I do," Fred assured him.

"Because if it was me sometimes I get so blown away by the picture, I forget who it's on, or what, or whatever. Anyhow, Eva was at school. Central. With…you remember, all that red hair she has, really red, not like mine?"

"I promise you, I remember Eva," Fred said.

"It's true we had a thing in high school," Arthur said. "Eva and I did. So what? Everyone had a thing with someone, and mostly it didn't mean squat. Anyhow, Eva's with Beth. You saw that. She's crazy and an asshole and I told her but what she decided, Kim, if I'm not home, I must be sleeping with Eva. I can tell you the only way I'd get through to Eva now is first I'd have to get past Beth and, besides, that's all over, years ago.

"So. Can you tell her?"

"What? Tell who what?"

"Tell Kim that Beth was there that night when I was doing Eva's ink, the whole time, and you could see, and anyone can see, Eva and Beth are the thing. Not me. That's all I can think of. Or I'll never finish it," Arthur said. "With Kim."

"Right," Fred said. "Sure. I'll tell her. Happy to. Next time I stop by CUT - RATE - CUTS."

Arthur explained, "People get ideas."

Fred let a silence develop until the silence seemed inefficient. It wasn't pregnant, but vacant. Arthur had drifted into deep space. Fred said, "I get the impression you're in trouble."

"I'm not like Kenzo Petersen," Arthur said—not responding, but coming out of whatever cloud he'd been in. "Kenzo, before he puts the needle in, he likes to put his needle in, the way he says it. That's not me."

"Got it," Fred said.

"Man, woman, boy, girl, it doesn't matter," Arthur said. "It's a Zen thing with Kenzo."

"Jeekers!" Fred said. "That's Zen too?"

"Kenzo's into Zen in a big way. The rest of it, I don't want to…"

"Listen," Fred said. "On another subject. We're here, everything's quiet, what I'm going to do—I give you a pencil and a clean sheet of paper, you sit down at my desk, and draw me that painting. I'll give you a hundred dollars for it. That fair?"

"Fuck that. For the painting?"

"For the *picture* you'll draw of the painting." Fred began clearing space on his desk.

"I don't draw with a pencil," Arthur said.

"A pen, then," Fred said.

"Ball point? I won't draw with that," Arthur said. "Ball point. That's grease."

"It's what I've got," Fred said. Clayton would have a fountain pen—but with him in Lugano or wherever he had been diverted after the wedding.

"Whatever you want," Fred said. "You don't carry your own pen? You insist on a fountain pen, but you don't carry…"

"How am I gonna carry a fountain pen?" Arthur demanded, gesturing toward the blank and pocket-less flat chest clad in Fruit-of-the-Loom.

Fred said, "You'll be offended if I offer you, say *two* hundred to draw the thing with a pencil."

"I don't draw with a pencil," Arthur said. He kept it reasonable, as if he were explaining to a two-year-old that humming birds don't swim, or breathe fire. "You want to see that painting. That's all you want. I don't know where it is. Besides up here." He tapped his head hard enough to shake out a thin scattering of dust or dandruff.

"Listen," Fred began.

"I don't have it," Arthur said. "People were…and I couldn't think…and I have it anyway, up here, is all I need, and Kim. The goal is Kim. Finishing Kim. You are going to settle Kim down for me, yes? It's what I live for. I'm not finished. That was a promise?"

"I'll talk to Kim," Fred promised. Talking with Arthur was like climbing up and down three toothless ladders all at the same time, none of which might lead anywhere. "Listen," Fred said.

"Kim's pissed. Wants to sell that painting, but I don't know where it is. She thinks I'm lying. Trying to figure out where I hid it."

"Listen…" Fred said.

"And don't offer me money. What everyone doesn't understand," Arthur said, "is I don't want money. I don't want money. I don't want it." He shuddered and pressed his hands against his ears.

Fred said, "I'm the same way. Maybe not as much, but I do understand. I take it back about the hundred dollars, unless you can use it."

"It's confusing," Arthur said. "Money. It's like a foreign language you don't want to know. That everything they say in it you don't want to hear. Like knock-knock jokes."

"Flash told him where I was," Arthur said. "Has to be. The old guy I was letting work outside my place. That's all I can figure.

Kenzo calls me, so he has my number, obviously, so therefore Flash gave him my number. Anyway, who else would? Says, How's tricks? Like everything's suddenly fine, he's not gonna beat my head in like he said. Instead, he's got money for me. For this fucking painting, he says, that nobody ever cared squat about."

"Kenzo," Fred said.

"That night. Then you called. Money," Arthur said. "The only thing makes most people ever stop thinking about money is sex, and most of the time even then they're thinking, what they're thinking, is, sex, sure; but how much can I *get* for it? Or how much can I get it *for?*" He noticed his coffee and took a big drink from it. It settled him into a tremor that was comforting in that its cause was physical, and not spiritual.

"I'll tell you the truth, Arthur," Fred said. "You and I are brothers at least this far. I hate it when art and money get confused. It happens all the time. Most people can't even see the art. The money's in the way."

"Like drugs," Arthur said. "Which I can't do because I disappear, but other people…you see, the TV in the G Spot, or Kim has one—I don't want one; TV is on, I disappear—there's a drug bust, all they'll say, the cops, the reporters, 'And in the trunk of the Buick le Sabre was a stash of heroin with a street value of three hundred thousand dollars.' Not how many people could get high on that for how long, maybe the entire city of Providence, Rhode Island, for a year. Or, I don't care. What color was it? The le Sabre. What else was in the trunk?"

"How much did Kenzo offer for the painting?"

"I don't know. I don't remember. Too much. He said so much money, if I didn't already know he was lying when he called me, said everything's great, how are you? I knew it was a lie when he said what he'd pay me for the painting. But he's a liar anyway. It's a Zen thing. Once you're that into Zen, everything is true.

"What I know is, he found me, and what he said he wanted to do to me, that's what he still wants to do. I'd be crazy, I didn't believe that. That's what Kenzo wants. Same as he wanted before."

Chapter Thirty-nine

Arthur said, "Then, when I got around to looking for it, it wasn't there."

"After I was at your place," Fred said. "The painting, yes? The other night? You were working?"

"Right. And you, I was already upset, Kenzo calling, then here you are, a stranger, suddenly you're after the same thing, I thought you wanted ink? Your note. You said you loved the Piero. Then you're here, suddenly you want the painting too, like Kenzo said he wanted and I didn't believe him? Big as you are? Wouldn't you be scared? So I threw you out, and then I went out later, get some air, I get, when I'm working…and then I got back, Beth and Eva had gone. I was longer than I maybe thought. I looked under the bed, thinking what Kenzo said, and you being there, it wasn't there. So they maybe have it. Took it. Eva and Beth. I'm rid of it anyway. It's not my problem. It's not like it was mine. Or, I don't know, they could give it to Kim except she's mad at Eva for the reason I told you, which is not a reason."

"And you're afraid of Kenzo Petersen," Fred prompted.

"Bastard said he was going to send someone," Arthur said. "You ever see the people he has coming by? That he could send? You bet your ass I'm afraid."

"Would Kenzo do that to Mr. Z?"

Arthur said, "It was an accident."

"Somebody went over him three times," Fred said. "Not a Zen thing, not even by Kenzo's definition. You know the guy. Kenzo. What do you think?"

"Coffee. I haven't eaten. I've got the shakes." Arthur took another trembling drink.

"Let's go out. Maybe find a fountain pen."

◇◇◇

They mixed with the late breakfast crowd at Rudolph's diner on Charles Street. It was an easy walk, and Fred was not inclined to take Arthur upstairs and cook him eggs in Clayton's kitchen, letting him look around. Arthur was too loose a cannon. A couple of inquiries, as they passed likely spots, convinced them that there'd be no fountain pen available unless they happened on a stationery store. Too specialized a requirement. That brainstorm would have to wait before it could be realized.

They sat at the counter. Fred watched Arthur tuck away a more than hearty ration of sausage, eggs, and pancakes with butter and syrup. "We'll talk about something else until we come out," Fred had said before they went in. "Not Kenzo and Mr. Z, OK? With people around? Or the other things we've been talking about."

"OK by me," Arthur had said.

They ate in silence, therefore, aside from occasional conversation between Fred and Rudolph, who was busy at the grill. "More scrapple?" Rudolph offered at one point, and Fred obliged. But Arthur had no conversation. Not sports. Not motorcycles. Women. Wildlife. Movies. Nothing. Arthur ate.

Stepping out again onto the sidewalk, heading back to Mountjoy—Arthur had put himself into Fred's hands—Fred picked up where he had left off, more or less, at least from the point of view of where he hoped he was going. "Kenzo got the idea, talking to you, that you might hand the painting over to him. Is that right?"

"A tough guy who gets his way," Arthur said, "he's gonna hear what he expects to hear, most of the time."

"Afterwards, after I'd been there, after Eva and Beth took off while you were gone, when you came back, you found out the painting wasn't there," Fred said. "When had you last seen it?"

"I figured, I'm free. Then next thing, I started thinking," Arthur said. The higher end shops were starting to open their doors—places whose customers can afford to sleep late. Arthur gave them not a glance, even the shops with works of art in their windows.

"Whoever Kenzo sent would find you didn't have it after all," Fred said. "And be, let's say, disappointed. Or figure you had it but you changed your mind. Maybe wanted a better deal."

In fact the someone Kenzo had sent was Stephanie. She had brought with her a different kind of backup persuasion—not violence, unless you counted sex as violence. She'd said nothing about money—not even when she was under the misapprehension that in Fred, she had found a larger-than-life-sized Arthur, well worth persuading from her point of view.

"I told him I didn't want any fucking money," Arthur said. "Then I hadda, it wasn't mine, exactly, and Tippy and I aren't, if I call her…that would mean Mr. Z again, because that's where she was. Maybe he would say the painting was still his? Like Kim said he could say. Her opinion. So we hadda…I don't know."

They turned up Beacon Hill on Mountjoy and Boston immediately became quieter, shadier, greener, less diverse. More brick, more history, more ivy. Fred said, "Mrs. Z. When she took off…"

"Yeah," Arthur said. "If Eva took it out of my place, why wouldn't she give it to Kenzo? Then I'm home free." He stopped on the sidewalk facing uphill, disregarding gravity and studying the question. "But how would Eva know Kenzo wants it? I get confused. Or no, knowing Beth like I do, what Eva would do, Beth would sell it to Kenzo. They were there when Kenzo called me, yes? Or was that before? They saw how upset I was. I can't remember."

Arthur started walking again, Fred at his elbow. He stopped abruptly. "I talk while I work," he said. "But I don't listen. You came to my place. You asked about the painting. I threw you out.

Did—see what I thought, why I was upset, when you mentioned Piero, I thought Piero was the one Kenzo was sending. Or you were Piero. Is that what I thought? I'm confused."

Arthur started walking again, in a daze. Fred steered him left at the walkway to Clayton's building, and down the stairs to the basement entrance; went through the charade again of punching the security code into the ivy. Arthur, thinking, paid no heed. Inside again, and seated on the couch, he asked himself aloud, "Did I mention how Kenzo offered money for that picture? Did I remember how much? Talking to Beth and Eva? While I was working? To keep them quiet? I might do that."

The effort required to keep thinking in a straight line exhausted him. Fred prompted, "Eva, being from Nashua, part of your crowd in the old days. She'd know Kenzo."

Arthur turned, stretched out on the couch, said, "Do you mind?" and slept so instantaneously it seemed he had been shot, except that he continued to breathe, deeply and regularly.

It was Flash who had told Kenzo how to find Arthur. Even though both Arthur and Flash had reason to keep out of Kenzo's sight.

Sitting at his desk across from the sleeping Arthur, Fred called the house in Charlestown.

Morgan again on that end, answering as he did with the single word, "Morgan."

"Fred," Fred said. "Checking in."

"Right," Morgan said. "Nothing going on. Beyond it's getting hot."

Fred said, "I can't talk now. That guy upstairs?"

"No problems."

"Can you expand on that?"

"Haven't heard anything," Morgan said. "Haven't smelled smoke. Or we'd throw him out."

"He's there? Put him on, would you? "

"I'll check," Morgan said. "Can't say I've seen him. Flash, right?"

"Right," Fred said. Arthur slept on. He had two amazing talents. He had such total recall of a picture that he could draw it accurately from memory with a fountain pen. And he could sleep on a dime. The books on the desk that exposed his own interest in Hieronymus Bosch, Fred moved downwards in the piles while he waited. No point dropping that name into the mix. As far as Fred knew, Arthur had never encountered the name Hieronymus Bosch. But he happened to be the world's sole living expert on one of his missing paintings.

"Not here," Morgan said.

"His bag? No, he'd have that with him. Listen, he left a pair of pants on the radiator, drying. Did you notice…?"

"Lemme check."

Fred pulled out the desk's top drawers and fumbled through them. Clay worked here sometimes. He favored fountain pens, as Arthur did, though the ones Clay used, like Danae, tended to have been visited by a shower of gold. There might be a spare.

No luck, but Fred found a deposed queen's ransom in paper clips, pencil stubs, and rubber bands.

"All present and correct," Morgan said into the Charlestown end of the line.

"The pants are there? Brown corduroy?"

"Dry as a bone."

Chapter Forty

Sammy Flash had left town.

"Rassle around," Fred said. "Would you, Morgan? See if anyone in the place talked with the guy. Is anything missing?"

"Will do," Morgan said. "Where can I reach you?"

"I'm moving," Fred said. "I'll call back when I can. If he left a note, you'd see it."

"There's nowhere to hide a note in your room," Morgan pointed out. "You live up there like a hermit nun."

Fred let Arthur sleep for an hour, amusing himself by sketching, in pencil, badly, what he could recall of the isolated images he had seen here and there on Kim's body. He could not fit them together into anything resembling even the nightmare-like coherence of Hieronymus Bosch at his average best. For Bosch a painting's surface was like a stage set whose perspective was forced and undependable, racing back to a horizon line that might or might not give way to sky; more accurately, the crowded surface might not be relieved by sky at all. The surface itself, on which humans, demons, animals and apparitions wandered, was treacherously riddled not only by water features: rivers, lakes, and bays—but effectively also by the kinds of trap door that, on a stage, can open to admit a dead man into the action, or gape suddenly to receive a living person into a fiery pit that snaps shut over her. A river transparent enough to fish in suddenly turns to ice, and cracks open on death. A black pool, opaque lens, an

ellipse without the power to reflect, gives up creatures who may have crawled all the way from the opposite side of the—what did Bosch think we live on, a disk? a dish? a sphere?

All Fred could see from his known works was that Bosch recognized that the young earth, during its first days of genesis, had a circumference. Because he drew it that way, as if it were either a disk or a ball (either one has a circumference), with its mountains separating reluctantly from its oceans. The volume enclosed by the circumference was not important. More to the point, at least as far as his myth-making symbols were concerned, Bosch saw no clear line of demarcation between his homeland in Flanders and either paradise or hell.

Flash forward in time and carry with you the mind from which Bosch viewed the world he lived and painted in. Put him in Nashua, New Hampshire. Give him a week to accommodate himself to the passage of five hundred years: the appearance of fire engines, donut shops, super highways, buildings higher than four stories, Western clothing, girls walking around in reasonable comfort in next to nothing, a multiplicity of openly professed religions.

For Bosch, the entrance to hell could open back of the LUCK-KEY CAR WASH. Adam and Eve, taking an evening stroll through their garden after a light supper of apples, might, in stepping through the garden gate, have found themselves unexpectedly standing in the lobby of Nashua Central High School, their escape blocked by an irate angel with a flaming sword.

Bosch loved themes of temptation, and it was never clear exactly what relation there might be, in his images, between temptation and outright sin. Nor was it easily divined what moral qualities, if any, Bosch might be assigning to the objects and circumstances that provided temptation. The Bosch *Temptation of St. Anthony*, for example, now in Lisbon, offered a confusing moral lesson, if it was either moral or a lesson. Yes, at the center of the center panel knelt the hermit, struggling to meditate, and working to keep his spirit focused on eternal things, while all around him teemed, not the things of the world in their obvious

daily guise, but a rat in a saddle blanket, and fish, a swan that was also an airship, a flying galleon, that burning city again, a matched pair of humble dogs, a bishop in whose cause you might decline to invest, the crucifixion, a nun masquerading as the devil queen, or vice versa, an outsize persimmon from which emerged a whole Halloween parade, a glimpse of perfect weather and a green hill you'd send the kids to for summer camp. In short, the place in question, where St. Anthony was said to be entertaining these temptations, was not all that far from Nashua, New Hampshire, or Boston, Nairobi, or Tokyo. And nothing about it was convincingly evil.

It was weird. And painful, sure. Having your city burn to the ground around you would be painful. Ask the folks in Hiroshima or Dresden. And we know that the person purposely setting the blaze is doing something to cause pain. But the confusing thing was, Bosch loved all of it. His working hands were filled with blessing. Not forgiveness. Forgiveness carries with it the stink of implied oppression. Blessing.

What was it that was tempting Anthony?

Others among the many painters in the Christian tradition made the story simple. Show St. Anthony as an old geezer whose religious vows have included poverty and chastity. Therefore, if he's to be tempted, let the temptations be the obvious: dancing girls to divert his chastity, and offers of personal wealth. Anthony's usual antidote to these attractions was normally to fondle a human skull, the idea being that the hermit, his mind on death, must disregard the pulsing erection that was a significant witness to his nature, a rubicund reminder of his identity as a mortal human being.

Not for Hieronymus Bosch this easy formula straight from the catechism. No, Bosch tempts Anthony with a persimmon and a dead skate, or (there's Anthony again in the right panel) a light picnic lunch for one laid out on a table supported by tiny naked people, one of whom is inverted. If Anthony does succumb to these temptations, what will the symptoms be? How will we know? How will even Anthony know? What was he being

tempted to do, or think, or be? Was the whole phantasmagoria intended to seduce the saint into the illusion that perhaps a human being is no more than that? That we are not immortal after all? That what we have and make of our surroundings, and our neighbors, is all we'll ever get of paradise?

Take Anthony out of the Egyptian desert and place him instead in the mall on the outskirts of Nashua. Park his car in front of Tina's Moonlight Lounge and figure out, if Hieronymus elected to take it from there, what might we see in the new painting?

"It baffles me," Fred said to himself. "There's enough trouble everywhere in most all of his pictures, people doing things they shouldn't do. Those fellows crucifying Christ, the women laughing at his predicament—these acts are wrong, obviously. We'd all agree, even the painter. But doesn't he love these people while he paints them? Then you rear back and appraise the Christian story line he's elaborating, everyone knows that without the crucifixion you don't get the salvation of the world. Working backwards, if Eve and Adam hadn't made a wrong turn and found their way outside of paradise, we'd never have earned the presence of the savior among us, walking around, snacking like the rest of us, and making trouble."

The phone rang. Arthur stirred. Clayton. Long distance. "I have telephoned several times," Clay complained.

Fred said, keeping his voice low, "Not when I was here." It was as close as Fred would bother to approach the issue again: For God's sake, let's put in an answering machine. Clay wouldn't do it. File and disregard.

"I have moved on to Venice," Clay said. "I do not like the Gritti."

"Venice must be hot," Fred said.

"The place I am staying is called the Pensione Segusa," Clayton pushed on, and gave its telephone number. "Unless there is something pressing, I propose to stay another week. There is an issue, a potential opportunity—not suitable for discussion on the telephone."

"Right," Fred said. Arthur opened his eyes.

"Is there mail I should know of?" Clay asked.

"Nothing that won't wait," Fred said. "Robbins wants his check, but he would, and he knows damned well you're on the fence. You don't want my opinion of the…"

"Send it back," Clay said. "I had forgotten it entirely. Therefore whatever I had felt about the picture, I had confused it with temptation. I recall the temptation, but not what caused it. Send it back. Telephone first with my thanks. Explain that I was summoned overseas. Anything else?"

"Probably not," Fred said. "You'll be there another week?"

"I changed my flight. I plan, yes, to return from Venice. The sale at Bengtson. Your instinct for these matters has already proven of value. We had spoken of your going to look."

That was true. An auction sale in three days, in Cleveland, where a Fantin Latour was marooned, unaccountably, amid reams of dreck. Or what purported to be a Fantin Latour. Clay had stopped talking about the painting so long ago that it seemed to have gone by the boards. If Clay wanted Fred to bid, he'd have to go out today and have a look, then start poking around. He wasn't prepared. It was the wrong context for such a painting to turn up. The whole business smelled wrong. If they decided to make a play for it, Fred would have to stay in town in order to be in the audience to place the bid and watch the action. The phones, especially, where some houses accommodated phantoms who placed imaginary bids in order to goose up the blood lust in the sale room. Clay had never done business with Bengtson. What they were able to learn about the auction house's reputation was not reassuring.

Fred said, "They hold all the cards. As I've mentioned, Clay, I'm not inclined to go to Vegas, either, to bet against the house."

"Never mind, Fred," Clayton said. "It makes me too uneasy. We looked at the transparency. We studied the condition report. The painting could be right. At the price they're suggesting it hardly matters. But the figure they suggest is meant to tempt the unwary. Whatever price is realized at the sale, as you well know, shall be established by the conflict that is engendered

amongst the interested parties, and not by the auctioneer's derisory appraisal. There will be struggle. They've advertised the picture everywhere."

Chapter Forty-one

Arthur sat up. Next thing he'd want to use the can. That would lead him toward the racks where paintings were stored. Fred, motioning toward the phone, gave Arthur a signal to be quiet. If Clayton got an inkling of this odd stranger within his sacred precincts, he'd have conniptions.

Clay said from Venice, "What you could do for me. When I next call. I won't speak the artist's name over an open line. Who knows what these Italians…Fred, get me a general sense of recent auction prices for drawings by…a man of considerable importance…start with T and finish with an o."

Tintoretto or Tiepolo maybe—but there had to be a dozen more. Fred joined the game. Arthur was listening with interest. "For a consonant four letters in. Might that be a T or a P?"

"It's a P," Clay said, exasperated. "Great heavens! What do you take me for?"

"Early eighteenth century? Seven letters?" Fred pressed.

Pause to allow Clayton to count. "If you include the first and last letters," Clay confirmed.

So Clayton thought he had a lead on a drawing by Tiepolo. Unless there was another notable seven-letter eighteenth century Italian artist starting with T, ending with O, and with a P in the middle. Working with Clay's contortions could be exhausting. "I'll get a read on it," Fred said. "You want me to check retail prices in the galleries while I'm at it?"

"Good God, no," Clay expostulated. "Don't make waves. The boat may already be filled to the gunwales and could become swamped. Do nothing that draws attention. Tell no one where I am. Should anyone ask, whom you feel deserves an answer, I came to a wedding in Lugano and decided to take the waters elsewhere. You are not sure where."

Clay rang off.

"What is it, code?" Arthur asked.

"Like that."

"He thinks he has a system," Arthur said. "Tell your friend, you go to Vegas with a system, like playing the numbers anywhere, you defeat yourself. I've seen it happen. New Hampshire, the lottery, people I know, they think, something like, my birthday, it's September 9, and now its 1999, how could I miss, betting nines? All nines. And they do, and once again the universe doesn't get it. State of New Hampshire doesn't know it's the guy's birthday. You got a men's room?"

Fred led the way through into the little hallway that opened on one side into the generous bath-with-shower and on to the large area in which Clay kept, in temporary storage, the paintings he was not hanging, hadn't consigned to more secure storage vaults elsewhere, outside the building, and wanted access to, to think about or worry or gloat over.

Fred stayed outside the door and stuck with Arthur when he re-emerged, steering him back into the office and closing the door again. Arthur appeared to have noticed nothing. He was on a roll. "One guy," he said, drying his hands on the seat of his pants as he was walking, "came into Kenzo's. In Nashua, couple years back. A biker. Wanted six-six-six done big on his forehead, red letters outlined in black; also his right hand. Which I didn't know, but Tippy did, she was working there at Kenzo's at the time. Her people, they were religious. Is supposed to be the mark of the beast. The people Kenzo gets sometimes, they're scary. Chains all over the place. Guy smelled like a mattress on fire. And you're not, there's pretty much a law everywhere, at least in the straight world, if it's not a law, at least you don't do

it, put a tattoo on a person's face. That's for convicts, makes it look like you've killed a person, or people, which this guy anyway, likely, had.

"So Kenzo. He did it. But what Tippy said, Kenzo wanted his usual price."

"The Zen thing," Fred said.

"That back room back of the back room," Arthur said, twisting with discomfort as he sat on the couch again.

"OK," Fred said. "Listen. I have to let you in on something because I don't believe Kim did. When you talked to her. Maybe she did. I think you're involved in something that could be a problem for you. It's not my business, but here I am, and I've seen enough, I guess it's my business too in a way. At least, because I've been spending time with Tippy, and Kim, and you."

"It's this fucking painting still," Arthur said. He came close to pressing his hands against the sides of his head again.

"Did Kim mention on the phone, you'd gotten a note from Lexington Orono?" Fred said.

Arthur shook his head.

"And you're right. It *is* this fucking painting again," Fred said. "The last place we know it was for sure was under your bed. Forget about who owns it for the moment. There's no reason I should be involved. Unless you need help.

"I was outside your place, waiting for you, yesterday evening, afternoon. A guy came up looking for you, who I happen to know, he didn't let on, is a New York guy, art dealer. Lexington Orono. He's looking for the same painting. Staying in Cambridge, at the Charles Hotel. What we know is, the painting already wasn't in your apartment when he came to see you."

"Which is the only thing you care about," Arthur said. "This fucking painting."

"Right," Fred said. "I want to see it." He pressed on. "Orono had already been in Nashua. He had already met Zagoriski— Mr. Z—and, I think, Kenzo. When I talked to Kenzo, what Kenzo called me, when he threw me out, was 'Another fucking art dealer.' Reading between the lines, Lexington was the first

one. I'm not an art dealer. Not important. Then I guess—no, obviously—Kenzo called you after he had, knowing Kenzo, told Orono he didn't know anything about the painting. Which is what he told me."

"Which wasn't true."

"The next thing, Lexington Orono went on to Mr. Z, again obviously, because he'd seen him before he saw his picture in the paper, when I showed it to him."

"I'm all snarled up," Arthur said.

"Why don't we talk to Lexington Orono?" Fred said. "See if we can get closer to the action."

"Because I'm afraid," Arthur said reasonably.

Fred reminded him, "I said, 'We.' Arthur, I gave Lex Orono the impression that you and I are partners. As far as whatever he cares about, I am going to stick with you. So that's all right. My thinking is, we talk to Orono, see what's on his mind, before Kim does, if it's not too late. I'll stick with you. You say nothing. I'll make Lex do the talking. We'll see where it goes."

"Why?" Arthur asked.

"Because hiding is not a practical long-term solution. First thing we do, you call him. The name he knows you by is Arthur Schrecking. That may mean something in terms of how he knows about you. Don't let him know I'm with you. Here's what you say."

◇◇◇

Fred listened as Arthur made a reasonable job of following directions. "Mr. Orono's room...Mr. Orono?...Arthur. You left a note?...Yeah...Yeah...I don't know...where I am, maybe an hour...bring it with me? Are you kidding?...Yeah...Sure... Then we'll see...OK, then...OK."

Chapter Forty-two

"Before we go," Fred said, as they gathered themselves together to step into the world again, "since we're working together…"

"Kind of," Arthur said.

"There's a woman, talks like she's from the South originally, works in Kenzo's in Nashua, named Stephanie. You know her?"

Arthur shook his head.

"Bleached blonde. Heavily tattooed. The tattoos are incoherent as a collection. Like she won seventy-five different contests where the prize was a free sample. She came by Green Street last evening, I was at your place, waiting for you. Calling herself Angela and wearing a red wig. You didn't see her?"

"I didn't go back to my place. I told you. That's who Kenzo sent?" Arthur said, looking dumbfounded. "A girl? That's all?"

"That girl packs a lot of woman," Fred said. "Don't sell her short. We started off, she was under the wrong impression. Before she got straightened out, I had the idea Kenzo's plan wasn't to intimidate but to seduce you. Works as well. Better, sometimes. Stephanie was supposed to get you into her pants, as a gift from Kenzo proving everything is OK, then she was going to get you to tattoo a souvenir, she said, on her right butt cheek, that she wanted to select from that painting, so you'd have to show it to her. That was the plan."

Arthur shook his head. "It sounds complicated."

"But it makes sense if where Kenzo wanted to start was making sure the painting was in your place, or if not, find out where it

was. If Kenzo sends someone else, who beats you up or whatever you were afraid of, and I don't blame you—they still have a way to go if the painting isn't there, making you tell them where it is."

Arthur said, "I want this monkey off my back. You, Kim, Kenzo, the rest of them. We'll talk to the dealer. No. We'll go. You'll talk, OK? Whatever I have to do to get these animals out of the thickets. So I can work. I cannot fucking think, all these spider webs, everyone running around, telling lies. Wigs. Things should be simple."

◇◇◇

Fred parked under the hotel. It was pleasantly cool down there, given the monumental, imperialistic shade of cast cement. Arthur, skittish and nervous, looked around him as if he were being haunted. "If there's anything you're not telling me," Fred said, "that it would be helpful for me to know, tell me before we talk to Orono."

"You say we are working together," Arthur replied. It was not much of a reply, but it satisfied Arthur.

"Make sure you keep your mouth closed," Fred said. "Silence gives you more power. As long as he thinks I represent you, I'm your heavy. He'll know you make the decisions, but you can take your time. You don't commit until you consult with your principals."

"My what?"

"He'll get the idea, as long as you're quiet. We introduce you, shake his hand, that's it. On the way up, and in the lobby, anywhere there might be people, we don't talk between us. You never know."

Orono, in shirt sleeves and open collar, no necktie, let them into a room decorated in such a way you had to think how much nicer it would be in Nantucket, with long gray breakers and seagulls out the window. Orono remained in the doorway blocking entrance to the room, looking from Fred to Arthur and back to Fred.

Orono glowered. "This is unexpected."

"Not if you have a memory," Fred said. "What I told you, on Arthur's landing—Arthur, this is Lexington Orono. Lex, Arthur—what I said was, 'When Arthur gets back, I go in with him and you stay out here. Afterwards, if he wants to see you, which I doubt, I'll be there too. With him. If you want to tell me your business with him, that's fine. Your business. Your offer. Up to you. If you want to…' And then, these are your words now, you answered, 'Fuck you. You're telling me who you're with is Arthur?'

"So don't tell me it is unexpected and you are surprised that I am with Arthur."

Orono had been using the time Fred made available with his patter to study the situation. He stepped aside, allowing passage for his guests. The covers had been hauled up on the unmade queen-sized bed. On the desk a tray held the remains of a colorful room-service breakfast, yoghurt with granola and berries in a silly parfait presentation, and orange juice. Arthur walked across the room and stood looking out the window onto the warm brick terraces below.

"I'll ring down for coffee." Orono changed his approach in the direction of disarming hospitality.

Fred took one of the pair of armchairs. Orono was left to choose between the desk chair and the other armchair while Arthur, apparently oblivious, stood in the window, looking out at the hot day.

"Maybe later," Fred said. "Fill us in, Lex. Start from the top. As if we know nothing."

Orono temporized, "I don't take coffee before ten-thirty, eleven in the morning. It's about that now."

"Suit yourself," Fred said. "I'll pass. Arthur?" Arthur, standing in the window looking out, shook his head.

"The silent partner," Orono said.

Fred said, "Any time you're ready. To save time, you have your card on you, from the Pieper Orono Galleries? In case we want to call you sometime down the road."

"It's like that, then," Orono challenged. "Save time, he says. We'll trade. Give me your card."

"I move around so much," Fred said. "'Fred' does it for me. People who need to reach me, I make sure they can. So far I don't see why you'd need to reach me, Lex. That's why we're here. So you can tell me. The story. Why you came to Arthur's. What you want."

"I'll order coffee," Orono said. "I was supposed to be in Paris." He fished a business card from a case he carried in his shirt pocket and laid it on the desk.

"Paris. We're impressed," Fred said. Arthur, turning inward from the window, scratched an armpit.

Orono picked up the phone, ordered coffee for three, put down the phone again and started, "This is confidential. I have your word?"

"Come off it," Fred said. "As soon as a word is spoken, true or false, it belongs to the blessed air. If you have something to say, go ahead."

"My clients are confidential. My sources are confidential. My entire business is confidential," Orono said.

"Imagine! Like the Emperor's new suit—but with an art gallery," Fred said. "What does everyone do, come in the place, look at bare walls? Buy an imaginary painting?"

Neither Arthur nor Orono perceived the joke. Both shifted restlessly.

Orono announced portentously, speaking in Arthur's direction, "My client is willing to accommodate to the irregular, shall we say, situation—the fact—that you have no title." He paused. "Based on the photograph we have an interested buyer."

"We're talking about a painting?" Fred said. "You haven't mentioned…"

"You know what we're talking about."

"You forget where I started," Fred reminded him. "Begin again from the top, pretending that Arthur doesn't know what we care about."

"Don't waste my time." Orono stood and started pacing. Arthur drew back, edging closer to the window to leave him room. "The painting. If you didn't have it, you wouldn't be

here. You have control of it. Question of provenance. It doesn't belong to you. We're willing to overlook that. But we have to see it. Arthur, you said you would have it with you. It's downstairs? In the car?"

Arthur turned again and looked out the window. Orono came to the other comfortable chair and sat.

Fred said, "Let's get this straight. For our initial report to our consortium. You have an interested client. Going back a couple steps. How interested would that client be? In numbers."

"Consortium!!" Orono exclaimed.

"I'm getting ahead of myself," Fred soothed. "Go ahead. Your client…"

"My client needs to examine the painting," Orono said. "As we do. Under our lights. Get the opinion of his expert. I say his, not meaning to limit the client's sex to male. His or her expert, I should say. Our client could be an institution."

"Oh, fuck that," Arthur said. "Fuck the he/she/it shit."

"How much money are we talking?" Fred said. "Keeping it simple."

"Let's try another way," Orono tried. "How much do you want? This painting that isn't yours? You and the consortium?"

Discreet knock at the door. "I'll get it," Fred said, moving fast.

Chapter Forty-three

Room service. Young man with the cart, the tray, the bill to sign. Fred, filling the door, signed the room number, fished out a couple of bills for the waiter and brought in the tray, scraping a place for it on the desk next to the remains of Orono's breakfast. "Go ahead," Fred told Orono. "As I said, I'm coffeed out. I'll pass."

Orono left the service untouched.

Arthur said, "Are we done?"

Fred shook his head. "Lex Orono has more to tell us. Start with the accusation, Lex. Possession of stolen property? That's what you're saying? Let's get this out in the open."

Orono poured coffee for himself from the vacuum pitcher the hotel had supplied, into the china mug. "I'm saying we are prepared to short-cut issues of provenance."

Fred said, "You talked with Zagoriski before he…died. What's that about?"

"That question has become moot." Orono poured coffee for himself.

"The photograph you mentioned," Fred said. "Show it to me. That way I know we're on the same page, talking about the same thing."

Orono shook his head. "The client gave strict instructions."

"What client? The buyer?"

Again, Orono shook his head.

"I'm going out on a limb," Fred said. "Mrs. Z. Mary Zagoriski. She came to you, peddling a photograph and a story, am I right? At the gallery in New York?"

Arthur, drawing closer to the conversation, pulled off his wire granny glasses and started to clean them on the hem of his T-shirt. Taking note of the carafe, he poured coffee into a mug and dipped his lenses, polishing them more successfully. Orono shook his head, drank from his mug, wiped his lips on a napkin, and insisted, "Our clients are confidential. Our sources are confidential. The material we represent is often confidential."

"In case I can stir up interest among my people, you'll be in town for a few days?" Fred asked abruptly. "I know, I know, you are supposed to be in Paris. France, I guess. Not Maine?"

Discreet knock on the door.

"I'll get it," Fred said, moving fast.

Kim, in the pink smock from CUT - RATE - CUTSS, in mid-entreaty, "I only get twenty minutes…" before she realized it was Fred. She'd put her long blonde hair up into a bun, looking businesslike; was wearing loose black linen pants and sandals. "Fred," she said.

"Arthur and I, we're paying that call on Lexington Orono," Fred said quickly, letting her in and gesturing in Orono's direction. "Friend of ours," he explained to Orono, pushing on so as to fill Kim in and keep her quiet. "We're following up on the note Lex left for Arthur. Lex is an art dealer. New York. He wasn't going to tell us that. The note mentioned money, but so far Lex is being vague on the subject of money. What Arthur and I decided is, let Lex talk. What these people do, art dealers, like Realtors, they run around the world looking for information, taking no risks, until they find a chance to make a killing off other people's stuff. I'm not blaming you, Lex. It's the American way. Meanwhile, Arthur has nothing to say. You with us so far?"

"I see there's coffee," Kim said. "It's a real meeting!" She walked to the desk, poured coffee for herself in the mug that was to have been Fred's, doctored it, and allowed the room's attention to concentrate on the question what she might do or say next.

"I was worried about you, Arthur," she said. She stood beside him, shut up, and smiled brilliantly at everyone. She drank from the mug. Everyone watched her. "Don't mind me," she said. "I've got fifteen minutes."

Fred said, "Your play, Lex." Kim could have blown this thing sky high. She'd learned good lessons from time misspent during her high-school years, dodging the weapons wielded by the forces of oppression. Don't waste a good silence by feeding ammunition to the other side.

"Who is this pretty lady? How do you fit in?" Orono tried addressing her directly but Kim resisted, shaking her head, drinking coffee and joining Arthur's inscrutable silence, remaining anonymous.

Fred said, "While Lexington plans his next move, I'll digress. In the wilderness, a hawk flies in its long slow circle over trees and meadows, screaming every now and then. It's silent except for the scream. Its shadow flits across the ground. It can't do much about the shadow. Its prey is going to notice that shadow and freeze with fear. But why does the hawk scream, since it's so good at stealth? Doesn't hand out its card or anything. Doesn't identify itself as coming from the big art gallery in New York. No. But it screams.

"Because the mouse or sparrow, in hiding, hears the scream and thinks, it sees us, and then scrambles for a better place to hide. When it moves, that's when the hawk sees it, unsheathes its claws and stoops.

"That's why Lexington put that concept *Money* in his note. It is supposed to work like the hawk screaming. Lexington screams money, next thing he expects, you'll leave your perfectly good cover and scuffle in the leaves until he gets his claws in you. When he's done, there'll be nothing left but scraps of dirty fur or feathers."

"Keep it simple," Lexington Orono said. He leaned back in his chair, crossed his right leg over his left, and glared. Then he rose, walked to the closet, slid its door open and pulled out his attaché case. He walked back to his chair and sat again, keeping the case on his lap. "The first thing my client insists on is

exclusivity. What that means is, if everybody and his monkey starts getting into the game, he's out. Or she."

"Meaning you'd as soon not get involved in competition," Fred said.

Orono, disregarding the interruption, said, "I had these pre-pared. Whoever the hell you are, Fred, or how you have horned into this, or the consortium you talk about, you are going to screw this up for Arthur if he's not careful. Listen to me, Arthur. You may not get another chance. I have other appointments and I can't hang around here forever. All I need from you, Arthur, is two things. One, I have to see that painting, in this room. Or in the gallery in New York. It's easier here. Cleaner. Quicker. Two"—he snapped the briefcase open and poked through the contents until he found what he wanted and held it toward Arthur—"your signature on this."

Two pages stapled together.

"I'll look at that," Fred said, reaching a long arm out to scoop the papers in. He read it aloud. "'I, Arthur Schrecking, in consideration of the sum of one dollar, surrender any and all interest I might have in the property described hereinunder, to the Pieper and Orono Gallery, blah blah blah, New York,' with places to be dated and signed blank blank and the location to be filled in. Then a space to fill in a description of the property. It's a quit claim deed, in effect."

"One dollar!!" Kim screeched.

"To make the transaction legal," Orono explained. "I don't have to tell you, the actual amount that will be involved in the transaction, to be paid in cash—keeping it simple for the tax man—will be real money. I would want to hear your suggestion as to how much. How much do you want? For your interest in a property that you don't own, Arthur?"

"What if he says ten thousand?" Kim said.

"I haven't seen the painting," Orono pointed out. "I can't talk numbers. Not without the painting."

"What if Arthur says fifty thousand?"

"Let's stop joking," Orono said.

"Good idea," Fred said. "That about does it for us. Arthur, we don't want to be late."

"For what?" Arthur said.

Kim said, "For the next thing, asshole. You want to tell this guy our business? Mister One Dollar?"

"Keeping it simple," Orono objected, "the idea is to pay a single nominee—that's Arthur—and Arthur, in turn, settles out with anyone else you feel, that is he feels, should be included. That's up to you, Arthur, you feel Fred has earned something. This lovely lady?"

Kim said, getting into it, "We'll get back to you. Right, Fred?" She led the way to the door.

"I have a deadline," Orono threatened.

"So what?" Kim countered. "You have a deadline. We have a painting. So…enjoy your deadline."

Chapter Forty-four

Walking down the hall, Arthur complained, "That guy Orono doesn't know my right name even, how does he have my address?"

They reached the elevator. Kim said, "Fucking Kenzo. All I can tell you, never buy anything from a guy like that, or give him anything. Worse, don't ever take a present from him. Next thing you know, you're missing your fucking arm. Those guys. I know those guys. Guys like Oreo. I'm telling you, Arthur. It's lucky I…"

"We need five minutes," Fred said. "The three of us. Alone." The couple in the elevator wanted to hear more of what Kim had to say. "We'll find a spot outside."

In the shade of a maple, overlooking the river where it lapped the edge of a bright field where a Frisbee was being passed, Fred brought them to a halt. Kim and Arthur, facing off, blurted out simultaneously, "Where is it?"

"That answers that," Fred said. "Neither one of you has the painting. We on the same page so far?" Arthur and Kim stared at each other.

"Something I want to tell you," Fred told Kim, "before we go on. The night I stopped over, met Arthur. He was working on Eva. Beth was there, Eva's partner. I mean to say, from my observation they are solid partners. In case…"

"Not a big deal," Kim said. "I get mad, start mouthing off, get ideas. OK, Arthur. I got over that."

"So it's Eva and that girl Beth, the partner," Arthur said. "They took it. Why?"

Kim said, "Doesn't make sense. Listen, if I don't get back to CUT - RATE, I'm out a job. Talk, Arthur."

"They were in my place, I had to take a walk," Arthur said.

"They know about Oreo?" Kim demanded.

"Not from me," Arthur said.

"He showed up later," Fred said. "Next day."

"Heidi's in today and she already has it in for me," Kim said. "I've gotta get back to my job. Keep working until the big score comes is my motto. Wherever the painting is, it's still yours, Arthur. Let's figure this out. Fred can help but I don't see why he should get any of our money for horning in. Your money, I mean. Can we get together this afternoon? My place or your place, Arthur?"

"I have to check with Tippy," Arthur said. "I haven't talked to her since forever."

"Talk to that slut, you can kiss my skin good bye," Kim said. "She gave it to you. I'm off at eight. Meet me at the door, we'll take it from there. No, better. We'll meet here. Check?"

"Check," Arthur agreed.

Fred nodded. "Or Arthur will keep me posted."

"Keep Tippy out of it," Kim insisted, and stormed off.

"I wonder where they live," Arthur said. "Eva and Beth. All I can figure, they heard me on the phone with Kenzo, and I maybe said something after, while I was working. Together is all I know."

The Frisbee game moved the orange plastic so close that it skidded in the black dirt under their tree. Fred scooped it up and tossed it to the nearest running figure. He told Arthur, "Listen. I have errands. You need sleep. Do me a favor. Between now and when we meet here at five, before you sleep or after, I don't care, whichever, take the time to make me a drawing of that painting. Bring it with you."

"You said a hundred dollars," Arthur reminded him. "I don't want money, but I could use a hundred dollars. Right at the moment..."

Fred peeled out a twenty. "On account," he said. "Listen, Arthur? Lock yourself in."

◇◇◇

Gilly, apparently cured, was at the library's research desk when Fred reached it before noon. "She stepped out," Gilly said. White shirtsleeves, red tie with Peanuts characters on it. "If you're looking for Molly?"

Fred nodded. Within the library, at least in the tight confines of its research personnel, word was out. The large man with the new haircut who'd appeared a couple of times in recent days had an interest in Molly.

"Any idea what direction I should wander?" Fred asked. "In order to bump into her?"

"She had her lunch in a bag is all I can tell you," Gilly said. "She's likely to stop across the street for coffee." He didn't even try a feint with the question, Anything I can help you with? Had the other staff here and there, at the checkout desk and shelving books, turned their attention toward Fred also? As if all were involved in the kind of office conspiracy that leads to surprise parties or presents chosen by committee. A woman at the circulation desk said, as Fred passed, "Molly left ten minutes ago."

They were all in cahoots. All whispering to themselves and to each other, with pleasure, "Molly's got a man." What seemed to be the feeling in this place was that Molly's fellow workers liked her and wanted something nice to happen for her. Unless that was no more than what Fred felt and wanted for her.

Both things could be true at the same time.

It was unnerving having this ill-defined group of well-meaning strangers, Molly's coworkers, thinking they were in on the opening chapter of a story Fred couldn't read, in which he was a character. Fred gave a noncommittal wave. So much poison can develop between people, underpaid and overworked, confined in a tight place, the evident good will felt by these folks toward Molly was a good sign.

Molly had found a bench in the dusty park, under a mottled sycamore. A woman was just getting up to move away from her, dressed in navy uniform, contraptions but no firearms hanging at her waist. The woman held paper trash bunched in one hand, and a square fat clip of forms at her side. She was traffic. Parking Enforcement. She made a feint toward the trash container near the bench, in deep conversation with Molly, who didn't notice Fred until his shadow crossed her. She gave a start. She was dressed in yellow-green.

"I'm interrupting," Fred said.

"I'm Dee," the uniform said.

Molly swallowed. "Hard boiled egg. Dee, this is Fred."

A flash of veiled recognition crossed Dee's eyes.

Fred said, "Because of persons like you, I left my car under the Charles Hotel. You hear that sound? It's money falling out of my pocket. Those folks charge. But I can't always run back to feed a meter or find another one."

"I can't get you under the Charles Hotel," Dee said. She was stout, dark-haired and of an olive complexion that suggested something Mediterranean. "Too bad. It's a town and gown thing. The Charles Hotel might as well be Harvard, MIT. You could do better, Fred, leave it in the street and let us ticket you. Cheaper for you. Also it helps the schools. When I get to know you better, you give me your plate number, I'll get the word around. As long as you're…Molly, I'm out of here. I'm late. Fred, it's been real."

Dee deposited her trash and headed for the road.

"I didn't happen to be passing by," Fred said.

Beside her on the bench, on the right side, Molly had balanced the cardboard cup from Starbucks, and plastic containers with her lunch. In her right hand was a white plastic fork. Her left hand, the one with the napkin in it, gestured toward the bench beside her.

Molly said, "I didn't happen to be sitting where I could see the road." Fred sat. "Hungry? There's another egg."

Fred said, "The breakfast scrapple is a vivid memory that will last till supper time. If you can spare a carrot stick, I'll keep you company."

Molly held the container toward him. "Dee and I went to school together. From fourth grade on, right through high school. She did Junior College, wanting to get out of the house, work, and get married. Walter, her husband, is my boss."

"Right," Fred said. "That could drop an interesting curve ball into an old friendship."

"It could," Molly said. She picked up the hardboiled egg she'd offered earlier, dipped its white flesh into the scattering of salt and pepper that lay in the corner of the plastic container, and took a bite. She chewed and swallowed before she took a drink of coffee. "But it doesn't," she added. "Walter is such a gentleman, you don't believe it until you've known him for several years. Half the words Dee uses in conversation—Dee has got a mouth on her—you think, but Walter doesn't know that word. He's courtly. That's what Walter is."

"Whereas the man I work for," Fred said. "The collector. Clayton Reed. Did I tell you? You'd say is a snob, except the man is such an innocent, and it comes so naturally to him, I don't know what to call it. Is he a nabob? What's a nabob?"

Molly said, "Indian word, from the Hindi, but with a B now in the middle where there used to be a W. People think it means 'snob,' but a *nawob* is a rich man or, more accurately, the way it was used a couple hundred years back, an Englishman who came back from India with a fortune."

"That's Clayton Reed," Fred said. "Except he managed to avoid India. But he sure came back from *somewhere*."

Chapter Forty-five

Molly said, "The Nashua business. I felt bad, stumbling over bad news and handing it to you, blind. That man, Zagorski?"

"Zagor*is*ki," Fred said. "Starts as a hit and run, but then looks more malicious once you get into it. It's nothing I'm part of. Then again, since I was talking to the guy a few hours before…"

"I don't mean to pry," Molly said.

"Slight change of subject," Fred suggested. "Here we are, it's lunchtime, a pretty day, well, hot. The one thing I can tell you so far for certain about Zagoriski is that he was not a pretty man. Complex, but not pretty. Fade to black. Cut to the Garden of Eden. Adam and Eve wandering. This is before the serpent puts ideas into their heads. They look up into the tree full of apples, what is one apple worth?"

"You mean in money?" Molly asked. She ate celery. "You have a thing with money, Fred."

"I have a thing *against* money. I have a thing with not understanding money," Fred said. "It's a dumb question, granted. The two of them look into the branches, one says to the other—I don't care which one says it—'That one on the end of the branch, the red apple with the yellow marking, has got to be worth…' fill in the blank. OK. Hold that thought. Next question. God says, 'Don't eat that' for the reasons specified. Does the value of the apple change? Next the serpent whispers, 'That apple is going to make you'—whatever the serpent promised. Now is the apple worth more or less than it was before?"

"This isn't how you earn your living, is it?"

"Before you start heading for the exits, if you've got a moment. The narrative I've stumbled into in a way is like that question, but maybe after the apple, with a couple bites out of it, is thrown over the fence of the Garden of Eden, into the wilderness outside. There wasn't money in Paradise. At least it isn't mentioned. Though if Adam and Eve were human beings there was trading for something going on. But out in the wilderness—here's a question for you. What is the first time money is mentioned in the Bible? Money, as in a worthless object to which symbolic value has been agreed sufficient to let it seem the equivalent of something to eat."

"I'd have to look it up," Molly said.

"Once Adam and Eve, then the kids, were out in the wilderness anyway," Fred said, "you can bet there was money or whatever. But here's the thing. The way I make my living at the moment means I have to deal with works of art. That means scrambling in the wilderness in a lot of ways I'm only starting to learn. Sorry to get all abstract on you. I'm trying to dodge telling you what…"

"It's OK," Molly said.

"But I can tell you whatever I want," Fred said. "It's not as if it isn't my own story. Secrecy is a bad habit, is all. It might be relevant, my metaphor of the apple. The story so far in a nutshell, I'm trying to get a look at a painting. It sounds like a honey. Can't tell. Could be a tempest in a teapot. Since I haven't seen it and the only descriptions I have so far come from people who don't know what they are talking about, heck, it might not even be a painting at all. It could be a reproduction, or a copy, or a poster that someone faked to make it look old and original. Not only can I not figure out what it might be or where it is, I don't know who it belongs to.

"Where my lunchtime fable comes in, at one time the painting, let's say it's a good one, had no value. Like the apple on the tree before God pointed in its direction and the serpent began whispering. The thing got passed from one person to another

and nobody worried about it because it was regarded as worth-less and therefore it *was* worthless."

"Right," Molly said. "Then the whispering of the serpent, and God's pointing finger too, let's be fair—those things started assigning value, but nobody knows what that value might be because in the art business, until the check is actually written, and I mean the *last* check in the sequence, how does anyone know?"

"The devil of it is," Fred said, "if I do find it, and if I can figure it out, and work my way through the rat's nest of who might be the owner of record, a life or two could be destroyed by the sudden appearance of money in significant quantities. Like the lottery."

"Not to mention what happened to Zagoriski," Molly pointed out. "If that's part of it, which you worry about."

"Well, of course," Fred said. "If some miserable jerk got the idea that Zagoriski's life was a fair trade against the painting. There's a whole story of Zagoriski owing money he couldn't pay, and another story about a pending divorce, and of Zagoriski's habit of mentoring his female high-school students more closely than you might want for Terry when the time comes."

"Oh, God help us," Molly said. She stood, gathering her containers into her black cloth bag.

Fred, standing with her, said, "If I were one of those girls' mothers I might drive a truck over the guy myself. But Zagoriski's death doesn't have to fit into any of my stories. Why should it? It could be an accident." Molly had started walking in a direction away from the library where she worked. Fred fell in next to her, pursuing his train of thought. "Hit and run. The random perpe-trator could be so upset by hitting the pedestrian, he backs up to see what happened, can he help? Maybe the driver's drunk—we know Zagoriski was."

"Horrible," Molly murmured.

"Of course. We are," Fred agreed. "So now he's run over the victim again, he panics, starts thinking what the consequences could be for his own life—his record, his license, maybe he's not insured, maybe he's an alien in the country without papers—he

decides he'd be a fool to leave his victim alive to testify against him and runs over him once more on the way to the car wash, to be sure. Or in panic, more innocently, keeps going in the direction he was going before that particular bump in the road. It isn't exactly murder. More like prudence."

"I like to walk a few blocks before I go back to the desk," Molly said. "Even hot as it is. So I forget that I spend the whole day inside."

"It stays light late in summer," Fred said. "It must seem that I'm wrestling with a lot of imponderables and intangibles. I guess I am. Part of it is, most of these clowns I mentioned—they're young, they're barely getting started, they don't know where they're going, this world is stacked against them, and I like them. They're full of goony energy. They're doing what they can even if they've knowingly cut themselves off from the support of the straight world.

"But if the best the straight world has to offer them is the compulsory mentoring of Zoltan Zagoriski, backed up by the institutional threat he wields of flunking them, maybe they didn't have much choice to start with."

Molly's walk had led down Broadway in the direction of Central Square. This part of town wasn't old in terms of its houses and apartment buildings, but its trees were old enough to provide shade.

"Hell, everyone's ignorant," Fred said.

Molly kept walking.

"I don't want them hurt," Fred said.

Molly kept walking. They'd reached a large brick school building across from which were shops. Molly turned to double back.

"Tricky," Fred said, turning with her. "Because I also want something from them."

"That painting," Molly said.

"I want to see it. I don't want to have it. I don't want to have anything, which I've confessed to you already is a flaw I bring to the table. Depending on what it is, it could be something the man I work for wants, if he can afford it, and if we can figure

out who owns it, and if the owner wants to sell it. And if I can keep these folks safe."

"You make it sound wonderfully easy," Molly said.

"What time do you get off work?"

Molly stopped short and looked Fred over for a full twenty seconds. "Eight o'clock," she said. "We're open late tonight. Gilly's got kids, and since mine are…I said…"

Fred said, "I'll…no, I forgot. I have to meet with a couple of the clowns."

Molly started walking again. "I almost forgot also. Business. I'm getting yearbooks from the Nashua public library. They're sending them down. Maybe tomorrow. They can't circulate. You have to…"

"I'll stop in when I can," Fred said.

Chapter Forty-six

Both Kim and Arthur, having eliminated each other, assumed that Eva and Beth, sensing an opportunity, had walked the painting out of Arthur's place three nights ago while Arthur, worried first by Kenzo's call, then by Fred's visit, was mooning around in the streets to clear his head. Both Kim and Arthur had dropped the hint, or the presumption, that Eva might take the thing to Kenzo in Nashua, whatever Kenzo might think he wanted with it. That Kenzo wanted it was plain enough from the fact that he had telephoned Arthur looking for it and then sent Stephanie. And he'd had dealings with Orono.

Fred recognized, turning away from seeing Molly back to her building, that he had reached the conclusion, under the white noise of his philosophizing about biblical values, that he had nothing to lose in going direct to Kenzo again and taking another look.

"All us blind people are after the same elephant," Fred said, the welcome wind blowing the scent of dog around the inside of his car as he headed north again. "The ones who have seen it don't know what it is: Kenzo, Eva, Beth, Tippy, Arthur, Kim, Zoltan Zagoriski. The ones who haven't seen it think they know: Lexington Orono and Fred Taylor. With that many people on the scent, who else is gathering? Unless Orono was lying, there's still a photograph somewhere. And if there's one photograph, assume multiples. Has nobody, getting the whiff of money, not wandered into Christie's and said enough to a pretty girl

behind the reception desk to get her seasoned uglier older sister or brother out from the private office upstairs on the run?

"The art business is dog eat dog. Everything looks friendly, like that Maypole dance, the dogs and bitches circling in a ring, each nosing the next one's anus and genitals, until the lights go out and they to gnaw, eating each other out, starting from the most vulnerable purchase. An image worthy of Hieronymus Bosch himself, almost. The dogs don't stop to snarl. Why would they? Their best cover is silence. Beware of the enemy who makes no threats."

Where had he heard that line before?

He'd said it himself. Tina. At the Moonglow Lounge. Z had owed Tina an unspecified large sum of money. Was Tina among the blind who knew about the elephant? Oh, yes, and there was Stephanie. She had come down from Nashua by bus to trick Arthur into confirming the painting's presence at his apartment yesterday afternoon.

"Another art dealer," Kenzo had said, when trying to figure Fred out. Fred had assumed that meant Orono was asking questions. But who else? Why only one? Why not one of the smiling principals from Ader Tajan in Paris?

"While we apply our driving time to idle speculation," Fred said, as the deep green countryside swished by, "the business Orono kept bragging he was missing in Paris—couldn't that have been with the auction house Ader Tajan? Isn't that where you'd go if you wanted a cutout between yourself and a fabulous old master painting for which you needed a fictitious recent European provenance? Throw a little smoke?"

Kim had told Claire at CUT - RATE - CUTS; Claire and whomever Kim had paraded herself in front of had seen multiple images from the painting. Tippy—dancing at the Moonglow—must have inspired questions from clients about the source of the interesting image on her buttock: those copulating beetles eating money.

Fred swung into the Nashua mall area and found a spot to park far enough from Kenzo's that his car could seem to have an

interest in baked goods. There was no shade. He locked the car leaving the windows open half an inch. "The great advantage in having nothing," Fred said to himself, walking toward Kenzo's, "is you have nothing to lose."

As he drove past the shop he'd taken note of the fact that the cardboard sign in the door faced outward with the message YES WE ARE. Stephanie, looking more like herself than she had in the red wig yesterday, at Arthur's. The bleached hair was her own. She sat back of her reception desk exposing the many samples on arms and upper chest. Pink tank top. She chewed gum into the phone's receiver. She stared in Fred's direction with such vacant nonrecognition you could sell that look for five hundred dollars to the CIA, to teach their agents. She held up a hand to stop him in case Fred had something to say, and gestured him to sit. She listened. Fred took a chair and picked up one of the magazines, riffling through it for a title such as *But Isn't It All Junk?*

"No," Stephanie said into the receiver, and continued chewing. The air conditioner groaned. "It's like before they even let you on the bus, you have to prove to them you're Chinese," Stephanie said past her gum. "I never saw so many. They can't all live here, can they? Isn't there a law?" She chewed.

Fred got up to walk past her, "Men's room," he said. She held up her hand in a gesture he disregarded. "I'll handle Kenzo," he assured her. He pointed at his crotch to prove his innocent intent.

The work area was vacant. Lights off; black padded recliner empty; rolling stools stationary, against the table well covered with tools in reasonably sanitary array. No Kenzo. No client. No painting. No place to stash a painting.

"Wait a minute," Stephanie was saying into the phone. Fred pulled the heavy curtain at the back of the work room and peered through.

That had to be the "room back of the back room" Arthur had talked of. The air conditioner's groaning was louder in Kenzo's Zen temple. The area was dark, a hallway, leading to what had to be a back door exit and another little door that must lead into the washroom that building codes, and the State of New Hampshire's

Licensing Authority, must require. The chrome objects next to the generous couch—call it Kenzo's Altar of Zen—must be the sterilizing equipment: autoclave, whatever; and sterile storage. The object on the couch was a sleeping woman.

There was room under the couch for a painting whose dimensions matched Kim's estimated "yay by yay," but Fred could see only bare green linoleum under there, and a small leopard-skin patterned overnight case, next to a pair of tan leather sandals. Stephanie, in little yellow shorts, her midriff bare, still chewing, stood between the curtains whispering angrily, "Hey, mister."

Fred turned and whispered back, "It's OK." The sleeping woman, on her front, and mostly covered with a white sheet—it was hot in here, despite the big box air conditioner that was set into the wall over the exit door—had her face turned toward the wall. Dark as it was in here, Fred could see a good deal of black hair, curly; a medium-sized displacement of female body under the sheet. He opened the bathroom door and slipped inside. Toilet and sink, clean, in good order. No painting. No room for the painting either. If the Board of Whatever cared, the room was sanitary, and Fred left it that way, tiptoeing past the sleeping woman again and meeting Stephanie in the passageway.

"You can't do that," Stephanie whispered, closing the curtains again behind them. "Kenzo's not here, clients have'ta use the Dunkin' Donuts down the way. Kenzo's gonna…"

Chapter Forty-seven

Fred said, "I'll square it with Kenzo."

"What can I do for you?"

Fred sat. "When do you expect him?"

"He said he'd be here—what time is it?"

"Quarter of two," Fred said.

"Then he'll be here," Stephanie said. She removed the gum from her mouth and dropped it out of sight on her side of the desk. A metallic ping followed. "There's green tea while you wait, if you want some," she said. Her sidelong glance took in the hotplate in the corner of the waiting area, on a table with mugs and a green cardboard box of teabags.

Fred shook his head.

"You didn't make an appointment."

"Kenzo and I have other business."

Could it be that Stephanie still didn't recognize him? He hadn't even changed his clothes since yesterday. She'd seen him three times; here twice. Yesterday she'd had her knee in his crotch and was doing her best to get him into Arthur's bed.

"Coffee." The woman from the room back of the back room stood in the doorway, wrapped in the sheet, her bare feet poking out beneath it. On one bare shoulder a bouquet of blue tulips.

"Green tea's what we have," Stephanie said.

"Where is he?" the woman demanded. "Also, no. I will not drink green tea."

"He's supposed to be here. He'll be here."

The women was not dressed, the hair unsettled. She was probably—Kim might estimate her as "yay by yay"—but Fred's guess was somewhere shy of forty.

"I can be useful," Fred volunteered. "Either mind the store or do a coffee run. Whatever."

"I could use coffee," the woman said. Stephanie made no move to surrender her position. "Driving since Godknows, and where is he? Who are you?"

"I go for coffee," Fred decided. "If I'm going to Dunkin' Donuts, you want something to eat? You?" He extended the offer to Stephanie. At the last moment he'd had the presence of mind not to use her name.

"If they have any kind of sandwich wouldn't make a cat sick," the woman in the sheet said. "Starting with not tuna fish."

"I'll have tea if I want something," Stephanie said.

"What's in the coffee?"

"Ice. Lots of ice. Cream. Sugar."

"Right."

Stephanie said, "Anyone asks, you went down the Dunkin' Donuts to use the men's room. Right?"

"Understood," Fred said. He had an ally now, or at least an accomplice.

When he returned the woman from the back room was standing by the desk, wearing sensible grownup clothes that a sensible grownup woman could have described easily. A skirt, blue. A shirt, white, with short sleeves. The tulips had disappeared. She still looked not much shy of forty, with her hair brushed and some attention to the face. Fred said, "I figured roast beef. Everything else seemed like it must be processed to where it isn't food any more. This is iced coffee, though they call it something else. They wanted to throw hazelnut flavoring in it…"

"Give me the damned coffee," the woman said. "What do I owe you?"

Exactly half the women in the world would take offense unless he told them. Fred let her find the appropriate bills and change

in the wallet she took from a small shoulder bag. In the same gesture she had pulled out a pack of Marlboros and a lighter.

"Kenzo doesn't let you smoke in here," Stephanie protested.

"He can tell me himself," the woman said.

"What is it from New York?" Fred said. "Five hours?" The woman looked at him more carefully than she had when she was counting money into his hand. "Saw the car," Fred explained. "New York plates. What you said, I figured…"

"Unless you have a flat," the woman confirmed. She took one of the chairs and spread out the meal Fred had brought, looking it over with distaste.

Fred said, "I'm not from around here. Our friend at the desk…"

"Stephanie," Stephanie said.

"Stephanie," Fred went on, "from that warm voice, is from down south."

"Newport News," Stephanie said. "Navy brat."

"The tulips are Kenzo's work," Fred said.

The woman looked up from her sandwich and told Fred, "A: It is not your business where I am from. B: The tulips are my business." She took a bite of the sandwich, considered it, chewed, swallowed, and wrapped the remainder in its paper. She stood, leaving it on the table next to the drink. She went into the back room and returned in a minute with the overnight case. She told Stephanie, "I'm going to the house."

"I'll tell Kenzo," Stephanie said.

"Kenzo is not coming near the house. I'll call. Or come back. Tell him not to call me. We don't know…There's going to be a thousand people…"

She picked up the drink and marched out, swinging the case.

Fred said, "I'll take some of that tea."

Stephanie shrugged. "Suit yourself." She walked to the hot plate and poured water into a kettle out of a bottle. "He's usually not this late," she said.

Fred was telling her, "I've got time" when Kenzo walked in, banging the door open, his face thundery, tossing keys across

the room, saying "I didn't get the fucking..." until he saw Fred and choked off.

"You remember Fred," Stephanie said. "He's the guy I told you, I thought he was Arthur, was at Arthur's yesterday when I didn't find Arthur?"

"Dimwit," Kenzo said. He stood in front of Fred, breathing hard, rippling with the pheromones of violence. "He was here two days ago. Asking about some painting."

His fists bunched at his sides. Ripped black denims; biker boots. Buckles, no spurs. "You're in my business," he said. The hands moved toward Fred's throat, fluttered, then hung back. Stephanie, at the hotplate, uttered a small squeak.

Fred said, "I'm interested to see that painting we talked about. Did something jog your memory, Kenzo?"

"I've been upstate," Kenzo said abruptly, directing the words to Stephanie, and ostentatiously disregarding Fred. "All the way to Colebrook. I am beat. I'm going to wash up." Kenzo walked out of sight, through to the back of the shop.

"You still want the tea?" Stephanie asked. "Listen, I've seen Kenzo like this. He looks like he's in control, then all of a sudden..."

"Sure," Fred said. She hovered next to the hotplate while the kettle warmed. Kenzo was gone for five minutes, long enough for Stephanie to get through the entire tea-bag ritual.

Kenzo came in again, saying, "So she's been..."

Stephanie cut him off. "She'll call, she said."

"Like fuck she'll call," Kenzo said. "I'm going over. Well, or I would if I had..." He looked in Fred's direction and clamped his jaws.

Fred said, "We have a common interest. I don't know how to say it any plainer. I want a good look at that painting. We can take it from there. I'm not a dealer. I do represent a collector. He could be interested. But I have to see it." He drank green tea from a mug that said, in a not-very-Zen way, STARBUCKS.

"Come here again, I'll break your neck," Kenzo said, crossing the room to stand menacingly at Fred's knees. "That's a promise."

Chapter Forty-eight

Fred said reasonably, "Step back, Kenzo. If I stand up with you on top of me, we'll start breaking stuff. It's your stuff…"

Kenzo paused before he stepped back, tardily measuring Fred's heft, and the likelihood that he could move quickly and painfully. Fred, standing slowly, concluded, "It looks like you have nothing to sell. You went to pick it up and it didn't show. When it does turn up, you have my number. Stephanie, thanks for the tea."

He stepped out into the hot mall. That should be Kenzo's truck, parked with its nose nudging the plate-glass window of the shop: a blue nose with its bumper liberally dented. Blue Dodge pickup with some years on it, a Harley chained in the bed, with a ramp tucked in beside it—as useful as the dory towed behind the schooner.

"Not exactly my business," Fred mused, walking to his car. "But if I'm going to be a citizen of the world and not a god-damned loner for the rest of my life, at some point I should figure out an honorable way to alert the Nashua D.A: Take a look at Kenzo's pickup. He's had time to wash it, but you can't get everything. See if there's hair or blood, or prints that match Zagoriski. Run our friend Stephanie from Newport News, with that red wig on, in front of the barman at the Moonglow Lounge. Is this the 'gorgeous redhead' you saw leaving the place with Z a couple nights ago, propping him up?

"Meanwhile…an exercise for the memory."

Starting again from the Moonglow Lounge, he set out to repeat the sequence Tippy's directions had led him on the previous night—in fact, early this very morning. This was proving to be a long day. The outskirts of Nashua were as anonymous as any landscape he had encountered in southeast Asia, but the mind and the memory had managed to hold onto useful signposts nonetheless.

Fred pulled in behind the red Camaro with New York plates. Tippy's car, once a light blue, almost as trampled and generic as Fred's own, still sat in the driveway, with a note under the wiper Fred took a moment to read, *Sorry Mrs Z I cant aford the tow. Ill get it out of hear. Please dont tow me. T. A.* with a noseless frowny face.

The woman stood in back of the building up to her knees in the brittle canes of long dead plants and vigorous new green weeds. The plot of land separating the Zagoriski house from its neighbors was small, but so overgrown that it provided cover. She seemed dazed, gazing around this mess, until her eyes met Fred's. "Zag changed the locks," she said. The keys she dangled from her hand, she tossed into the undergrowth. "Our happy home," she said.

"Mary Zagoriski," Fred said, "I'm Fred Taylor. I…"

"He thought I was going to what? Sneak in while he was in class? Or at the Moonglow? Sneak in and rob what's mine?"

Fred said, "Did you have a chance to start what you have to do downtown? You were still married to him, yes?"

Mary Zagoriski nodded. "Till death did us part. They don't know how to find me," she said. "Kenzo had to…Zag didn't know either. He would have tried to…I called him Zag. He hasn't touched the garden. He changed the locks. Front door and back. I tried them both. What do I have to do, get a court order to enter my own home?"

"That's kind of the long way around," Fred said. "With your permission…"

"You're with Kenzo?" she asked.

"The last thing Kenzo said to me was, 'Come here again, I'll break your neck. That's a promise.'"

"So you're not with Kenzo. Or not any more. I'm…I had roses back here."

Fred picked up, "With your permission, I can get you into your house in forty seconds. There's not even an alarm."

"How do you have a key? Fred is your name?"

"No key," Fred said. "All I need is your permission. Do I call you Mary?"

"OK." She nodded.

Fred walked back through the weeds and opened the trunk of his car. "People use credit cards," he said, "but it's hard on a credit card, and I don't use them anyway though I should. If I'm going to be a man of the world. This putty knife…" He opened the screen door and applied the tool to the space giving access to the back door's latch. "Not even forty seconds," he boasted. "It's all yours, Mary."

Fred stepped back. Mary hesitated under the overhanging roof and said, "I go in alone."

"Sure," Fred said.

"I don't know what you want or why you're here. Thank you, I guess. Wait, do you mind? You know my name, you seem to know the situation, so…wait…I'll be back."

An aluminum lawn chair amongst the undergrowth had enough of its webbing left for Fred to open it under an apple tree and sit. Birds had been taking advantage of the general neglect. They objected noisily to Fred's presence. It was twenty minutes before Mary came out again carrying a kitchen chair. She set it in the weeds next to Fred. "He's wrecked the inside too. People don't change," she said. "That's useful, I guess. It helps me hate him. Helps me not care so much what happened to…Not keep imagining…We talk out here. Tell me what you want. I have to go downtown, introduce myself, identify Zag's body, start that whole thing. My lawyer says I have to."

"I'll leave the putty knife," Fred said. "A present. Lock up while you're out. Word gets around fast a house is empty."

"There's stuff missing. I don't think it was Tippy. Zag must have been selling…Tippy left me her keys. Kitchen table. The girl renting upstairs. If you believe that. People don't change. I was Zag's student too. He had this golden…and I loved him. He loved me, I know, but his attention…People don't change. Locks change. Zag saw to that. There's stuff missing he must have sold, but he couldn't pay the goddamned telephone bill. The phone's been disconnected."

"You've got family in the area," Fred started.

"No. Twenty minutes," Mary said, looking at her wristwatch. "No. Wait." She went into the house again and came out with the three framed reproductions of samplers Fred had seen in what Tippy called the living room. She propped them against the trash cans next to the back door. She kicked through their glass a couple of times. "OK," she said, taking her seat again.

Fred said, "Kenzo came in the shop after you left. It looks like he didn't find it."

Mary said, "If you're waiting for me to say something…"

"I'll back up," Fred said. "First, I apologize for being clumsy. I can say I'm sorry for your loss, let the chips fall where they may. Why I'm here is why I was at Kenzo's. It's a small thing next to a man's life, even though…well, I've got nothing useful to say about that. I met your husband once. I'm interested in seeing a painting that used to be in this house."

"I don't…" she started.

"Give me a few of your twenty minutes," Fred said. "The man I work for collects paintings. He's in Boston. Out of the country at the moment. I came into the story backwards and I haven't even seen the painting Kenzo was looking for. I've heard about it, and I've seen copies of details. I don't know who the rightful owner is, and I don't even know if it's what I think it might be. From what I saw…"

"What you saw," Mary repeated dangerously. "What did you see?"

"Details from the painting, used as the basis for tattoos. A local guy, a genius, Arthur Schrecking…"

"I know Arthur," Mary said. "Go on."

"I liked what I saw. I wanted to see the rest of the picture. When things started happening, I started to feel not only interested, but responsible in a way. Though I can't tell…Anyway I see from the commotion that two other people want to find the picture. Kenzo is one. The other one is a New York dealer, Lexington Orono. Lexington has to be related to Glendon Orono, of the Pieper and Orono Galleries. You're familiar…"

"I know the gallery," she said.

"Lexington Orono says he has a photograph," Fred said.

"Not unless he has a spy camera. I'm fourteen kinds of idiot, but I'm no fool. I've got the one Polaroid, and I never let it out of my hand. Go on. However you know he's after the painting, you know he's after it."

"He is," Fred said. "With a briefcase full of quit-claim deeds for people to sign."

Mary said, "What I agreed with the old man, Glendon Orono. Lexington's the son. After I showed the old man the Polaroid he said he wasn't interested. It didn't look like much. There's no market for old masters. He couldn't tell anything from a Polaroid anyway. He doesn't have clients for it. It's the wrong size. People resist religious subjects. It's not signed. An anonymous picture, there's no way to sell it. Still it might have some interest from a decorative point of view. If it's as old as it looks. No museum would touch it, but there are collectors, people he advises, rely on his taste and judgment, even everything there is going against it, he'll offer me, if I can get the picture to him, he has a chance to look at it under his lights, he can't make any promises, as much as twenty thousand dollars."

Chapter Forty-nine

"Now the son of a bitch is running around behind my back trying to find it? Trying to buy it?"

"That's what it looks like," Fred said.

"Where is it?"

"That's the question."

Mary said, "I walked out of here with nothing. I'd had it. You don't need the story. Whatever, behind my back. But I knew. The Camaro was mine. Is mine. He had his own. I don't see it. Some clothes. We'd work the rest out. Then I found out, I talked to Zag a couple of times, him saying how much he's changed and wants me back, he loves me still, I still have tender feelings for him. Meanwhile he's mortgaged the house and he's in debt and since we're married I'm in debt at the same time, and I know half of what I walked out on is mine, but he says…"

"I can hear him say it," Fred said. "Whoever walks out, all bets are off."

"You did spend time with Zag," Mary said. "Then, after I'd been on my own long enough to see I could, I didn't need him, I wanted to start a business. That means I have to have a credit rating, and that means…so I started thinking. Even the equity in the house, if we sell, if I can make him sell, when you put that up against the other debts he has, and some other debts he told me about I won't go into, which as far as I am concerned are his problem, he's welcome to them. I started thinking, I'm

in New York, I have an idea to get started, and I remembered the wedding present, this ridiculous painting his uncle brought over before the war and gave us, when we got married, and told us it should be worth something if we ever needed to sell it. Like a fairy story. We believed that fairy story as much as you believe the other fairy stories.

"I happened to still have in my bag the Polaroid, because I showed it to some people putting together one of these multi-family yard sales, in Nashua a couple years back, and they said they weren't interested. Maybe forty-five dollars. That's worse than not interested.

"Don't ask to see the Polaroid. I've learned my lesson; also it's in New York. I won't tell you where I live."

"How does Kenzo get into the mix?"

Mary looked at her watch. "Kenzo was the only one left in town I'd talk to. Anyone else wanted to know where I was. Kenzo, before, when I was trying to…never mind…I thought it might make a difference if I got some ink. Zag wanted me to do it. To make me younger, I think now. The tulips. Even after everything else, I was touched. I knew this crowd, Kenzo knew them, I knew Tippy Artoonian, one of Zag's students, was walking around with a thing on her she'd gotten…Anyway, I called Kenzo, told him I needed the painting. By now I couldn't talk to Zag any more. Kenzo said he could get it, he knew where it was, who had it. It was out of the house. Nobody ever thought it was worth more than forty-five dollars, and even that was a stretch. Kenzo said he'd keep it quiet. I'd sell it, and it belonged to both of us? So I'd keep Zag's half against what he owes me. And give something to Kenzo.

"I was talking with Kenzo about it anyway, and next time I talked to him, he said Zag was dead. Also, because I wasn't sure how I was going to handle that, I needed to find a lawyer. Kenzo told me last night when I called, he'd have the painting today, from the person who had it. I could pay him later. And it's mine."

"Kenzo doesn't have it," Fred said. "He didn't tell me. He wouldn't tell me anything. He was telling that woman Stephanie, then clammed up when he saw I was in the shop."

"So he has it and he's lying to Stephanie," Mary said. "Or he doesn't have it. Or he has it and he's going to lie to me about it too. But why would he?"

"Did you put Orono in touch with Kenzo?" Fred asked.

Mary pulled her breath in, stood and stepped into the wreck of the back yard. She bent and pulled weeds.

"Lexington Orono came to Nashua," Fred said. "He talked to Kenzo about the painting. He talked to your husband. I know that because he recognized Zag's photograph in the paper the day after he was killed."

Mary Zagoriski, her hands full of unwanted vegetation, said "Killed," as if the fact of her husband's death hadn't occurred to her in so brutal a word. She carried the weeds to the trash area and dropped them onto the samplers. "Meaning Kenzo and Orono have an arrangement of their own," she said.

Fred spread his hands. "This painting is floating around the world without its dog tags," he said. "How do you prove it's yours?"

"Or Orono and Zag had a deal," Mary said. "Leaving me out, obviously. Because whoever walks out, all bets are off." She pulled more weeds. "Or Kenzo and Orono and Zag together," she said, "had an arrangement that doesn't include me. That's the idea? And if the kids are in the mix…"

Fred said, "Rely on that. The number of loose ends—I try to look at evidence without forcing conclusions."

"Have you been to the Pieper and Orono Galleries?" Mary asked. Fred shook his head. Mary dropped her weeds on the pile and sat down. "I have time. First there you are, on the sidewalk at the street door, and already that's meant to make you afraid. Bullet-proof plate glass, all that simplicity everywhere on the front of the building that says *Money*. You can't just walk in, you have to ring a bell. Be admitted. So OK, it's New York. You do that, the girl back of the desk, miles back, the other end of the marble room, the girl so beautiful the only reason she isn't running for Miss America, she hasn't got the hair. She looks at you like she's ready to turn you down for the bikini wax.

"You feel like they're thinking, 'If she had money, we'd know her. Since she doesn't have money, why deo we want to know her?'

"She knows you can't afford to be in there.

"There's an acre of floor space. The day I was there, they had three pictures on the wall. Three. On all the walls in that whole room. I don't know what they were. How would I know? A friend of a friend told me that's where I should go, not a friend who could call over first and say I was coming. So I'm there cold. Me and the photograph in my bag. The place is already making me feel like a piece of crap. All I have is this crappy Polaroid of the painting the yard sale lady told me might fetch forty-five dollars if I'm lucky and she wants ten percent.

"Up to now in my life, on the whole, I have not been lucky.

"The beautiful girl looks at the piece of crap and asks me, 'May I help you?'

"I want to ask her, 'The picture behind you that looks like the dog's breakfast, he had it yesterday—how much you want?'

"What can I lose? I've rehearsed. The one thing I know, this girl is here because of her legs and her breasts and her smile, and she hopes she lands a rich man coming in who wants a picture of the dog's breakfast yesterday and something to go with it, looks good in an expensive outfit or outside it. I tell her my business is confidential. I'll talk with a partner, or however I said it. I forget what I said.

"I had dressed for this. She saw through it, but I had dressed for this. Even borrowed a handbag. Gucci.

"She says everyone's busy. Everyone's away. Nobody's here. I can make an appointment, but I have to tell her my business. The whole time there's doors to offices, three of them, open, and men in suits inside at desks, on the phones, or reading papers, or one was on a computer, it's like the bank if you go into a New York bank, not like in Nashua. In New York everyone's important and busy. I tell her, this girl fifteen years younger than I am, I'll take my business somewhere else, but I will not

tell her what it is. That convinces her I must have something going, because it's secret.

"'I will see if someone is available,' she says. Any fool can see there's three men available. She goes into the office in the middle, behind the painting of the dog's breakfast second time around, which has a sign next to it *Monet Nymphs.* I wouldn't want happening to me whatever happened to those nymphs. There's two big comfortable chairs next to her desk but she doesn't offer me a seat, I'm standing there and she comes right back with the tall young guy, it sounds like you've met him."

"Lexington Orono," Fred said.

"Who wants me to keep standing there while he asks me, like the beautiful girl did, 'May I help you?' meaning 'Take off.'

"'Not here you can't help me,' I said. So this and that and the next thing and he takes me upstairs. He has an office up there. He's young, he's upstairs. I tell him my story—the uncle, the wedding present, that I told you—and I show him the photograph. He tried every way to get me to give him the photo to show to the very busy people downstairs too busy to come up and look, but I wouldn't. He took a moment to look in a book or two back of him I couldn't see, and another book, and said, 'Wait,' and was gone for ten minutes until he came back and took me downstairs to see the old man. I held on to the photo while the old man looked it over, and said what he said.

"So I came away with that twenty thousand dollars in my head. And called Kenzo, to help me get hold of the painting."

"You must have said enough to let Orono know you didn't have it," Fred said. "Or enough so he knew to look for the painting in Nashua. You must have given him your name."

"How could I not?" she said. "All this commotion. Orono the son sneaking around and telling lies. Listen, that gallery, the overhead has to be twenty thousand a week. They wouldn't do all this unless they thought…"

"Good point," Fred said.

Chapter Fifty

"I'm using up your twenty minutes fast," Fred said. "I'll run through what I know about where the painting's been so far, until it dropped out of sight. It was in Europe—maybe Poland? You'll tell me—until Zagoriski's uncle came to the US before 1939. He gave it to you and Zagoriski when you were married, whatever year that was, not important. It stayed with you, stayed in your house. When you walked out, that's where it was. Am I right so far?"

"Keep on."

"All this time, nobody worried about it. Arthur Schrecking sees it and likes it, in the room where Tippy Artoonian is staying. According to Tippy, Zagoriski gives it to her. This we can't check with Zagoriski. Even if that's what happened, your lawyer would argue, Zagoriski had no right to give away something that belonged to both of you. He'd argue that now Zagoriski's gone, it belongs only to you."

"Did Zagoriski make a new will?" Mary wondered. She got up and paced in the yard, staying close.

Fred continued, "I reckon once the painting's out of the house, it starts moving around with the personal effects of recently graduated high-school students of no fixed abode. Since it's still worthless it doesn't much matter where it is, as long as whoever has it has a roof. We can argue that Kenzo had seen it. It may have been in his shop while Arthur was around. We

know that Arthur based Tippy's tattoo on a detail. But he'd have it all in his head, wouldn't need to refer directly to the painting.

"Next thing we know, Kenzo flies into a fit when he rightly suspects that Arthur has what these folks call a 'thing' with Tippy, who's been working in his shop at the same time as having a 'thing' with Kenzo. Kenzo threatens Arthur, and Arthur moves out of Nashua, lock, stock, and painting. He has the painting with him. It's not clear that Tippy gave it to him. Tippy doesn't think that's even an interesting question, not so far. But I can point out as a side issue that she can't afford forty bucks for a recharged used battery, which she calls a new one. Arthur sets up shop under the radar in Cambridge. Even changes his name. Kim Weatherall drives him, and…"

"Kim Weatherall?" Mary interrupted.

"Sorry. She changed her name too. At Nashua Central she was known as Ruthie Hardin. She was known also…"

"I know Ruthie," Mary said. "She was another of Zag's… students. It was like an illness with Zag. If that's true, I was an illness with Zag, too. That he got over when he had to make room for the next infection. I won't…"

"…Ruthie was at Kenzo's," Fred said. "The with-it kids impatient to get into the world hung out at Kenzo's. Until a few days ago the painting was in Arthur's apartment in Cambridge. Under his bed. What Arthur thinks is that Eva heard him talking about it, recognized it must have value…"

Mary stopped her pacing and squared off to face Fred, interrupting firmly, "Eva, now. God, all of them. Here's what I don't understand. With everyone in this business so far being a sneak and a snake and a god-damned liar and a traitor and a thief, what is your angle sitting in my yard that was, and talking straight? Don't you want the painting too? That's what you said. Don't you also want to get it for less than it's worth, whatever that is? Playing your game in my field while I'm blindfolded?"

"I haven't seen the painting," Fred said. "What I want is to see it. If it's properly yours, you should have it. If you want to sell it, you should have it appraised *not* by the person who

wants to buy it from you or sell it for you—someone who has nothing to gain and who isn't in league with someone who has something to gain—which leaves out a lot of people—and…"

"Eva, you were saying…" Mary resumed.

"The art world is a small world. The man I work with, the collector," Fred said, "to finish that thought—if the time comes, once I've seen the painting, if you'd like to show it to him, I know he'd…"

"This is pie in the sky," Mary said. "It always was. I have to get a local lawyer lined up. My New York man made an appointment I have to keep. Eva, you said—There was an Eva in that class."

"That's the one. I don't know her last name. She lives with a woman named Beth, not from here. The idea is, if Eva ran off with the painting, she's enough connected to Kenzo that she'd give it to him or sell it to him. She doesn't know what it's worth, but nobody else does either. Nobody even knows what it is. Nor knows *where* it is. Kenzo, when he came into his shop, but only after he'd seen me, said he'd spent the day driving north all the way to Colebrook. So chances are he was meeting up with Eva in Cambridge, and she gave him the runaround."

"That's the story so far," Fred said.

"I have to go," Mary said. "I'd give you my number here, but it's been cut off and I'm not going to pay the bill. I'll give you my lawyer's number in Nashua, the one I'm going to meet." She led him to the driveway and pulled Tippy's note from under the windshield wiper, tore it in strips and, consulting a card in her bag, wrote a name and a phone number. "My address in New York, I am not giving out. Write your name and the rest of it and drop it in the mailbox. If you find that painting, I hope you'll tell me. Right now I have to deal with a dead husband and a new lawyer and a mortgage and an empty house and identifying a body and probably signing a thousand papers."

Fred said, "If the lawyer's any good, he'll stay with you for all this."

"And charge me," Mary said. "Meanwhile, I don't even know if Zag made a new will. After he changed the locks on my house!

It'll be me who has to arrange for the funeral. I'm bound to be in this house for the next couple weeks. If you find anything out, if you're straight, tell my lawyer. The one I'm going to hire. If I have to find someone else—I'll call if you leave your number. I don't have time for this."

Mary Zagoriski backed out of the driveway in her red Camaro, squealing the tires like a hot-shot high-school boy.

◇◇◇

Fred took the strips of Tippy's note. The one on that Mary had written her lawyer's name and number went into his wallet along with the mailing address of the house he took off a mail-box already stuffed with circulars. So much domestic neglect. A mailbox grows weeds as fast as a back yard does. He took the obvious crap out of the box and dumped it into one of the trash cans. Once the obvious crap was gone there was nothing left but three issues of the *Nashua Sentinel.* The one on the bottom of the pile had Zagoriski's face on it, along with the lie "Beloved teacher," and so on. Mary wouldn't want these, but she might need them for something.

His own name, and Clayton's address and number, he wrote on another strip that he put under the kitchen door where she ought to see it. On another strip he wrote—he might find a way to get it to her somehow, though it would be better spoken, and in person, *Dear Molly, What I hoped, when I asked when you get off work, was to have dinner with you anywhere so I could hold your hands in the crumbs and say I'd love some day if you would do me the honor to let me meet your children. Fred.*

It was all wrong. He'd think about it, driving back.

Chapter Fifty-one

He beat the rendezvous at the shady spot next to the Charles Hotel by ten minutes. He'd nabbed a meter not far away. It wouldn't start to apply until eight the following morning. The evening was blowing cool air from the river. It picked up enough dust and trash to lend a festive air to the wait. Fred had taken a bench. He had not overdosed on sleep the past few days. Kim approached alone, her black linen pants moving with almost military precision. Above them was a loose long-sleeved man's white dress shirt.

"He won't know," Kim said, noting Fred's attention to the shirt. "Can't show my tats in Harvard Square. Heidi lives around here."

Fred said, "The next thing is, we pay a call on Eva. How do we find Eva?"

"You're wrong," Kim said. "The next thing is, where's Arthur? Him and Eva. They've had six hours. Meanwhile I'm stuck in CUT - RATE - CUTS, welcoming the people, telling them good-bye, watching Heidi keep their tips. Where's Arthur?"

"It's five after," Fred said. "Arthur doesn't keep tight to a schedule. You know where Eva lives? She lives with Beth, right? Where she works? What's her last name?"

Kim hadn't sat down. She stood in the walkway looking here and there as they talked. "You're wrong," Kim said. "All this talk about money. That changes everything. You don't know Arthur. He's a baby. One time…and another thing. There he is. No."

"So we call him," Fred said. "Wake him up."

"We do not call Arthur," Kim said. "We go over there is what we do. Five minutes more, he's not here, we go over. I've got keys. He's sleeping? We wake him up. He's sleeping with her? We wake them both up. He's not there? We find that out and move on."

"We'll give it five minutes," Fred said. "But if the first thing on our minds is finding the painting…"

"Which Eva was hiding for him," Kim said. "You don't see that? When Kenzo and them, and you, and this art dealer Oreo from New York, started asking about it. Listen, you don't know Arthur. How women push him around. All he wants in this world is to set those paintings free, putting them onto people, like he's doing with me. To get his revenge on Mr. Z.. That's all he thinks about. And so there's always been a woman to watch out for him.

"Or he did what I told him not to do, called Tippy Artoonian, and she convinced him she didn't give him the painting in the first place, it was a loan, or whatever she says it was. She gave it to him all right. It's his.

"The thing is, it's the only thing he's ever loved. Not Tippy, not me, his mother. He'll never sell it. You don't know Arthur. He doesn't care about money. Not even when he needs it. Somebody has to make him. Everyone knows where he is now. Kenzo. Arthur can't stay in Cambridge. He's gotta go out West, and how is he gonna do that? Has he had his five minutes? Let's go."

"Three minutes left," Fred said. "In the meantime, tell me about Eva."

"Unless we find Arthur at Eva's, we are going to find Eva at Arthur's," Kim said. "That's what I can tell you about Eva. And as far as I know that skank Beth she's with now, and Lexminster Oreo and his piece of paper, unless he's already finished and out of there and Arthur's sitting on a check for six hundred dollars, grinning like a moron, he's got it made. Let's go."

"You convinced me," Fred said. "We'll take my car."

"Mine's fucked anyway," Kim said. "Shocks. Struts."

◇◇◇

At Green Street they pushed up the stairs, Kim in the lead. Arthur was on the landing at the top of the stairs, dithering, managing

to tear his hair and clean his glasses both at the same time. The door into the apartment was open. He looked at them, dazed. "I don't know if we should go in," he said. Dogs barking and baying in the neighborhood. It gave Green Street a whole new ambience.

"It's your apartment, asshole." Kim pushed him in in front of her. The place was as Fred had seen it last, but with the furniture moved around and a uniformed policeman taking notes on a clipboard. "Nothing missing?" he asked Arthur.

"I don't *have* anything but my tools," Arthur said. "Which I can't use in Cambridge, on account of the laws of Massachusetts. Everything's here."

"You'd locked the doors? You are certain?"

"I always lock the doors," Arthur said. "And I never even use the back door. That's open too."

"If nothing's missing, what do you want us to do?" the officer said. "Somebody came in, looked around and went away, I guess it's a crime, but all you have to do, you're sure it was locked? Maybe a former tenant? Change the locks."

"You don't take fingerprints?" Arthur insisted.

The cop put his hands on his hips and stared. "You're kidding, right? Who are these people?"

"A friend," Arthur said. "Also another guy."

The cop put a meaty hand on Fred's shoulder and suggested, one adult to another, men of the real world, "Explain the situation, would you? You always have so many dogs around the neighborhood? We don't hear them down the G Spot." He tramped out and down the stairs.

Arthur settled onto the couch where Fred had first encountered a supine Eva. "I couldn't get there," he said. "The meeting. Or I forgot. Or, but anyway, the thing is…"

"Where's Eva?" Kim demanded. "Where's the painting? Give me that check, Arthur. Where's Oreo? Are you out of your mind showing your operation to the cops? What the fuck is going on?"

"Start with 'What the fuck is going on,'" Fred suggested. He took the rolling stool and left Kim to drag a chair around. If

they'd been in the woods of Georgia he'd have said the dogs out-side had treed something: coon, or bear, or an escaped convict, a murderer, running for his life and motivated by the stunned blinding knowledge: all life, even mine, is precious.

Arthur, still in the mode of nervous victim, gulped air. "Everyone told me to come home. Both of you, under the trees, next to that hotel we were at. So I did. I walked. And sleep. I got back, I can't swear it, I think the door to my place was unlocked. Or open. Or whatever, I was so tired I thought, and we'd just been together, maybe Kim was here for some reason. I don't know what I thought. But, so I went and lay down on my bed and, like you said, went to sleep. I was walking all night and I haven't been sleeping.

"Then I woke up maybe an hour ago. I remember we are supposed to meet again, the same place. Fine. I'm in time. I start noticing, like you do waking up, like a stair's missing: something's wrong. Even, everything's wrong. The bed even. All the furniture's been moved. A little bit.

"First thing I think, like you do, is I'm crazy. Everything's here, only it isn't where it was, like your teeth have been arranged differently from what they were, even if they're all there. And I start looking, someone's been into the closet, the clothes are off the hangers, rugs moved around, and I thought, Kim doesn't believe me. Got mad and came back looking. With that man Fred. But that didn't make sense and anyway, here you both are. The back door too. Was open. Which I never use. Stuff in the back hall, whose it is, search me, is shifted around. Somebody's broken in.

"Except nobody's broken in because nothing's broken. Nothing's taken. The painting already wasn't here."

"You gave keys to Eva?" Kim accused him.

"No. What Eva is, is with Beth," Arthur insisted.

"Who else has keys?" Fred said.

"Nobody. Me and Kim," Arthur said.

"And Sammy Flash," Fred said.

"Shit. I forgot Flash."

"He left his keys when he took off?"

"Flash wouldn't," Kim said. "Flash doesn't check in. Flash doesn't report. Flash doesn't say thank you. Flash goes his own way, is what Flash does. It is fucking hot up here, Arthur." She opened the man's white shirt down the front and rolled the sleeves up, displaying Arthur's brilliant work, and how much remained to be completed.

"Whoever came in had keys," Fred confirmed.

"Unless I or Kim left the door open," Arthur said. "Which it wasn't me, because I wasn't here last night. Kim was. Waiting to rag me out on account of what I am not doing with Eva, who is with Beth now. I keep trying to explain to you, Kim, Eva's a dyke. Converted to a dyke. All I can say about Kim, knowing Kim, and Kim, you are an organized person, if you left the apartment door open you did it on purpose, it was no accident. So did you? You have something going with Orono? But there's nothing here. And there wasn't, before. Anything. Here."

"You dork," Kim explained. "Someone was looking for the painting that you stashed with Eva. I wouldn't leave the apartment open. This neighborhood? This neighborhood, they'd steal the tray of kitty litter if it isn't locked up. And find someone to sell it to. Somebody came in looking for the painting who didn't know that the painting isn't here. Who's left is Flash. No problem. Flash was too late.

"Listen, Arthur. The whole thing's in your head forever. The painting. You love it? Forget it. We travel light. With money we can leave town. Everything's lined up. Oreo, that dealer's waiting. We collect the painting from Eva. Fred's with us. Fred knows what the thing is worth as soon as he sees it, we give Fred a cut—we'll work it out. Let's do it. Get this into your head, Arthur. You don't get a chance like this every day. Whatever cut you think Eva deserves, call it a tip."

Arthur said, "I was afraid. It's like having a person walk over your grave, when a stranger has been inside where you live, moving everything, looking through everything. I thought, Shit, there's the G Spot. They know me. I didn't think. I went

down, grabbed that cop, brought him back. You saw how much good that did. I was sure they would take fingerprints. I always wanted to see that."

"We know it was Flash," Kim said. "Forget it."

"Maybe some day tattoo fingerprints all over a person," Arthur mused.

The apartment door was pushed open.

Chapter Fifty-two

"Something else," the cop said. He had a crackling walkie-talkie out now. "Arthur Pendragon, you said your name is?"

"Yes," Arthur said. "Not exactly. Not legal. I didn't change it yet. The paper."

The cop said, "I want everyone's name who's here. Names and addresses, phones, everything." He spoke into the walkie-talkie. "I'll stay with them if you're covered."

The answering crackle indicated that the other end was covered.

Sirens approached and gathered in the street below, some of them turning to growls. The dogs reacted noisily, alarmed or joining in.

"Fill us in, officer," Fred said.

"You fill me in," the cop said. His brass name plate identified him as T. Murphy. He took a seat on the couch from which Arthur had risen. From the apartment windows overlooking Green Street it was possible to see the gathering of squad cars, and a movement of uniformed officers toward the area back of the building. Whatever was causing the commotion could not be seen from the apartment.

Murphy said, concentrating on Arthur but gesturing toward Kim's exposed skin, "Your work?" Arthur nodded. "Nice. I'd like to see the rest of it some time. Tell me again, buddy. No. First tell me your real name."

"Schrecking. I'm from Nashua. New Hampshire."

"OK, Schrecking. Tell me again what time you came home? And what you saw and what you heard again. Take it from the top and go slow. You'll be repeating it when the detectives get here. Think of me as an interested citizen."

Fred said, "Myself, Arthur, whenever a cop tells me he's an interested citizen, and he'd like to hear my story, first thing I do, I wait for my lawyer. That's me."

"I'll wait for my lawyer," Arthur told Murphy.

"And what brings you here?" Murphy asked, the question designed to hit Fred between the eyes. His glare swerved to include Kim. His walkie-talkie crackled. He might be able to distinguish words in the otherwise impenetrable noise. Kim shook her head. Fred said, "I'm going down the back stairs. Let your colleagues know. I might be able to help. Tell them Fred Taylor. If I'm no use to them I'll come back up." He didn't wait for permission.

The staircase was dark, rancid and splintery. The dogs were louder. He'd been hearing them since he parked down the block. Blinded by the invisible painting, he should have paid attention to so significant a change in the environment. A huddle of cops, most in uniform, stood around one of the refrigerators that had collected in the back yard. When Fred had seen the discarded appliances a couple days back they had been lying on their fronts, to prevent children from getting into trouble. Two boys, maybe twelve years old, stood to one side, the taller sporting a black leather cap that was hot for the season, and outsize for the boy. The dogs, kept back by the cops, expressed thwarted interest.

"We're the ones found it," the boys told Fred.

The refrigerator in question had been rolled onto its back and opened.

"You boys aren't strong enough to roll that thing," Fred said.

"My brother," one of them said. "He took off. Damn sure."

The man crumpled into the bed of the refrigerator was missing the leather cap and satchel, and was wearing a pair of yellow trousers Fred didn't recognize; but there was otherwise

no doubt. He hadn't been dead that long. Heat like this, he'd blow up and stink fast. As it was, though the dogs had winded him, the scent wasn't much.

Fred told the gathering, "His name is Sammy Flash. That's what he goes by. He used to hang out upstairs, on the landing."

From the look of him Flash had been beaten to death. Though there was not much flesh exposed, the head, neck and hands were welted with regular bleeding bruises that hinted at interlocking curves. Flies did their best to adhere to the bloody patches. A heavy chain could do that kind of damage.

"He comes in the G Spot sometimes," someone said. "Flash, you said? I never heard his name. This is convenient to where he drinks. Stick around, Fred. Tom called down from upstairs, said you could help. What else do you know?"

"People upstairs likely know more," Fred told him. "Depending if they are free to talk."

◇◇◇

He didn't get out of there until after midnight. He was dead beat. He'd done what he could to signal to Kim and Arthur that with a murder at issue, they might as well be as helpful as seemed appropriate. In the long run, that would save them time and trouble, as long as they hadn't killed the guy. Once you start being seen to impede a murder inquiry, folks want a lot of your company.

But as far as Fred was concerned, before he would spill everything of what he knew, or what he thought, or what he suspected or wondered, he needed to think. And he needed to think where he wasn't going to be disturbed. First, he needed to sleep.

He'd given his address as Clayton's building and his phone as the number there. So that's where they'd look for him if they started to think of more questions to ask before the time in the morning he promised to show up at the station to pick up where he'd left off.

Traffic was sparse along the river and over the bridge to Charlestown.

"Where do we start this thing, and where do we stop?"

How did Kenzo and Flash fit together, aside from the obvious? Flash hadn't come into Arthur's to search the place. He'd made a mistake, a big one, reading Kenzo wrong. Flash had told Kenzo, I'll get you the painting. Meet me on Green Street. Kenzo had driven by motorcycle from Nashua to meet him, likely out back, among the refrigerators, and there was no painting. Flash said whatever foolish thing he had said, which probably involved a more generous payment, meanwhile pulling his keys out and starting for the back stairs. Kenzo had already got out of him that Arthur was holed up upstairs. And Kenzo had already called Arthur, threatening him, that night before Fred met him.

Now Kenzo, fooling around with the bike chain, pretending to lock up, said yes, sure, whatever you want, let's go up and talk where it's comfortable, killed Flash, took his keys, and stashed him in the convenient refrigerator, not taking the heat or the flies or the Green Street dogs or the Green Street boys into account.

Then Kenzo took his time upstairs. And found nothing.

Where Flash had been the past couple of days, who knew?

Talking with the first run of detectives, Fred hadn't mentioned Charlestown.

Unless Kenzo was a better actor than he had demonstrated in Fred's brief exposure to him, he genuinely hadn't found the painting. He'd walked into his shop this afternoon, disgusted, throwing his keys—scratch that. No. Those were Arthur's useless keys, he'd taken off Flash—across the room, complaining to Stephanie, "I didn't get the fucking..." until he saw Fred and adjusted course.

That left Eva. A wild card. There was no way to explore Eva before daylight, for one thing because it would involve cooperation from Kim; and Kim, so voluble by nature, had come into an unusual taciturnity. Arthur was going to bunk in with Kim. He was not going to be allowed into his apartment until it had been gone over by technicians. He'd finally get those fingerprints examined, though the technicians weren't going to allow Arthur to watch. The idiot had asked if he could.

Supposing Fred's suspicions were correct, Kenzo's prints would be all over Arthur's place. If for no other reason than that, Fred would do well to introduce the subject of Kenzo tomorrow, when he spent quality time with homicide detectives, starting at noon. And that would lead, in turn, to homicide detectives in Nashua.

◇◇◇

All he wanted was Molly's hands between his among the crumbs. He hadn't had time to leave the note. He hadn't thought of a way to make it better, either.

◇◇◇

Eva's the wild card, Fred thought, pulling up across the street from his own house, where a light always burned in the front vestibule and someone always sat waking.

The night was cool. Cool air blew through the open windows. He'd found a part of the world that was halfway between settled and unsettled. Small houses jostled against larger buildings. But there were trees. The occasional children did not seem entirely out of context. It looked like Morgan at the desk inside. Fred turned his lights off.

"Stephanie in the red wig. Check. On a mission from Kenzo to nab if she could, or at least see, the painting. OK so far. A 'gorgeous redhead' meeting Zagoriski at the Moonglow the night he died. We're still on track. Stephanie as decoy, bait, wearing the same popcorn-smelling wig? OK so far. But why? If Kenzo drove his truck over Zagoriski, why? To simplify the issue of ownership? Figuring he had Mary Zagoriski already? Or—did Kenzo run the errant husband down on contract for that, as she seemed, perfectly nice woman? Mary had reason to hate the man. But kill him?"

Chapter Fifty-three

Eva. Could anyone pass up the chance to sum up Eva as a "gorgeous redhead," even if he hadn't happened to see her naked? Reading between the lines, as well as taking into account Kim's spiteful jealousy, Arthur and Eva had a 'thing' at some time in the past. For an awful dweeb, Arthur certainly had enjoyed success with the ladies, probably based on his skill as an artist. Not that he'd ever allow the term *artist* to be applied to his role in what he did. Also he projected the need to be taken care of, which can attract multiple kinds of care.

"Because it's missing, and mostly because I want to see it almost to the point of obsession," Fred grumbled aloud, "I'm letting that painting infect my reasoning. These things don't have to fit together. You can take the pieces of half of seventeen jigsaw puzzles and shake them together in a box. Try to put them together into one picture? You've got problems."

Did the painting even play into the more important things that had happened? Didn't it seem to be a factor because, after all, everyone was looking for it—everyone except, perhaps, Eva and/or, perhaps, Arthur if he was in league against Kim with Eva and a much better actor than Fred suspected?

Zagoriski had reason enough to be killed in a hit and run. Being as drunk as the skunk he was was reason enough.

But the violent sudden death of Flash—no—that was cause and effect.

Until he could be proved wrong, and he'd have to put this together for them tomorrow, Kenzo had come down from Nashua because Flash had told him he could lead him to the painting.

Had Flash traveled to Nashua, during these intervening days? Why not? Finding a way to ingratiate himself with Kenzo again. Take it from there—why not put Flash in that red wig, leaving the Moonglow Lounge in the company of Zagoriski on the night Z met his fate? Flash could wear a red wig as well as anyone else. If E. Howard Hunt had taught us anything, he'd taught us that. "'A gorgeous redhead,' the man behind the bar had said—well, there'd been no evidence to date what standard the barman used to measure 'gorgeous' against.

They could even have come down from Nashua in each other's company, Flash stringing Kenzo along, and Kenzo driving the truck—that must therefore have been seen in the Green Street area.

But even after all that, if that's what happened (barring the ridiculous diversion of Flash in the red wig), Kenzo was still among the many who had no clue where the damned painting was. He'd acted too soon.

Fred entered the house and told Morgan hello.

"Flash never returned," Morgan said. He was a big man, square, whose military posture back of the desk had gone to seed somewhat, but was still formidable. He put his comic book aside. "No word, either. But people don't—our kind of people—what we do is go away. If people wonder what happened, they keep wondering."

Fred went on up without getting into it.

He'd taken for himself the smallest room in the house, one that was in the center of the building and commanded a view of the street. The fan was still blowing through the cracked-open window, making the temperature reasonably uncomfortable but not insufferable. He tossed Flash's brown corduroy pants to one side. They'd go into the overflow recycle box, for strays who turned up needing pants. Fred would run them through the machine first.

What had become of that satchel Flash always carried with him—the collection of stuff that gave him, like a wandering

tinker, a profession? The way Fred phrased the question to himself assumed the answer. Kenzo had tossed it into a body of water that crossed his route back to Nashua. He'd either taken out anything useful, like a tattoo machine, or, if he was prudent, left it inside the satchel to give it weight.

No smell of cigar. Fred had half feared there'd be some vestige of the departed guest on the wall: a sample of his flash, or a photo of his work to keep him company. He'd steeled himself to allow for this invasion; but there was nothing. His walls were as bare as he liked them. He allowed not even a calendar or cork board to distract the walls. He took a quick look in the closet for any sign of the visitor and found nothing. Without the telephone calls with Morgan and Zeke, he'd never have known his room had even been used. The testimony of a pair of worn brown corduroy pants—that was Sammy Flash's sole legacy to the earthly paradise he'd left behind.

Fred heaved the window the rest of the way open and turned off the fan. He'd listen to the street while he slept. Let the street's light keep him company and ease him awake when it became daylight. By the end of the day, by the next dark, who knew where he'd be? If the forces of law and order got picky in Cambridge, or in Nashua, for the length of time it had taken Fred to figure things out, put two and two together, link Nashua and Cambridge—well, he'd face it tomorrow. But he'd carry a toothbrush with him. He was beat.

He turned off the overhead light, stepped out of his loafers and lay on the foam mattress, remembering, "I hope Flash took that bath before he slept here."

Hard ridge across his back.

"Dog my cats." Fred flipped the mattress over.

◇◇◇

Green garbage bag not, from the way it appeared, being used for the first time; and in it a hard slab, slightly bowed, that measured "yay by yay" if anything ever did. Fred eased the mouth of the bag open and pulled the panel out, gently, as if it might explode.

Flash had laid the thing down on its face. That was a good thing, since the panel was warped slightly. Face down, it had acted as a cradle. Face up, and convex, the weight of the sleeping man—whether Flash or, later, Fred—would have split the panel.

"Look at the back first," Fred told himself. He'd watched Clayton, on first examination of a painting of some antiquity, spend so much time studying the back side that he seemed prepared to be completely satisfied with that. The back can tell crucial stories relating to where a piece has been, and what it is—but not for now. Not here. Fred took the panel to where the murky light from the window fell on it. It was the real McCoy.

The panel's face was so dark Flash might have been blowing cigar smoke across it for the past five hundred years. Fred lit the lamp he kept on the small table where he sat when he was reading, and tilted it to play on the painted surface. The panel almost burned between his fingers. "I wouldn't doubt it for a minute," Fred said.

Since the floor's ratty carpet extended under the bed, there'd been no additional abrasion to the painted surface that appeared now that Fred flipped the dark panel over to expose its face. It would take a month to figure it out, if he had a month to do it. Under the protective skin of dirt and varnish—perhaps nothing had touched Hieronymus Bosch's paint since the artist applied the first coat of varnish—a hundred figures writhed and paraded across a fantastic landscape in which were surprising pockets that looked like every day. On quick appraisal, this must be either an early sketch, or later summing-up, of many of the themes that had been worked out in the huge altar piece that now hung in the Prado Museum: *The Garden of Earthly Delights*. But the Prado version was in three segments. In this one, everything had been compressed. Those pink and naked figures down left, separated by a robed figure, had to be Adam and Eve addressed by God, in the Garden of Eden.

Nowhere was there evidence of the comforting barrier the old stories liked to place between Paradise, where our first parents sinned, and the outside world we live in, into which their

sin condemned us. No, not at all. Everything was crammed in together: the flowers, birds, fish, demons, fruits, tortures, weapons, burning cities, a woman milking a goat with a lion's head, the carafe of fornicating beetles, ships sailing backwards on a prairie, a flying bear; that judgment of Paris without Paris that Fred knew already from Kim's thigh; people everywhere assaulting each other, naked or in fantastic partial costumes; loving each other; selling things to each other—you could spend years making stories to explain what these people were doing.

And in the midst of it all—though it was placed in the lower right, where it balanced the vignette of Adam and Eve with their creator—Kim's goblin. That segment alone, two and a half inches on each side if you had cut it from its matrix—was enough to prove the panel's authorship. An egg with the feet of a chicken and two heads, yes. The egg was hollow, a shell only, raggedly broken so that within its interior could be seen what might be priests and bishops feasting on the intestines of a pig who was alive. The egg's legs and feet, cruelly clawed, stretched to run in opposing directions, and from the leg bones feathers grew that pierced the egg's shell. What might be milk, or blood, water or honey, leaked from the shell's wounds. Even when the painting was clean, it would be hard to know what the painter was thinking.

The two heads: one was certainly male, its features gaunt and rugged; a man in his prime who may have seen too much. The other, facing upwards as if the two heads belonged to separate bodies that were engaged in intercourse, might be a woman's or a young man's. A woman's probably. A woman in her prime, and also one who had seen too much. But was still game. The whole painting celebrated tension, balance, despair poised against hope, all these forces wrenching against each other, keeping the fabric of the complex world in tension.

"It was painted in daylight and for daylight," Fred said. "We'll look at it in daylight."

He slipped the panel back into its plastic sleeve, and slept.

Chapter Fifty-four

The original plan for the start of the day no longer applied. The painting was accounted for. Where Eva was didn't matter.

Fred rose, looked at the panel. Washed, looked at the panel. Made a mug of instant coffee downstairs and carried it to his room to drink while he looked at the panel. With reluctance he turned it around and made, for the second time, a cursory examination of the back, the wood so darkened with age as to be almost black. There were partial paper labels, vestiges of notations in ink, applied with fountain pen in a language that might be Polish. Chalk marks and annotations in red crayon. Enough fragments of information just on the back to keep a graduate student busy long enough to stretch the work into a thesis matching the thesis the interpretation of the front would inspire. It would be interesting to see what Clayton Reed made of it when he returned.

It would be interesting, also, to see Clay jump when he saw the panel's face.

Before Fred stopped in at the police headquarters in Cambridge, he put his nose in at the public library's reference desk. "She's out today," Gilly told him.

"Trouble at home?" Fred asked. It slipped out. It was not his business.

"Summers our hours get crazy," Gilly said. "She'll be in tomorrow."

Fred left the note. He hadn't thought of a way to improve it,
beyond adding the phone number at Clayton's. Then, looking
at that, he'd thought it not an improvement. But it was done.
Too late. He'd thought that exchanging a few irrelevant words
with Molly might help get him the balance he needed to deal
with the crowd of themes closing in on him from all around.
He was in the middle of this story. He'd followed the possibility
of a painting which had led him, like a will-o'-the-wisp, or *ignis
fatuus*, into a swamp where fellow travelers had started drown-
ing. Others might be in danger. And it was his own damned
fault. He'd asked for it.

Meanwhile, he had laid hands on a fabulous painting and,
in all the world, he alone knew where it was and what it was.

Were it to be discovered now, in its present refuge, its pure
identity as a living work of art would be lost immediately under
a heap of inferences. It would be evidence, not art. It would
become a permanent bone of contention. What is it worth?
Whose is it? Whose fault is it? Who's dead on account of it?

What should Fred do with it?

At no place in his being could Fred find a desire to keep the
painting. He had slept with it. He had held it, studied it. He
would like to see it after it was cleaned. His partial reading of
events pulled his sympathies here and there. Arthur, in fellow-
ship with the artist, had a collegial claim of ownership, if only
on the basis of affection. Tippy Artoonian had reason, if she
cared—as she must were she to discover a financial value in the
painting—to feel she had a claim. The painting had been given
to her, and she had accepted it in good faith, even if Zagoriski
had no business passing it along. Tippy in turn had either given
or loaned it to Arthur, or let him hold it for her, still in good
faith. In fact, as long as there'd been no question of value, good
faith had pretty much characterized the various transfers of the
property, starting with Zagoriski's uncle's wedding gift. Even
bums and jerks, as long as they're not thinking about it, can act
in good faith. It was a tangle.

Everything should be simple, Arthur liked to say.

The simplest thing was to acknowledge Mary Zagoriski as the painting's rightful owner.

But if the painting turned up now in Nashua, in her hands, she would inevitably become a person of interest to those who, putting two and two together, noticed the fatal coincidences that had led to her uncluttered possession of what the media would quickly call, in its tedious shorthand, a "priceless" "masterpiece."

Fred didn't know Molly and he couldn't reasonably burden her by describing the problems that he faced. But he would have enjoyed looking into her face before he decided what to do. He'd like to measure his decision against that look.

◇◇◇

The Cambridge detective he was assigned to, a man named Gamble, was as canny, common, knowing, and experienced as a cigar butt. He was silent and dangerous, and Fred wasted no time trying to put anything over on him. He only withheld the discovery he had made last night. As far as the story went, the characters and their interactions, Cambridge and Nashua, the works—even the notion that there might be, floating around somewhere, an old unsigned picture that had once been appraised for forty-five dollars—he let it all hang out. The fact that Sammy Flash had spent a night in Charlestown didn't come up. The men in the house would never mention it. Sammy Flash wouldn't. As long as it wasn't relevant, why should Fred?

Inevitably, the number of persons in the circle of interest widened, and because every human being is the hub of his own complexities, things got complex. Lexington Orono had grabbed an early morning flight for Paris. He would be interviewed on his return. Gamble had called on Kim at her place of work, and hauled Arthur into the station for a protracted interview. Because Fred started his own interview with his suspicions of Kenzo Petersen, Gamble interrupted their conversation at the outset by putting a call in to Nashua to alert the forces there that something might develop.

"They want to talk to you," he said. "Their question is, and my question, do they send a car down? One of those cars with no handles inside the back door."

He waited for Fred's reply.

Fred said, "I pretty much know my way. Whatever you folks want, obviously."

The issue was left hanging while Gamble wavered back and forth between addressing Fred as a colleague and as an intruder he would as soon lock up.

"What I don't like," Gamble said finally, "and what I don't understand, and why don't you help me with this? What are you doing in the middle of all this? That's what I don't get."

"I'm baffled myself," Fred told him.

"I listened to your story, and I don't believe it," Gamble said.

Fred had no useful reply. It was reminiscent of Kenzo Petersen's complaint of the prosecutor's recurring gambit, 'I take it that' whatever. Impossible to answer.

"I think what you are is chasing girls," Gamble concluded finally. "Your story. To hell with it. Chasing girls is the only thing that makes sense. I like facts, but facts are no good without motives. I've seen these girls. Kim, the one at the hair place, the one you started with, according to you, following her tattoos, which I have only seen a little bit of, I'm a married man, got enough trouble with that—still, that I can understand. Chasing girls. Running after her. The redhead, Eva? OK, I see that too. There's one in Nashua dances naked—no, you said two? I see where you're coming from, Fred, and I see where you're going. And I am telling you as one who has been there. Don't.

"Be where we can find you. I'll let you drive to Nashua on your own but you are a witness and I want to know when you get there and when you get back. When you get back I want to know where you are. Thanks for your help, and leave the girls alone. Girls are trouble. Especially girls with tattoos. I will certainly see you again."

◇◇◇

Nashua was more involved. Kenzo, reacting with fury to the initial questions as to his whereabouts the previous morning, had flown into such a rage that he had given the cops reason to lock him up. The information he had included accidentally in his tirade, together with what Fred had reported from Cambridge, gave them enough to apply for warrants, to impound his truck and motorcycle, and to seal off both the shop and the trailer where Kenzo and Stephanie lived.

"This much I can tell you," Fred explained when he sat down with them. "When Arthur left Nashua, whenever that was, he was scared enough of Kenzo that he changed his name and left no address. Didn't tell anyone where he was, except Flash. Or Flash found him. I don't know which."

They'd handed him over to a youngster trying to make his way up through the pecking order. "According to you everyone wanted a painting," the youngster said. In plain clothes—tweed sports jacket in this heat, and open collar—he wore a tag saying Hamada. He might be one of Nashua's five Hawai'ians.

"Nobody can put their hands on that painting at the moment," Fred said. "Mrs. Zagoriski, as she's probably told you, when she took a photo of it to a gallery in New York, was told if they liked it, they'd give her twenty thousand for it."

Hamada drummed on his desk and smirked. "In India, Mexico, the Congo, they kill you for twenty thousand," he said. "We don't do that here. Twenty thousand? Hell, these days anyone can go to the bank even without collateral and borrow twenty thousand. Forget the painting. I talked to Gamble on the phone and he's right. He's been around. It's women. There's women all over this. The Cambridge end, that's their problem. We're glad to help, as far as we can. Looks like the murder of Sammy Flash leads back to Kenzo. Why, that's another story. We'll go through Kenzo's place. The trailer, the shop. Look for the keys you said he tossed. Test the motorcycle chain, the back of the truck, the rest of it. The guy was washing the bed of his

truck when we picked him up. That blond chick with him—wet Tee shirt, everything.

"The girl, Stephanie her name is, all I can say so far, maybe she was in the apartment in Cambridge a couple days back, looking for Arthur, like you say, Fred. That's interesting and we'll follow up. But nothing happened to Arthur. What might make sense, if you're right. Flash, the dead guy, had robbed so much stuff from Kenzo Petersen…but this is nothing to do with you. I'd make you stay in town, but Cambridge wants you. I promised they'd get you back."

Chapter Fifty-five

Fred's appointment with Constantino Zeldas was not until four o'clock. The lawyer's office was in a new semi-brick, semi-colonial, totally incongruous building perched at the edge of yet another mall west of town. Across the hall was a dentist's office. As instructed, Zeldas had found a way to get hold of Mary Zagoriski. She was already in the waiting room. She looked up, alarmed and expectant. "What…?"

"I'll hold off until we're in the presence of your attorney," Fred said. "Nothing bad. I like to know you have attorney-client privilege."

"There's something happening," Mary said. "I can't believe. Constantino told me there's an idea—Kenzo—that he—that Zag…"

"Let's wait," Fred said. "As long as we're waiting, let's wait. How did it go yesterday?"

"Purely awful," Mary said. "Then after, I had to sleep in his house. It's his house now. Not mine. He found a way to burn me out of there. Everything we ever—then that girl upstairs. But it's true, what she said. In her note. She was upstairs. I will never understand…"

They'd been put in an alcove off the entrance where a middle-aged woman dodged telephone calls while acting as receptionist for nobody more than Fred and Mary Zagoriski. In response to a buzz on her desk she motioned them to go past her into the office.

Constantino Zeldas was a little round man about as tall when he rose to greet them as he had been when seated behind his desk. He beamed dangerously. "I might not say much," he told Fred. "I am Mrs. Zagoriski's attorney. Beyond that—you have something you'd like to say?"

Arid little office with generic sailboat paintings on the walls, grimly haunted by motel cubism inspired by Marin and Feininger.

Fred said, "I have a couple people in Boston I can talk to. They tell me I should be glad that Mary lucked into you. I'm Fred. What do I call you?"

"Tino is good. Or counselor."

"We'll start with Tino. If I begin to piss you off I'll switch to counselor. I'm here thinking Mary's team can use some help, which may include some legal elasticity. I want to talk in front of you, Tino, so that attorney-client privilege can apply if you can stretch it. But I'm guessing that doesn't extend to what Mary might say to me, which doesn't matter. It's not me I'm protecting. More important, she needs a witness.

"Mary had a thousand things to deal with yesterday, and more coming up. I'll talk to you. Tino. If Mary overhears, what can I do?

"Even with everything else going on, maybe Mary mentioned a painting yesterday. Wedding present from an uncle of Zagoriski's. The painting got out of the house when the divorce was pending. Zag's motto, 'Whoever walks out, all bets are off,' I'm guessing has weak legal standing. I don't know law. I don't even know what's right. What I do know is what the situation is.

"That painting. A pirate in New York, hoping to do much better, told Mary he'd give her twenty thousand dollars for if he liked it. By then she couldn't put her hands on it. The murder in Cambridge that you've heard about, which I think involved Kenzo Petersen, killing a man who had worked with him—you know all this? Then I won't repeat it. I know where the painting is.

"Sorry. Better than that, I have it."

"Here?!!" Mary exclaimed.

"Not on your life," Fred said.

Constantino stood and lowered. "You want to explain what you're here for?"

Fred said, "I have the painting safe. I'll do whatever you want with it. That's why I'm here. I have to tell you, Tino, this looks to me like an important picture. Really important. But I am no expert. Mary has already been jerked around and this has to sound like a continuation of the jerk-around. I can't help it. The art business is worse than law or finance, because fewer people understand it and the ones who do don't talk turkey.

"Now I want to go carefully, and I want four ears to be listening. If I am right, the painting is by Hieronymus Bosch, and done five hundred years back. If I am right, if Mary wants to sell it some day, I have no doubt it's worth between half a million and, I don't know, maybe five million dollars. Money's not what I'm good at. You don't want my opinion on value."

Mary's face had turned white. Tino's was a complementary crimson.

"What I want to do," Fred said, "is give you a receipt for it so there's a paper trail in Mary's file. I came by it honestly, even, you could say, lucked into it. With your permission I'd like to move it from where it is to the place where I work, where it can disappear among some other paintings or, better, if he agrees, into the vault of my employer, who is a collector of paintings. Still, with whatever receipts you want.

"My thinking being that, until these present disturbances are worked out and the fallout from Zagoriski's death has settled—not my business, but did Zagoriski get around to changing his will?—until such time as the coast is clear, a year or two down the road maybe. Unless she's lucky there will be trials, conflicting claims, conflicting witnesses…"

"Mary and I will discuss this," Tino said, "and let you know. Continue."

Fred said, "You don't want to have your sheep cared for by wolves. So the choice isn't easy."

"God!" Mary said. "Half a million? I can't afford that! How do I insure…"

"Insure it the same way you did before, is my advice," Fred said. "I didn't put the painting in my car, for one reason because I'm being interviewed simultaneously by the police in both Cambridge and Nashua. Also I don't like to park on the street with that thing in my trunk. All this heat. Rattling around. Not that anybody's going to steal my car. Still…And second, I don't think you want it in Nashua while all this other stuff is pending. Certainly not in that house. That house is going to be empty, it's going to be put up for sale…"

"But I never liked that picture," Mary Zagoriski protested. "The one thing I know, it's not going to Orono. That's for damned sure."

Tino reminded her, "We'll discuss this, Mary. Fred makes some good points. Our own conversation is protected only between us. Fred, is there something else we should know?"

"The art world is full of pirates," Fred said. "You don't know me, but talk with the people I talked with about you." He handed Tino a sheet with names and addresses. "I haven't cleared this with the man I work for. He's out of the country. What I'm suggesting, counselor…"

"I'm going to talk with my client," Tino said. "And it's still Tino."

Fred cooled his heels in the alcove waiting room. He might have napped but for the interesting display made by the receptionist. He had seldom seen, in a person with so little to do, anyone keep so busy. She managed to do it without getting up from her chair. She did her nails twice. She rearranged the papers on her desk. Three times. She wrote a memorandum on a Post-it note and adhered it to the outside of an envelope, considered its placement, and changed it. She answered the telephone, accomplished another Post-it-note memorandum, and adhered that to something else. She was like an entire colony of ants rolled into a single ant.

The telephone rang again. She picked up the receiver and listened. "I'll put you through," she said. "Please hold. A Detective

Hamada," she said in a more deferential manner into the phone. "For Mrs. Zagoriski, but he'll speak with you." She hung up, looked in Fred's direction and began doing her nails.

"I'm stepping out for a burger," Fred told her.

"I wouldn't," she said. "That is to say, I suggest you wait here. You go for a burger next door, in my experience, you'll be going the next thirty-six hours at least."

The phone rang on her desk. "Go on in," she told Fred.

Tino spoke. "Mary likes your suggestion. I don't. Mary's spent time with you. I haven't. I called these two people. They say you're OK. I still don't like your suggestion. Mary still does. The decision is Mary's."

Mary smiled across the room.

"We'll write a receipt for the painting," Tino said. "The wording will be tricky. I don't want to see the thing. From my point of view, it's hearsay, and nothing more. You'll dictate the specifics since I'm in the dark. I do not know from art. You will send me a good photograph for my files. Later we'll talk about getting an appraisal done. If we go that route. You will do nothing more without Mary's written agreement."

"Except what you said," Mary added. "Put it where you work, or in the vault. And later…"

"The next item of business, I'll mention before we get to the receipt. The Nashua police have tentatively confirmed an alibi for Kenzo Petersen, for the night of the hit and run. He was at a rally in Wolfboro, he and Stephanie both, the girl who works in the shop. They're going to have to prove it, but that's what Hamada believes. He's confident enough it's going to turn out that way, he called to tell us."

"Thank God," Mary said. "I couldn't see Kenzo…well, maybe I could, but I didn't want to."

Chapter Fifty-six

Fred was halfway to Boston before he whacked his forehead with the heel of his hand and muttered, "Shocks and struts!!"

That throwaway line, in Kim's equally throwaway voice.

◇◇◇

Shortly, standing in the building's vestibule, Fred found the buzzer next to Ernest Weiner's name, and pressed it. The day's heat still reflected from the street and sidewalk, and roiled against the coolness from the surface of the river. Rumblings to the east suggested the possibility of rain later. A determined silence was the only response to the buzzer. He buzzed again, looking through the interior door's plate glass into the lobby and stairwell until Kim showed up, descending the stairs in her chosen most casual summer outfit, next to nothing.

"We didn't want to take a chance." She opened the door. "But all it is is you." She called upstairs, "It's only Fred," and added, "What can I do for you?"

"I'm coming up," Fred said.

"I'll talk here."

"I spent most of the day in Nashua," Fred said. "Want to make sure our stories match." He started up. Kim, her choices limited, followed. "Did you ever get hold of Eva?" Fred asked.

The question answered itself. Eva, with Arthur, stood in the doorway of Ernest Weiner's apartment. Eva held a brown bottle of beer. Her dress was a loose T-shirt, black running shorts, and

white sneakers. The crackling forces zipping around among the three of them, Arthur, Eva, and Kim, suggested recess during the negotiations over the fate of Jerusalem.

"A reunion," Fred said, pushing between them into the apartment. He looked around the living area, making not too much of a big deal about it. "Funny. I was sure I was going to see that painting finally. If you can manage, if you've got one to spare, I sure could use one of those beers." He sprawled on the couch.

Arthur said, "I can't work. I can't work here. I'll have one too, Kim. They won't let me have my tools. They won't even let me in my own apartment. I should never of told the cops."

"You should never of been an asshole," Kim said. "But as soon as you were born, Arthur, it was too late." She strode into the kitchen. Eva took a seat at the other end of the couch. Arthur, too nervous to sit, shuffled around the room fiddling with fixtures.

"I'm itching all over," Eva complained.

"Give it a couple more days. I might as well drink. The old guys, Kenzo, Flash, and them, they always say it doesn't hurt, they can drink and drive at the same time. But you can see it, their work. Flash, he'd hold out his hands, 'Look how steady they are,' and they were. But steady is not what you want. Even and easy and *moving* steady, in control, always moving, in control of the line. That's what you want."

"And Flash is dead. They're steady now all right," Eva said. "Neighborhood like that…"

Kim came in with three bottles, saying, "I'm not washing glasses."

Whatever the beer was—Fred didn't look—it was better than Old Brown Dog. Hoppier. Fred said, "I imagine you've been asking each other about the painting." He let them exchange glares of mistrust. "That's what it feels like to me. I don't know if Eva ever had an interest before, but by now—Eva, I never heard your last name."

"You don't need to," Eva pointed out.

"I put that wrong," Fred said. "Eva, I take it you have a last name…no, that won't work either. What I'm saying to myself,

and it doesn't matter, is, knowing how human beings are, or how they can be, what the present situation could be is, since I don't see it here, and you're all falling out—Eva, who might never have given any thought to the painting before, since there's been so much excitement, and a couple people killed adds emphasis—Eva has the painting, and she won't tell anyone else except we assume Beth, maybe. Where's Beth? That's one possibility.

"Or Eva's got something going with Arthur, and the both of them won't tell Kim. Or Eva's got something going with Kim, though it doesn't feel like it.

"Or Kim's got the thing stashed and won't tell Arthur. Or Arthur's got it stashed away and won't tell Kim or Eva…"

"That fucking Orco already flew to Paris," Kim said. "According to the desk when I asked at the Charles Hotel. Which is a lie. They gave me his number, a hotel, you call it, turns out the name of the hotel is the Athenian Plaza, which is obviously in Greece, so forget that. So there's no point calling. What is Oreo gonna say? How he did it I can't figure out. I never saw that painting, he'll say. Painting? What painting? I'm in Paris, all I want is vacation, climb the Arc of Eiffel. For the snails. But the whole time he's in Greece. He got the painting, maybe found it in Arthur's place while Arthur was out."

Fred took another drink. The theory of it was even better than the beer itself. "Another possibility," Fred said. "But speculating that one of you sold it to Orono, or if two of you sold it to Orono, because it's obvious all three didn't: where's the money?"

"And how much did they get?" Eva said.

"And what are you, here looking for your cut?" Kim demanded. "Too fucking bad."

Arthur put his hands over his ears. The right hand still held the beer bottle.

"Money. Arthur gets like this," Eva said.

"Or it was Sammy Flash," Kim said. "Always hanging around. Flash could of taken it, stashed it in that refrigerator, then when Oreo came to buy it from him, Oreo killed him instead. Cheaper."

"Yeah," Eva said. "What was Flash doing there? How long had he been dead? Did they say? How did he get there? Or Flash sold it to Kenzo."

"I can't," Arthur moaned, his hands over his ears.

"Next thing I do, I'm talking to Kenzo," Kim said. "Kenzo's in it. We know he called Arthur about it. Which had to be Flash telling Kenzo how to find Arthur."

"I can't do it," Arthur said.

A buzzer sounded. Eva and Arthur and Kim looked at each other. Kim shook her head. The buzzer sounded again. "I'll get it," Fred said. He pushed past the protesting group, found the contraption in the hallway and pressed the release while telling the receiver, "Top floor." He cracked the door open.

Heavy steps on the stairs. A general scramble behind him while he held the company back. Gamble appeared in the stairwell with two men.

"We're having a beer," Fred said. "Come on in. I reckon I can't offer you any since you're on duty. Or is that an urban myth?"

"It took us a while," Gamble said. "After your call, Fred. Thanks for holding the fort. Since it's registered in New Hampshire like you said, the registry's closed, you have to wake somebody up, convince her it's important, then roam the streets of Cambridge until…."

Kim caught on first. It wasn't clear that Eva did at all. Arthur was hopeless. Kim stood still as stone but her beer bottle clattered against the TV console until she put it down. The tattoos on her legs and belly reflected from the TV screen. It was a truly inefficient way to study a painting.

"You want to sit a minute?" Fred offered Gamble. "This isn't what I do."

"They're sending folks down from Nashua," Gamble said.

"Maybe a glass of ice water," one of his backup suggested.

Gamble glared him down. "We wait here or we wait at the Green Street station. To answer your question that you are not asking, Fred. Because like everything else this is not your business. Not what you do. You happen to be here. Yes. We found a

car registered to Kim, in the name of Ruth Hardin of Nashua, New Hampshire. Parked six blocks away. And yes, its hood is well dinged. And yes, we had a warrant. And yes, we had it towed to where we could give it a quick once over. And, yes, the damage to the hood and undercarriage is consistent with involvement in the hit-and-run and yes, there's organic matter underneath that will be collected and analyzed in the morning when the techies wake up. And we'll try for a match.

"Anything you want to say, kids? Kim I know. Arthur I know. Who's the redhead? Do we know anything about the redhead?" To Eva, "Who are you?"

"You're not going to want to say anything," Fred advised the three clowns. "Beyond your names. Let's step into the hallway," he suggested to Gamble. He carried his beer with him. With any luck he wouldn't go into Weiner's apartment again.

"These people don't talk to each other," Gamble instructed his officers. "Anything they say out loud, whatever it is, take it down. Got that? And no, nobody gets ice water. Nobody leaves this room. You got that? Nobody goes to the bathroom. Nobody gets on the phone. They can finish their beer, that's it. It might be the last one they have for a long time." He joined Fred in the hall.

Fred said, "It's Nashua's problem, I know. What they are going to find is that Kim's car did the job on Zagoriski. I don't know if Arthur was in the car at the time, but I suspect he was. He supposedly doesn't drive. Something got them excited in Cambridge, they drove up there, found Zagoriski. Or he found them and got them to come up. There's a long relationship between Zagoriski and his students, and it's not pretty. Now he's dead. You can believe that Kim is figuring out right now how it was an accident.

"When I talked to Zagoriski the afternoon before he died, he wanted to know where Arthur Schrecking was, and where Ruthie Hardin was. The question I ask myself—why did he care? Had he heard from one or both of them? Had they made an appointment to meet him? Had Ruthie—Kim?"

Kim had zapped Zagoriski all right. Fearing his interest could threaten Arthur's possession of the painting that might be her ticket to Phoenix, she'd simplified the chain of ownership by interposing a corpse. Fred wasn't going to get into that. Why should he? Better the painting stay out of the story if that was possible. Kim wouldn't volunteer such a motive. If Kim admitted anything, she wouldn't commit beyond accident.

Fred interposed some sympathetic mist.

"I don't know if Eva was in on it. I can't get a reading on Eva, that's the truth. Was she in the car? Why? When Nashua talks to the barman at the Moonglow Lounge he will say, if he remembers, that Zagoriski left the place that night, solidly in the bag, and in the company of a gorgeous redhead."

"That redhead could be Eva. Or she's a coincidence, could even become collateral damage. I haven't a clue if she's involved, but she is…"

"A gorgeous redhead," Gamble finished. "I can see that."

"Then again, Kim could have worn a red wig," Fred pointed out. "I like Kim for it. Then again, Arthur's got red hair though I wouldn't call him gorgeous. I like Kim, but anyone can wear a red wig. Ask E. Howard Hunt."

"Who in the blazes is E. Howard Hunt?"

Chapter Fifty-seven

Telephone.

Fred dragged himself out of sleep by the fourth ring.

"I didn't dare call again after ten last night."

Molly's voice. "Now that I waited, it's too early in the morning. I'm sorry."

Seven-thirty. Was that rain? Yes, it was raining.

"It's OK, Molly. I'm awake," Fred lied. Between greeting the contingent from Nashua late last night, Hamada included, and getting free of Gamble's last-minute questions concerning the fact that the Charlestown address where his car was registered didn't match the address where he claimed to be staying on Beacon Hill, and stopping by Charlestown to collect the painting, and sitting with it in his office for long enough to ensure that it was still all in one piece—he hadn't gotten around to closing his eyes until four.

"I'm sorry," Molly repeated.

How did she know where to reach him? Fred wasn't about to ask.

"With everything going on," Molly said, "I didn't know how badly you needed them. I have the yearbooks you wanted. They came in yesterday. I was out. Gilly said you came by. He could have given them to you himself, but he didn't know, or he didn't think of it. Today's *Globe*. That man killed. If you need the yearbooks, I wanted you to know they'd come in. They don't

circulate. If they have anything to do with—I don't know what you might need, Fred. In case it's important..."

Gilly had called Molly at home. Or wherever she was. She had this number from Gilly. Gilly had read his note. His note to Molly.

Fred swung around and sat up. The floor was cold on his feet. Hieronymus Bosch's painting, *A Paradise for Fools,* on the floor leaning against his desk, glowed under all that dirt, trouble, and old varnish. From a black pool lizards crawled. The gremlin's two heads, distracted from each other, gazed balefully at Fred, but in a friendly way that could bring tears. In spite of all the trouble in the world around them, was it possible? They were lovers. Closer even than Adam and Eve had been.

Fred said, "I'll stop by when I can. I would like to look at those yearbooks, but it's not pressing. Thank you. They picked up some of these folks last night. Folks from the high school who climbed over the fence, got out into the big world outside the gates of Eden, and found things aren't much better on this side. I'm feeling sort of bad about it, tell you the truth, Molly. About it. About them. I feel like there's this pile of wheat left to rot in the field, while the chaff gets dragged back to the barn. Which is which, I don't even know. Such a waste."

"I got your message," Molly said. "Obviously, since I have your number, to wake you up. You figured that out. Listen, about the yearbooks. I had a minute, looked through them. A couple of them, you never think, a high school year book. A couple of them have brilliant drawings."

"I'm not surprised," Fred said. "That's one of my clowns. Arthur. I don't know if the guy is a genius because I'm not even sure he has a soul. The high school where he was, they did their best to kill it, the way I read his story. Maybe he'll find one yet. I think a genius has to have a soul. As a technician, though, I believe the guy could run circles around even Salvador Dali.

I'm gloomy. Sorry. I'm trying to keep you talking. You want to meet for coffee?"

Molly laughed. "I'm at my house in Arlington. It's too early. It's too late. Both. I barely have time to get washed and go to work. Go back to sleep. One drawing—do you know the painting? What am I saying? Of course you know it—Botticelli's *Venus* rising from the waves, she's naked except for the hair?"

"A gorgeous redhead," Fred said silently.

"One of the kids did a version of her to illustrate the swim team page, but with a little polka-dot bikini to appease the censors. I noticed that man's name, the dead man's, Zagoriski, listed as the yearbook advisor."

"Before he himself was censored," Fred said. "Listen, I feel bad. The other day, and then I stopped by yesterday, you weren't in—I wanted to sweep you up and persuade you to have dinner with me somewhere."

"I'd love to. Gilly read me your note."

Fred said, "But I don't know when I'm going to pry myself loose from some conversations I've gotten into concerning the Zagoriski business and the rest of it, and these clowns, who need help finding lawyers, and I don't know when I'm going to get my freedom. I can't make plans. When I do get loose— well, I'm serious. Where would you like to go? I don't know these places. I tend—a can of sardines. Beans when I want to get fancy, have something hot. If I'm by myself. At some of the places, where you're supposed to applaud when they bring out the bacon...You'll be at your desk later? If I stop by? The problem is, I have to go to New Hampshire again. They've got the idea I can be helpful. You never know. They might keep me. Then there are the clowns—the system hasn't done much for them so far.

"I haven't had coffee yet, Molly, and I've been trying to talk with you but making the mistake of doing that while I'm not in the same place you are, and not hearing your answers. What I said in my note, about the crumbs, and maybe one day meeting..."

"We'll start with dinner," Molly said. "It's cheaper if I cook. And fewer crumbs. We'll get to the crumbs later, maybe."

Note: Fred and Molly's conversation in Chapter Two raises a question concerning values of currency in matters of art history. Readers who are interested are referred to Richard E. Spear, "Scrambling for Scudi: Notes on Painters' Earnings in Early Baroque Rome," *The Art Bulletin*, Vol. 85, no. 2 (June, 2003), pp. 310-320. See also Spears' *Painting for Profit: The Economic Life of Seventeenth-century Italian Painters*, Yale University Press, 2010, with contributions from Philip Sohm, Christopher Marshall, Raffaella Morselli, Elena Fumagalli and Renata Ago.